The Other Side of Surfing

GALINDO

PUBLISHING

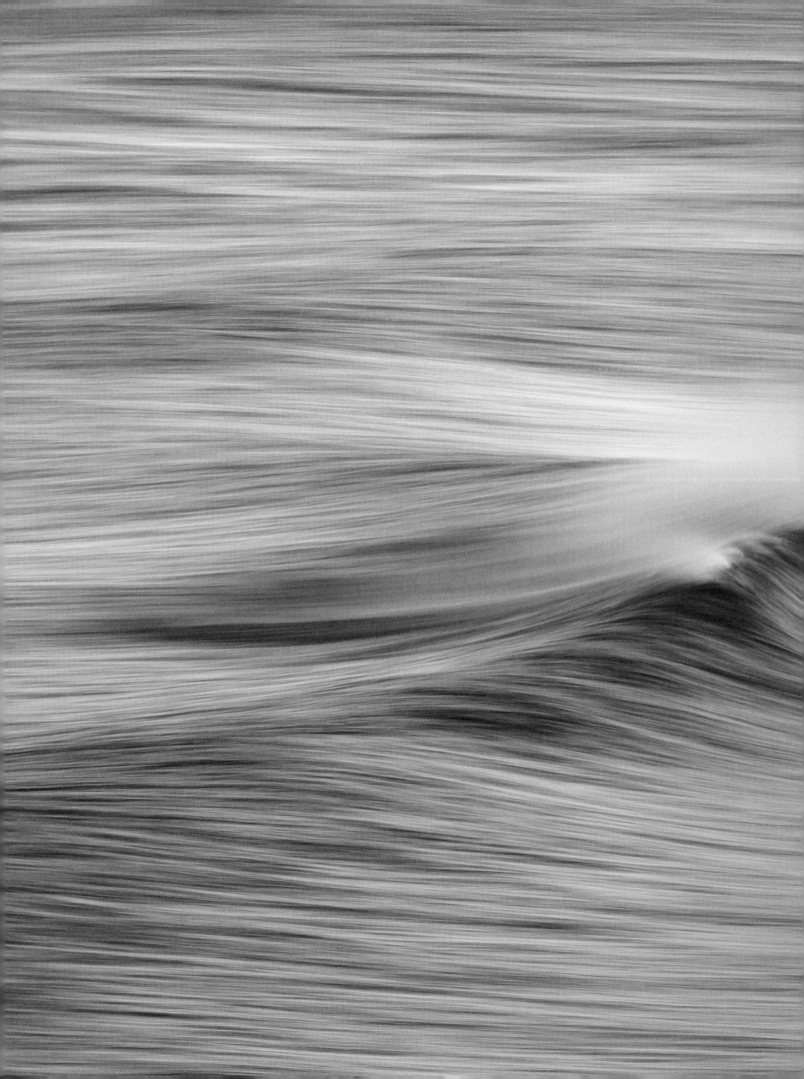

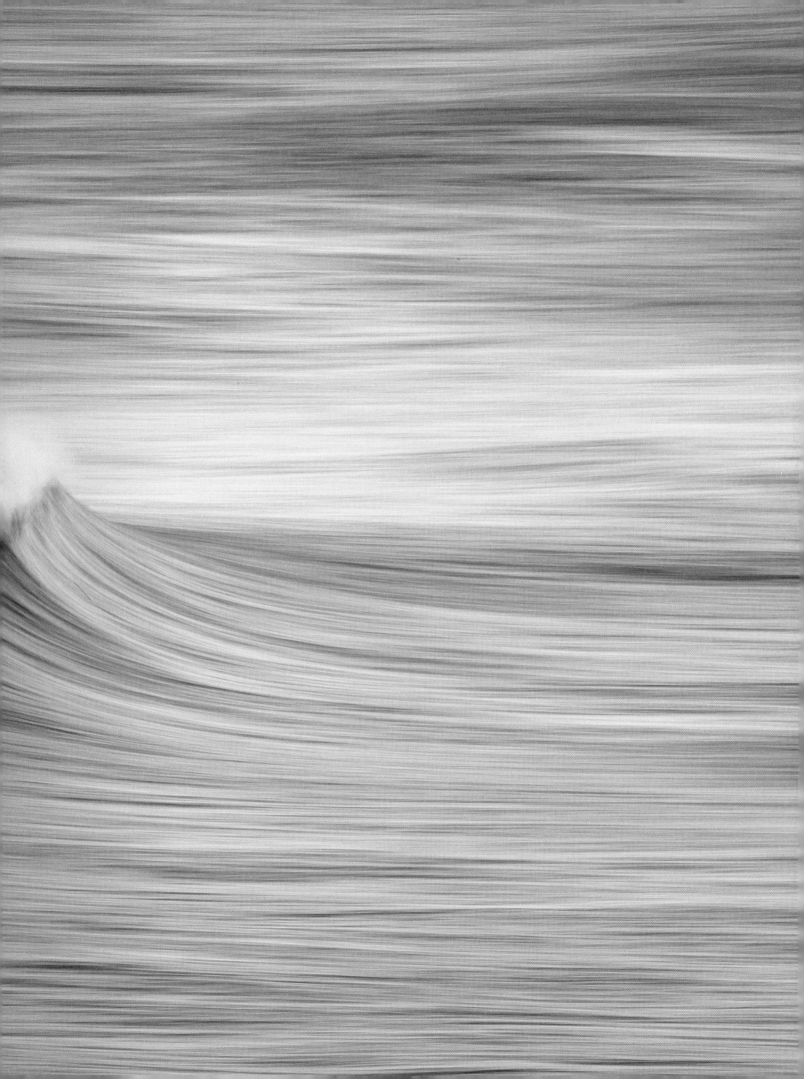

Content

Content

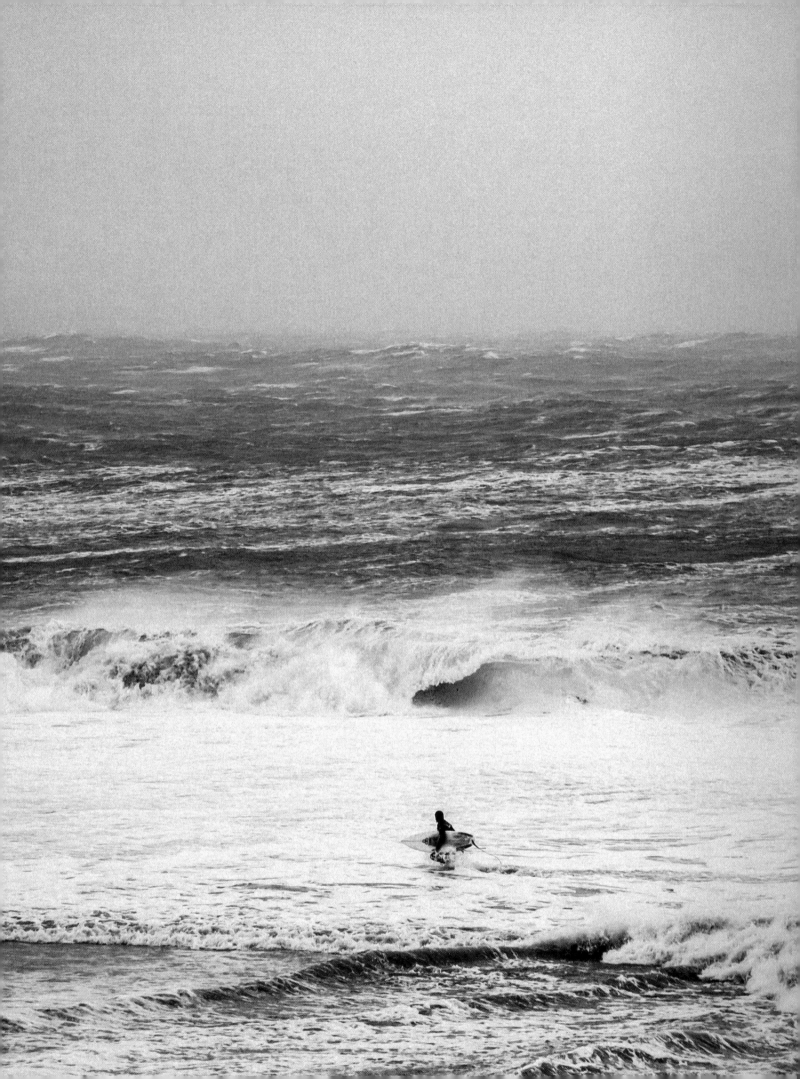

— On the face of it, people who retreat, who engage in any hedonistic pursuit, could be seen as escaping from reality. But as surfing steps out from underground scenes and opens its doors to a broader audience, people have begun to see how surfers have created communities of their own, and how they engage with like-minded people from around the world to form new experiences both on and off the waves.

Much more than just a sport, people often praise surfing's meditative qualities, its ability to make participants more aware of their surroundings as well as of themselves. The sport itself is rarely the endpoint of a surfer's creative explorations. Riding waves has contributed to the careers of notable photographers, filmmakers, social entrepreneurs and environmentalists. The ways that people experience surfing are as diverse as those who surf. Average people with an affinity for nature – and an appetite for adventure – seek to recoup some kind of internal balance and trajectory. The wave becomes a tool for self-reflection and reconnection with our physical environs and attitude toward life.

Surfing feeds other human experiences, and often surfers find that their love for the sport ties into broader passions that, in turn, are informed and enhanced by being in the ocean. Certain qualities linger in surfers who have found other creative pursuits: an appeal to rawness and naturalness; humility when faced with nature; and awareness of the need to preserve and protect both the environment and its inhabitants.

Photographers and filmmakers who come from a surfing background often acknowledge the ocean's influence on their art in similar ways. They commonly reject ultra-stylized, meticulously cultivated scenes and images. Rather, they are accepting of a blemish on a subject, of wind noise on audio and of cameras that cannot always be stable. This isn't due to a disregard for the quality of the end result; instead, it comes from a willingness to accept the power of their surroundings to influence their work, both on a creative and a physical level.

If the ocean is able to invoke awe and allow an artist to dive into the depths of their inspiration, then it is only natural for these qualities to tangibly seep into their final work. Specks of sand on a lens and voices that are disrupted by the crash of waves are much less irritations than they are aspects of the job that need to be embraced in order to offer an honest response to the elements. The environment demands a great deal from surfers. In fact, their enjoyment of the sport is contingent on the environment. The power of the current and the waves can make or break an experience, and surfers are well aware of this fact. For this reason, many surfers have been witness to the marked changes in the earth's eco-systems, caused by human interference. The sport cultivates a concern for sustainability for no reason greater or less than a desire to keep surfing alive for generations to come.

A passion for surfing dictates, also, a willingness to travel. Surfers are forced onto the road in order to find new swells and, because of this, surf culture has cultivated a modern nomad aesthetic. However, far from disregarding the world, these travelers report back to their communities on their newfound experiences. What's more, social media and faster flight times have allowed for a global surfing community to be built, and for surfers to share their unique interpretations of the sport with others on far-flung beaches around the world.

In some cases, social media has helped launch a surfer's creative career. As they document their journeys, followers – including everyone from fellow surfers to investors – can participate in their experiences. If some are hesitant to become nomads themselves, the option is there to envisage the lifestyle and, perhaps eventually, set out on an adventure of their own. As infrastructure and technology attempt to isolate us from nature, surfers offer a refreshing example to those who are looking for it. While many people would retreat and shut out seasonal changes – flood their apartments with gas heating or air conditioning, for example – surfers willingly throw themselves into the elements.

Whether they've been surfing for four years or 40, and whether the sport has moved them into a creative field or a new enterprise, the surfers on these pages: share a palpable appreciation for the natural world. If a football pitch is waterlogged, the game can be moved inside. Tennis can be played on grass or clay. Even many pro-skiers train on dry slopes in the summer months. But surfing is dependent on nature to an extent unrivaled by other pursuits. Surfers know this, often talking about the profound understanding of the environment that the sport commands. They allow natures to not only permeate their experience on the board, but also to inform their creative work and mental cosmos once back on dry land.

In this book, we hope to capture the ethos of a diverse group of individuals who have been influenced by surfing in one way or another. Whether professionals or occasional riders, these are people who see the act of jumping on a surfboard and facing the elements of nature as an inextricable part of their every day. But ultimately, surfing is merely a stimulating stories, and creative endeavors from gateway to experiences around the world – from riversurfing aficionados in Germany to makers of bespoke boards in California; eco-conscious initiatives within Europe to a documentary about the lesser known surfing scene in West Africa. We'll meet all kinds of surf lovers in this book: athletes, makers, artists, publishers, filmmakers and everything in between. Our goal is to approach surfing in a spherical manner and share the invigorating excitement invested in the sea. This is a celebration of a growing, vibrant surf community and those who have allowed the sport to infiltrate their daily lives in a variety of ways. ●

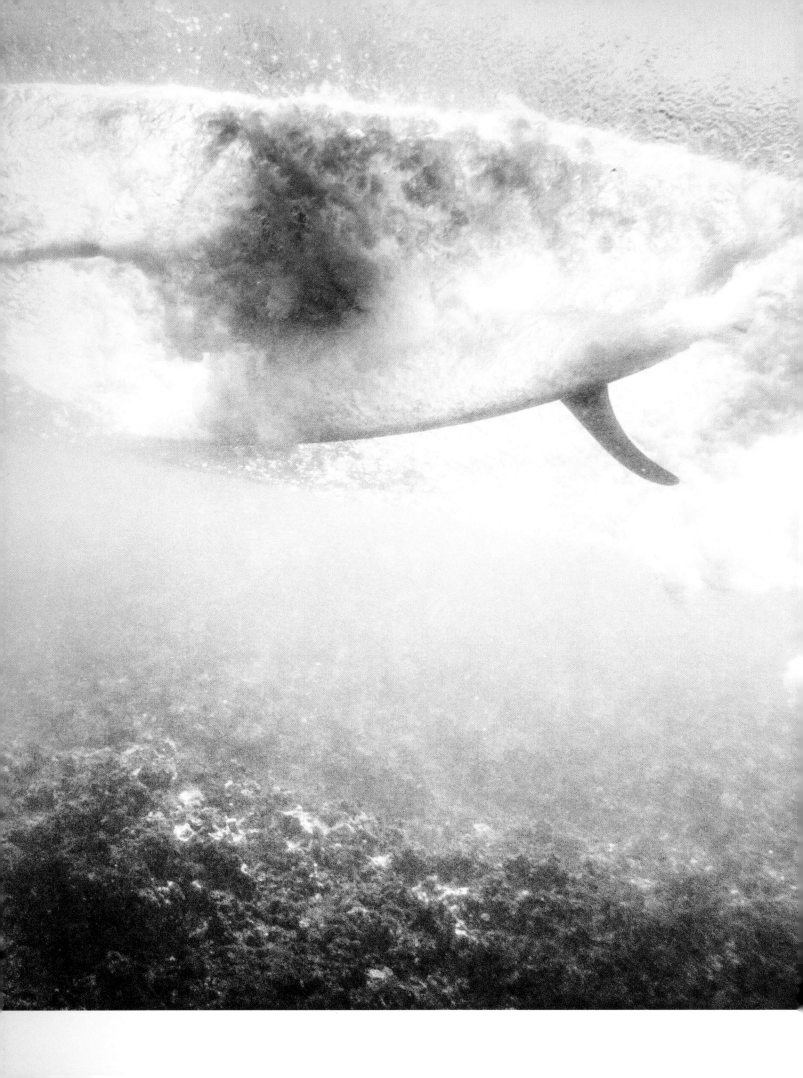

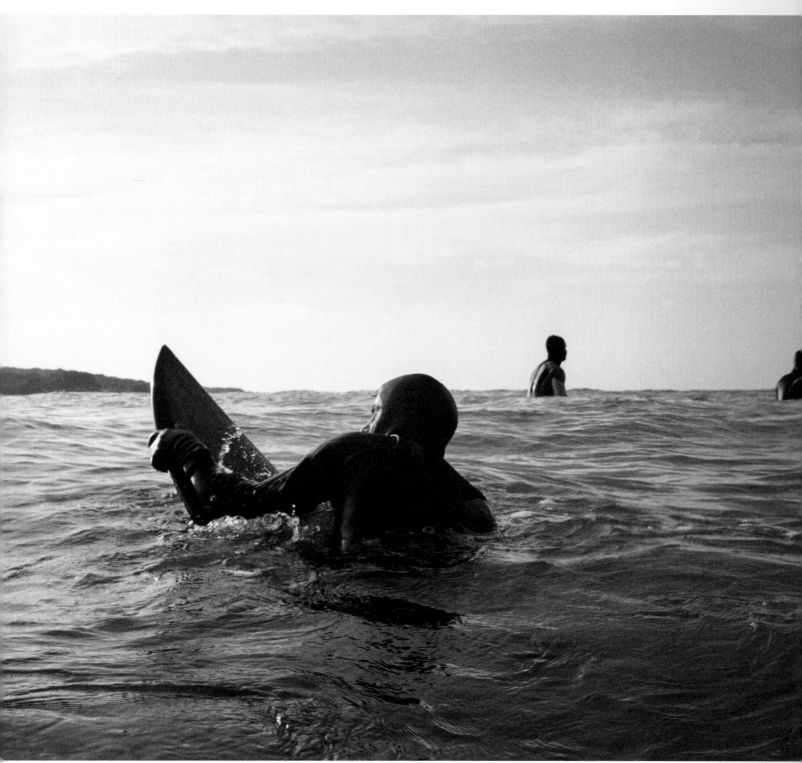

The only thing warm was the light.

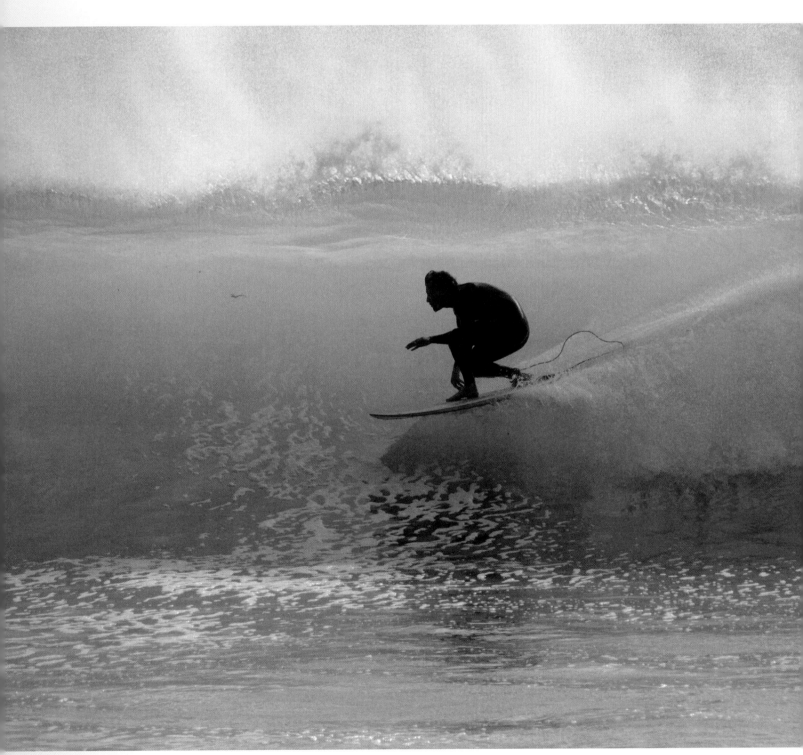

Primoz Zorko on the other side of the lens.

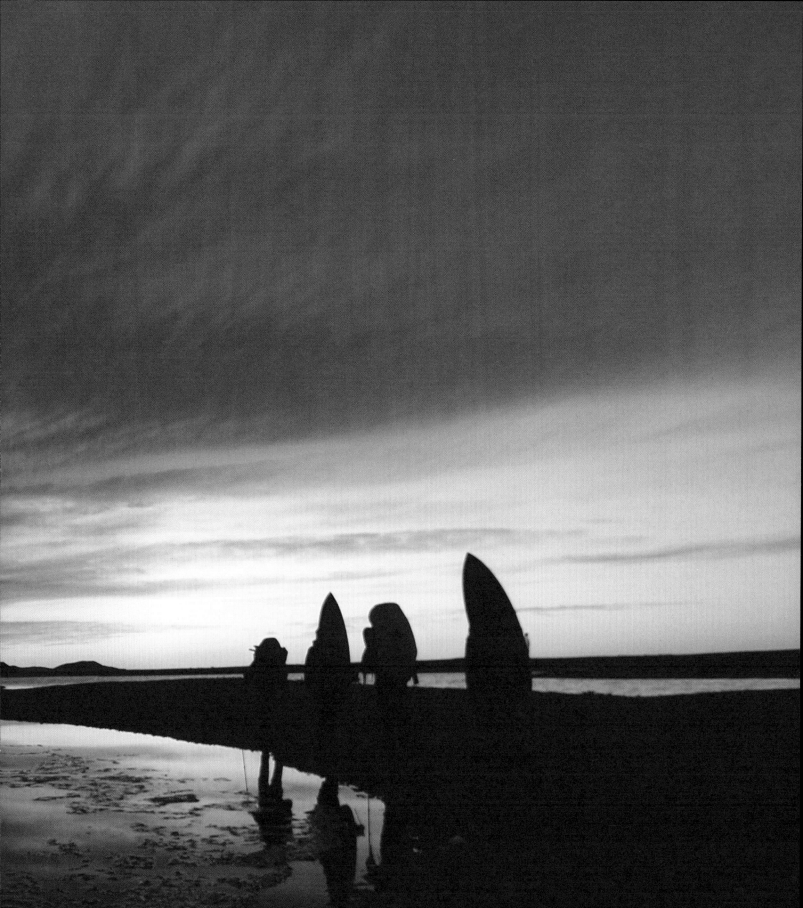

Moving Away from Mainstream

Nathan Oldfield balances intention and intuition to create a unique brand of surf film all his own

Soaking in the afternoon light, post-surf in Queensland, Australia.

— What does it take to make a compelling film about surfing? The answer seems obvious when the film's protagonist happens to be a highly photogenic sport which, most of the time, delivers ocular pleasure and heaps of wanderlust through a screen. However, in the oversaturated surf movie market, surfing films can also be quite insipid and bereft of creativity. A crop of cookie-cutter features glorifying glassy curls, pro-surfers and ostentatious production leave the viewer hankering after genuine experiences with a stronger narrative element.

Enter Nathan Oldfield, whose films allow emotional journeys and uncontrived human stories to take center stage. "What I hope to communicate in my films is that there are lots of simpler, subtler moments taking place that are just as valid as those presented in mainstream portrayals," says Nathan, who sees his work as a comprehensive documentation of surfing life and all the rich layers within it. His anthropocentric approach to the sport seeks to highlight our connection to the sea as an invaluable component – after all, our interaction with water is profoundly therapeutic, both physically and mentally. "I've always felt that surfing is clearly not just physical, it's metaphysical. It's an experience of the heart and spirit."

Nathan doesn't follow scripts; he relies on his innate appreciation for the sea to kickstart an intuitive filming process. *Seaworthy*, one of his most renowned pieces of work, is a paean to the surfing lifestyle and the simple joys transpiring from engaging with waves with an almost sophomoric enthusiasm. What propels Nathan to tell stories is the need to capture beauty teeming with adventure and a sense of freedom amid the wilderness. "Storytelling nevergets old and no two waves are the same. There will always be a fresh image to be made about surfing – it's endlessly inspiring and motivating." His relationship with the ocean has come a long way from the days of building sand castles and obsessively watching surf movies in the hopes of imbibing skills by visual osmosis. What has remained the same is his unwavering belief that the sea offers solace to those who know how and where to look for it. "The ocean is my heart country and surfing is how I find my place in it." ●

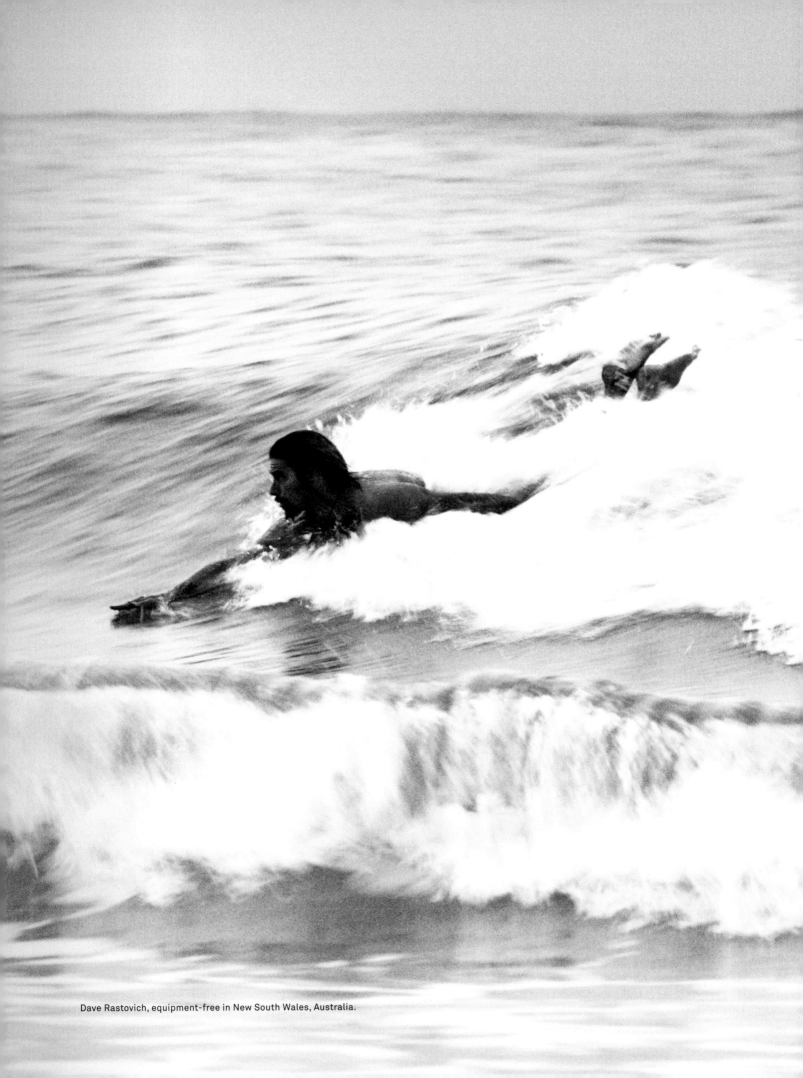

Dave Rastovich, equipment-free in New South Wales, Australia.

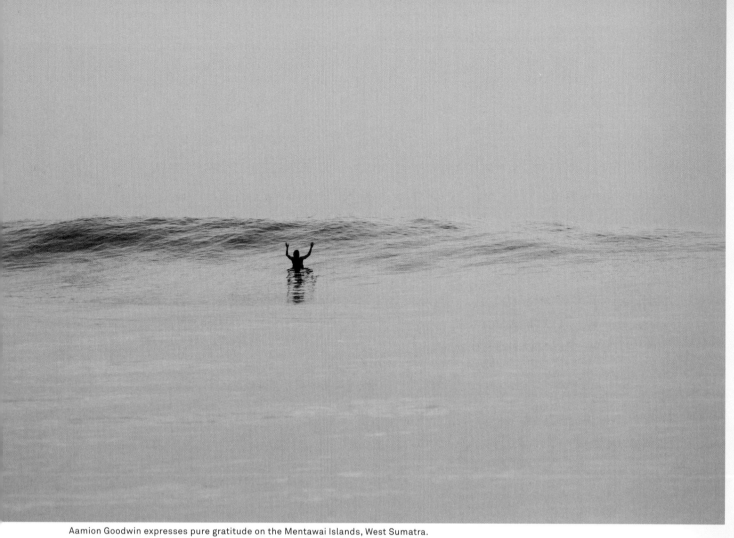

Aamion Goodwin expresses pure gratitude on the Mentawai Islands, West Sumatra.

No leash, no pants, no worries in Madang Province, Papua New Guinea.

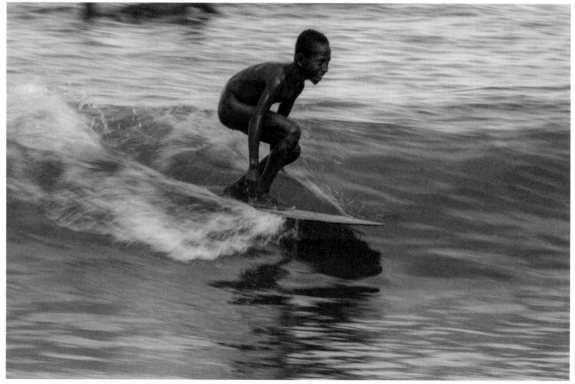

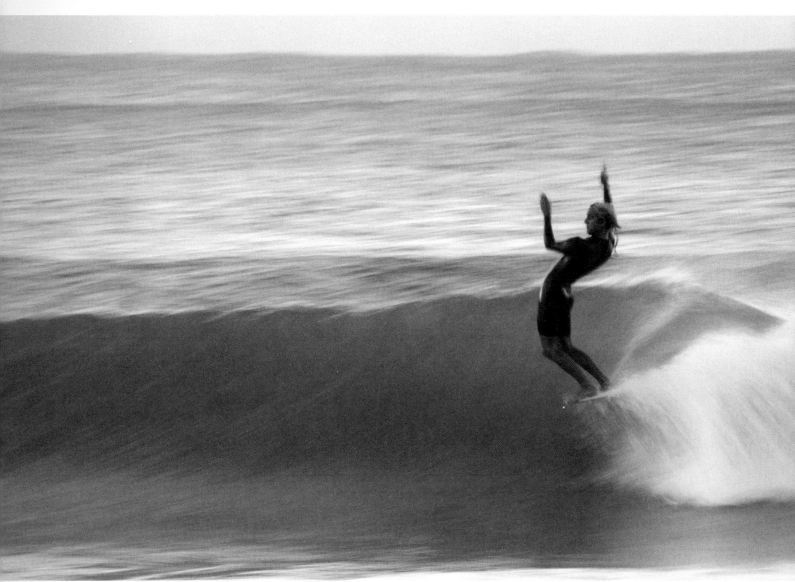

Alex Knost hits the waves full force at Noosa Heads in Queensland, Australia.

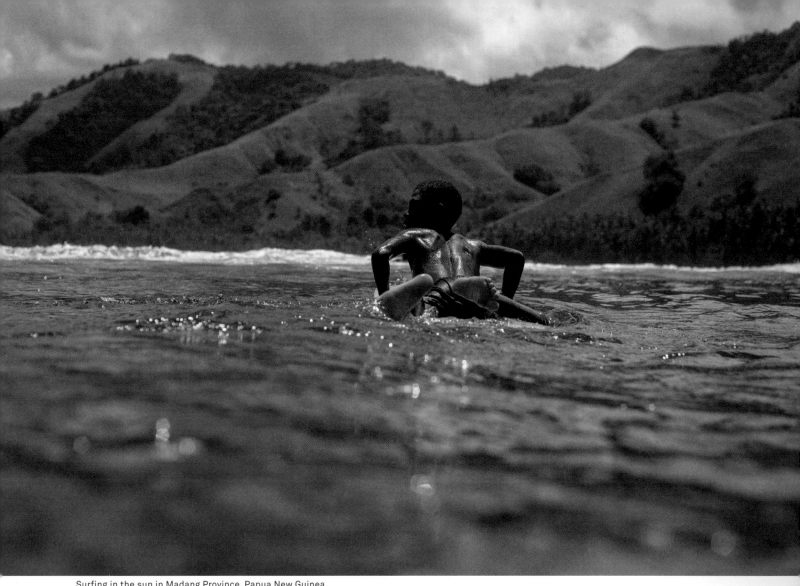

Surfing in the sun in Madang Province, Papua New Guinea.

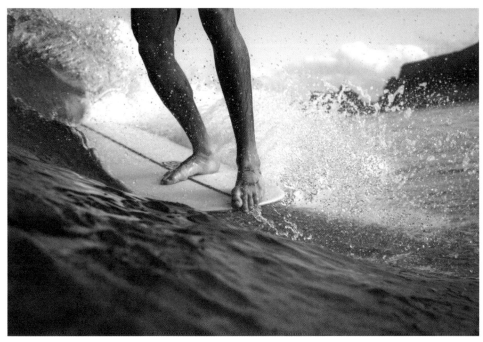

Zye Norris gets his feet wet in
New South Wales, Australia.

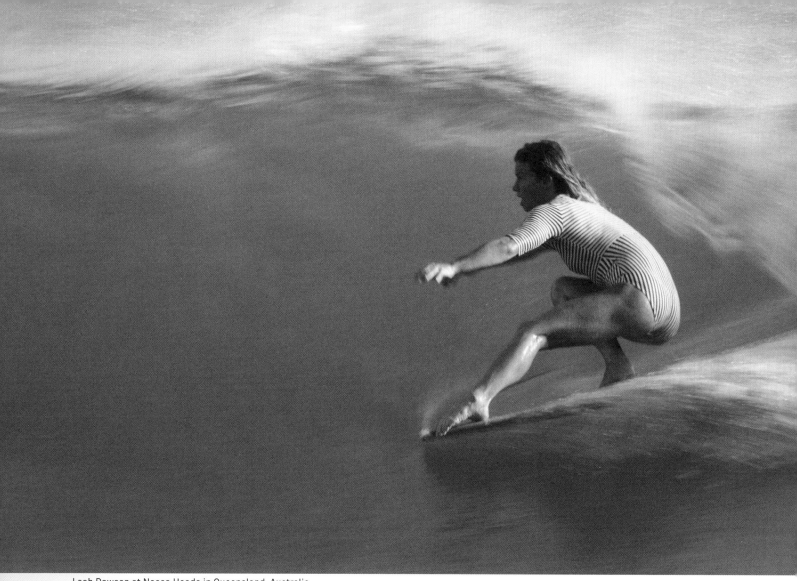

Leah Dawson at Noosa Heads in Queensland, Australia.

Village children of Madang Province, featured in Nathan's film, "The Church of the Open Sky."

Presenting a Female's POV

A group of "German girl gypsies" share photographs, art and stories on a vibrant Tumblr page

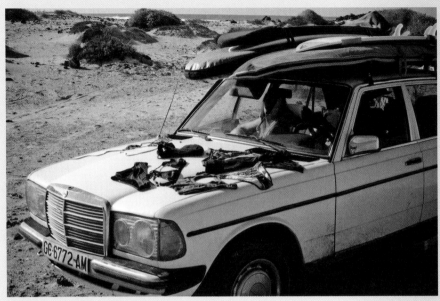

"Surf gypsies" on the Canary Islands.

— It began with a lot of photographs. Instead of allowing her captured experiences to gather dust or be banished to the far corners of the Internet, Valerie Schlieper began sharing her photos with fellow surfers, who contributed their own in turn. Soon, the Tumblr page Velwet was born, exhibiting the photographs, art, and experiences of a group of German female surfers. Valerie describes the unique appeal of the page as "portraying an authentic girls' surf lifestyle, away from sexist ideas." It's a creative space, she says, about "feeling beautiful, as well as connecting with nature."

In a male-dominated sport, Velwet is a welcome space for showcasing the female side of surfing. Valerie sees surfing as a tight-knit community of like-minded people. Velwet expresses this community, through its inherently collaborative nature. As Valerie explains, "We all inspire each other [so] that everyone can express and improve themselves in their own really unique way."

While Valerie's surf community is tightly bound, it has taken her regions of the world, in search of waves in the Baltic Sea, Canary Islands and along the California coast line.

For the women behind Velwet, searching for the right surf environment is as important as the surf itself. "There is no specific wave where we can be found," Valerie says, before adding, "More than surfing, we really love to look for interesting surroundings and explore everything around us." In exposing their surfing experiences to the world, the collective behind Velwet prioritize the social element of the sport – if surfing is a community, Velwet have found their niche within it. The lineup on the water is, for Valerie, a snippet of society: "There's the old local, the strongest guy, the best surfer, the relaxed surfer, locals, tourists, women, kids," she explains. And no matter where they may be, the women from Velwet find their space within that lineup. ●

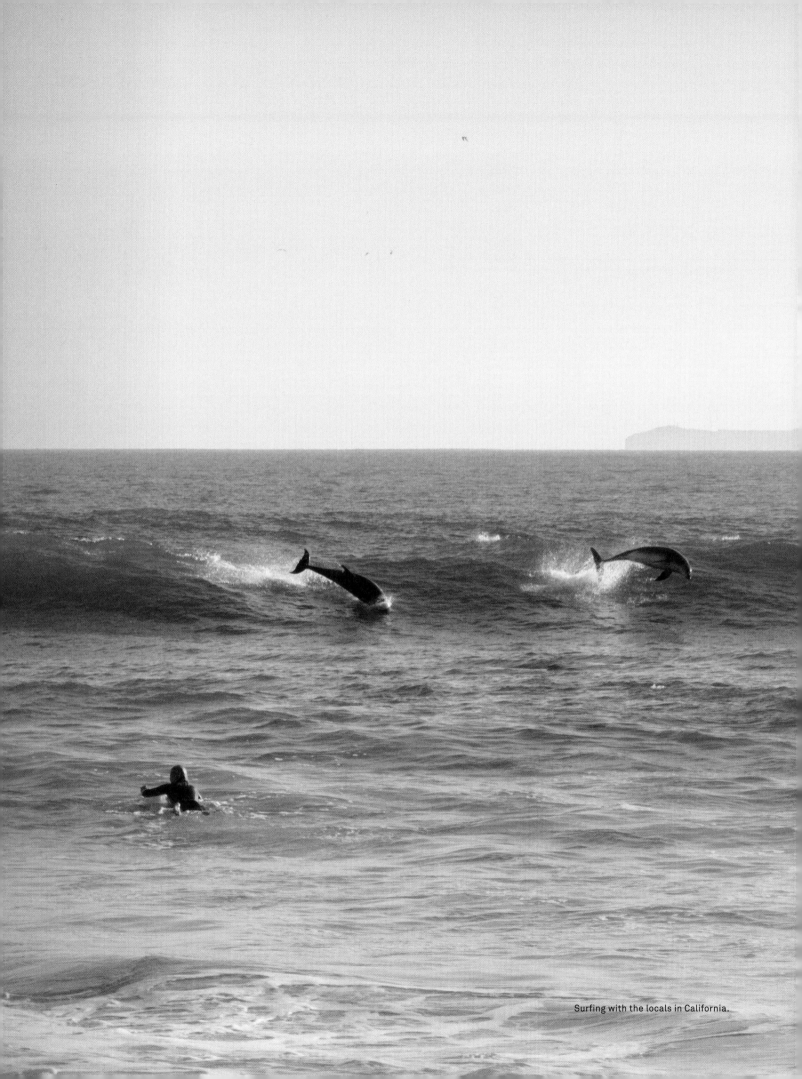

Surfing with the locals in California.

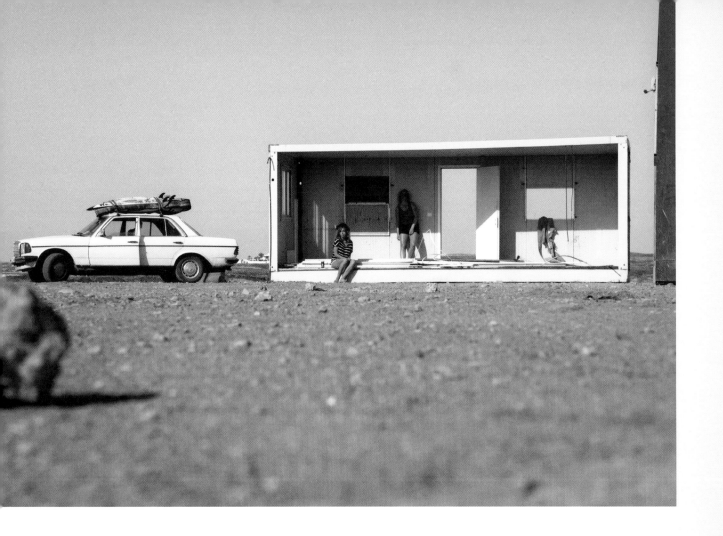

According to the women of Velwet, "home is where you park it."

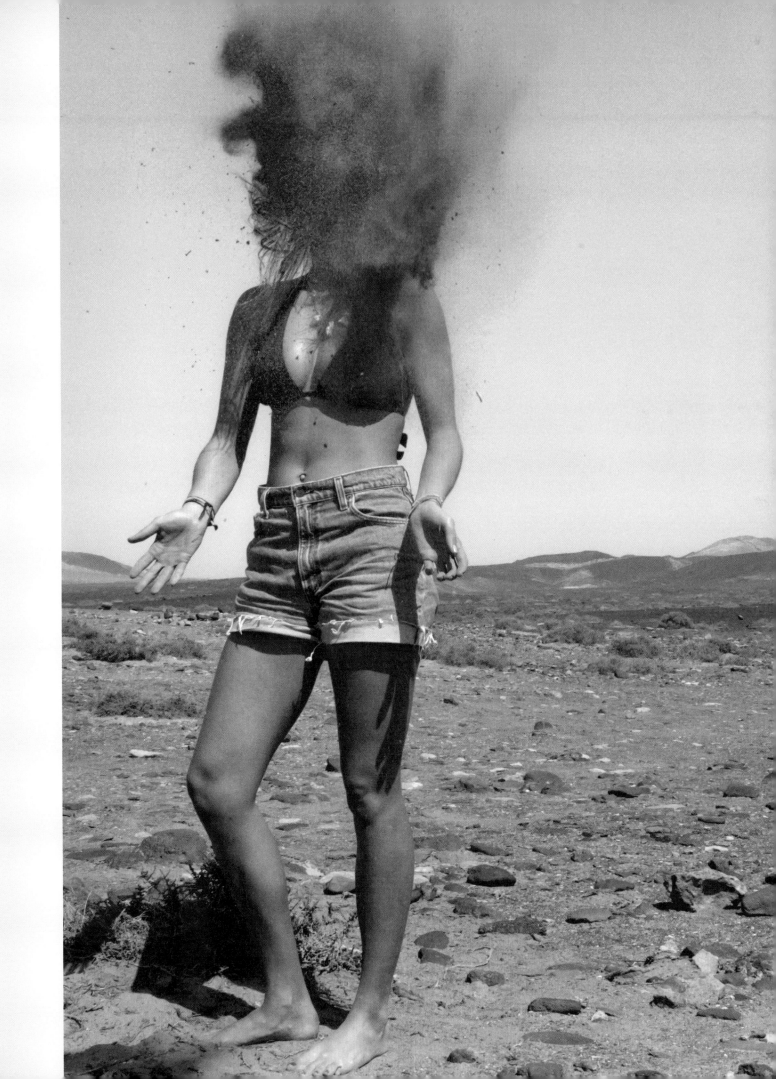

Reimagining Refuse

Frankenhein surfboards bring new life to materials otherwise left for dead

— Look! It's alive! Pieces of broken boards, scrap wood and all kinds of "trash" are given a new leash of life when meticulously patched together by Frankenhein Surfboards. These refreshing creations don't try to hide their DIY nature behind glossy paints and monochrome veneers. Instead, the boards openly celebrate their origins and the fact that they're built by hand in a sustainable way, using discarded and unwanted materials.

Jered and Shannon, the inventive minds behind the project, first got the idea when Jered was in need of a new surfboard but had very little money to spend. Shannon noticed a few of her brother's broken boards sitting in the garage and challenged Jered to resuscitate them. "I returned from work one day and found that Jered had taken my bookshelf off the wall and was using it as a spine for a surfboard blank along with unused objects he found lying around," she says, delivering a story likely to be passed down in the family from generation to generation.

After the birth of their first Franken-board, the concept grew as they went on a scavenger hunt, collecting scrap material from backyards, shores and construction sites. Each handmade piece is a testament to the old-school way of shaping, and proves how trash can transform into truly unique art. Inspired by tribes who fully utilize their resources to create what's essential, Jered and Shannon are adamant supporters of one maxim: necessity breeds creativity. ●

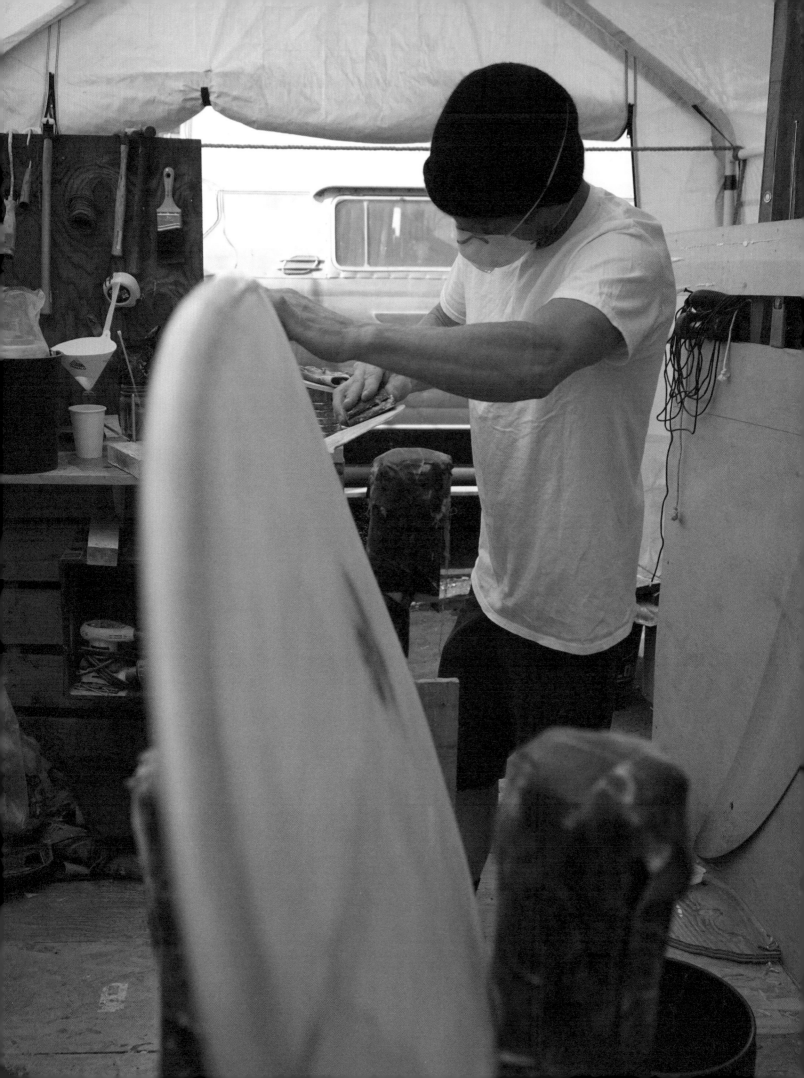

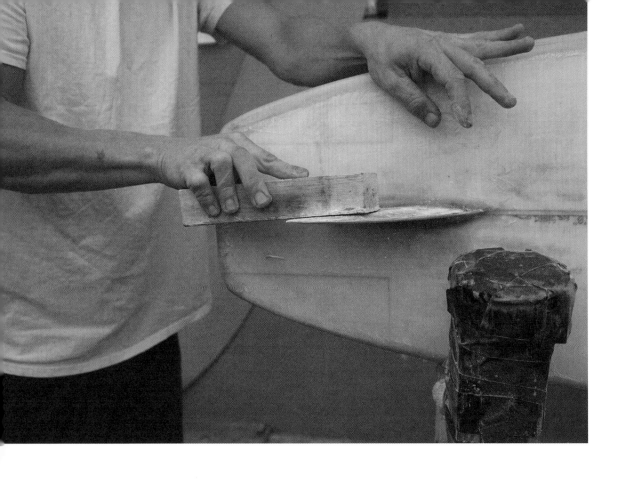

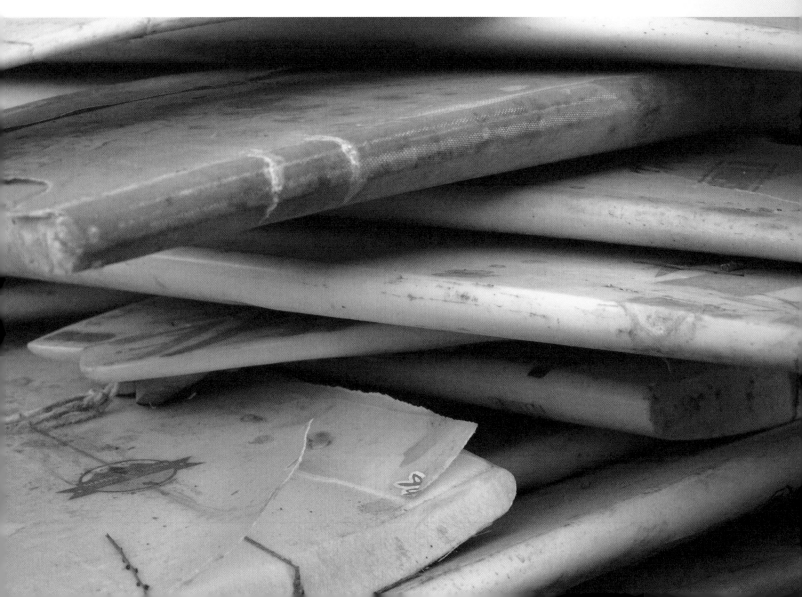

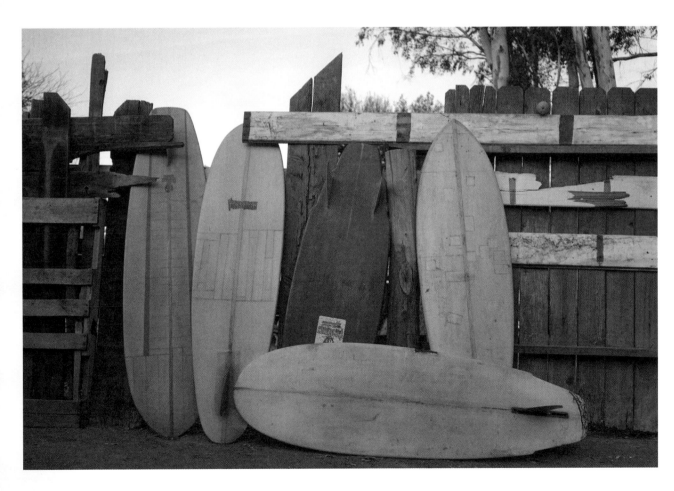

Finding Fluidity

Tripoli Patterson makes himself at home in the waves, and in the New York art world

—— Tripoli Patterson was 8-years-old when he first experienced the thrill of riding a wave. "When I started, I couldn't swim. [But] you overcome fears by putting your physical body right in that scary place and figuring out how to survive. I wanted to surf and I had already made up my young mind. Now that I think about it, not knowing how to swim probably helped, because I didn't want to fall off my board." Given his subsequent successes in the world of surf, it comes as no surprise that on that fateful day, he stood up on his board on his first try.

Originally from Sag Harbor, New York, Tripoli grew up surrounded by the ocean; over the course of his adolescence, his mother, Terry Patterson (also a surfer), moved her family to Bali and New Zealand for stints that only intensified his love for the waves. "I like being constantly humbled and challenged," he says. "Surfing has taught me how small and powerless we are in the bigger picture. When you're in the ocean, it's very clear who's in charge. With that said, it has also taught me that our battles come from within, and as much as you're willing to bite off, there's always way more ahead. As any surfer knows, the eagerness to catch one more wave really never ends."

A longtime art aficionado, Tripoli owns two galleries in the Hamptons, both built to showcase the works of "real people with a real vision." (The first exhibition in his newer space featured art by fellow surfer Félix Bonilla Gerena.) While Tripoli's passions may strike some as wildly different, he insists it's this sort of variety that keeps life moving forward. "Bacteria prefers to grow in still water," he says. "So make sure your life is fluid like a rapid." ●

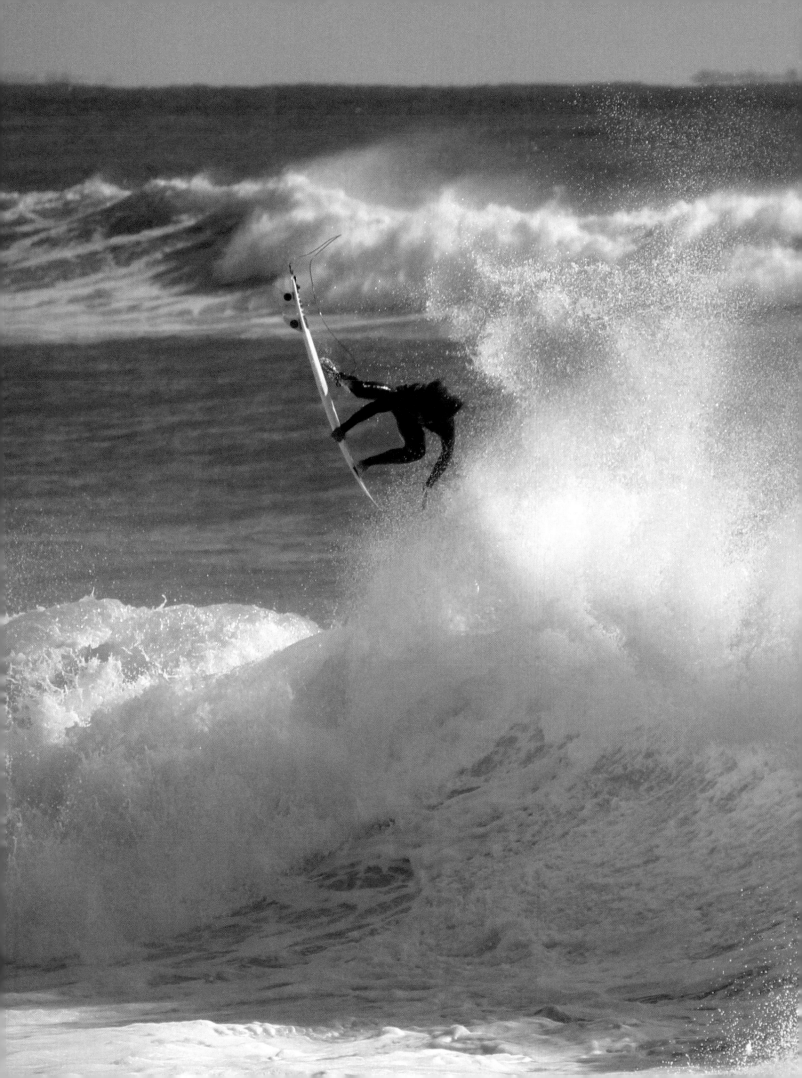

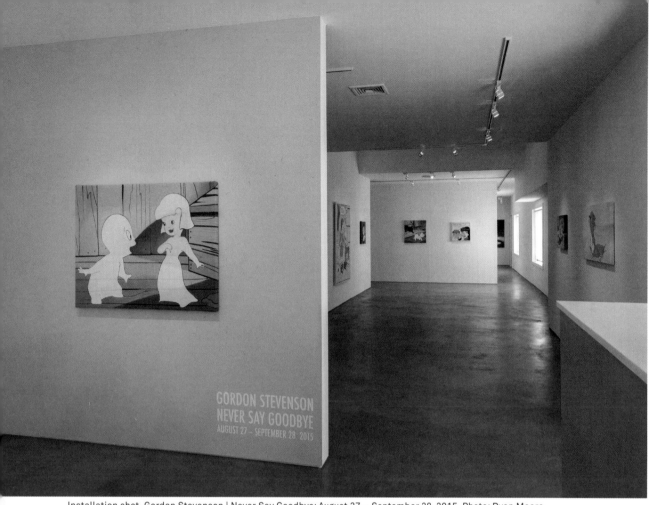

Installation shot, Gordon Stevenson | Never Say Goodbye: August 27 – September 28, 2015 Photo: Ryan Moore

Installation shot, Gordon Stevenson | Never Say Goodbye: August 27 – September 28, 2015 Photo: Ryan Moore

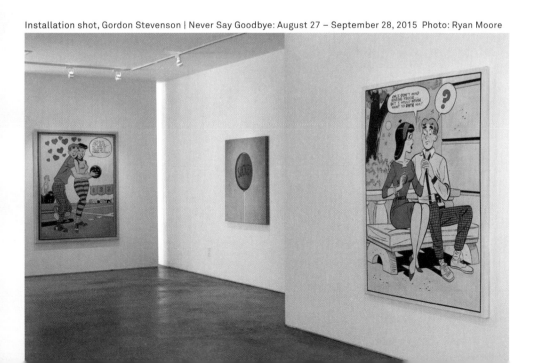

Elevating Surf Imagery

Nick Pumphrey brings surf photography to meaningful new heights

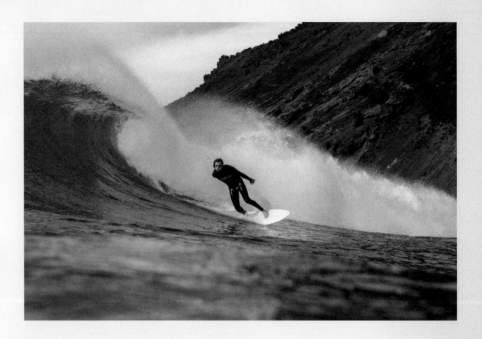

— As a photographer, Nick Pumphrey has a varied portfolio. In it, you'll find weddings, portraits and snapshots from his many travels – but when it comes down to it, he always seems to come back to the beach. Growing up in Cornwall, Nick had a voracious appetite for surfing magazines, snapping up as many as he could. Now grown up, he's living his childhood dreams of going on surf excursions around the world (from the Arctic Circle to Nusa Lebongan, Indonesia), documenting everything along the way. But it wasn't always a clear path to get here – while working in a surf bar in Hossegor, France and taking photos on the side, Nick realized that his true passion was photography. He dropped the bar gig and never looked back.

Nick exudes a calm, powerful positivity and his photography combines the trained eye of a professional photographer with the lifestyle of a true surfer.

Well away from the average daily grind, he's making a living doing what he loves most positive impact on the environment. After taking an underwater photo of a friend swimming in litter-filled ocean water alongside a manta ray, Nick attracted the attention of ocean advocacy group Take 3. Seeking to bring awareness to the alarming levels of pollution in the ocean, Take 3 hope to turn the tide and bring back balance to the delicate ecosystem – and Nick's photography helps their mission. Nick is thankful to be living such an idyllic life of surf and creativity, so to give back to the oceans that provide him pleasure seems only natural.

Above all, though, his images elevate the art of surf photography, with a certain artistic beauty one may not typically associate with sport. There's a clear progression from his days as a kid in a sleepy Cornish town, living vicariously through surf mags, to the photographer he is today. ●

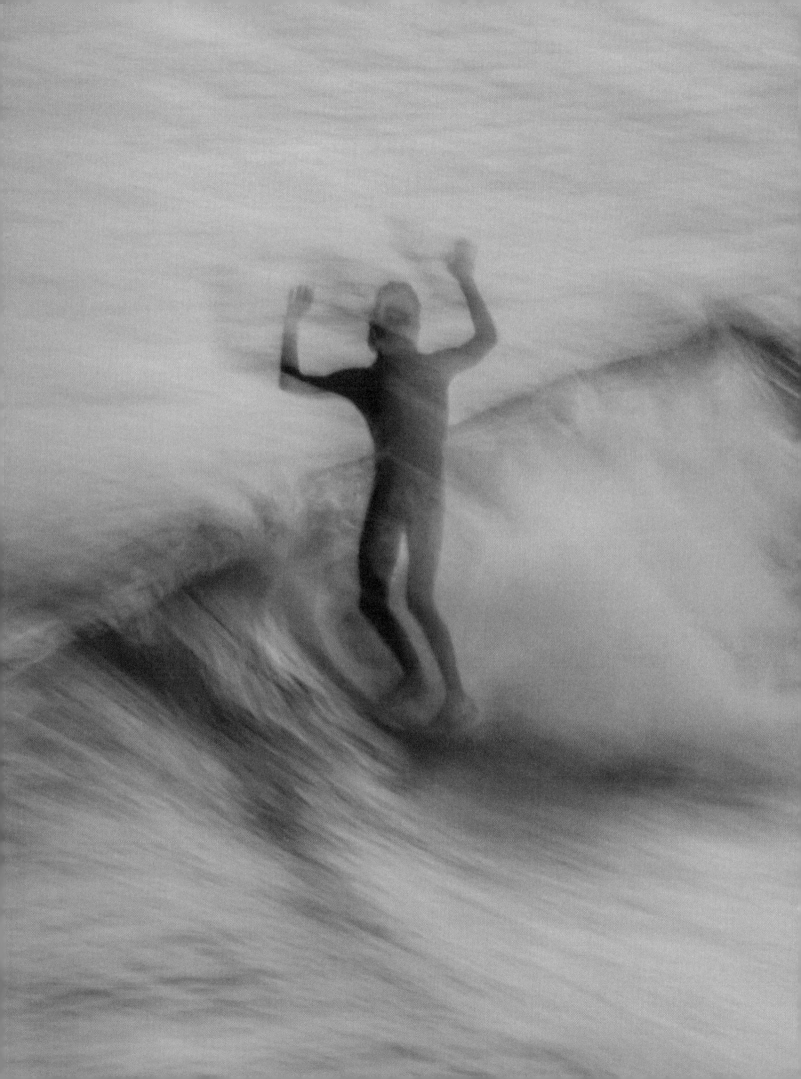

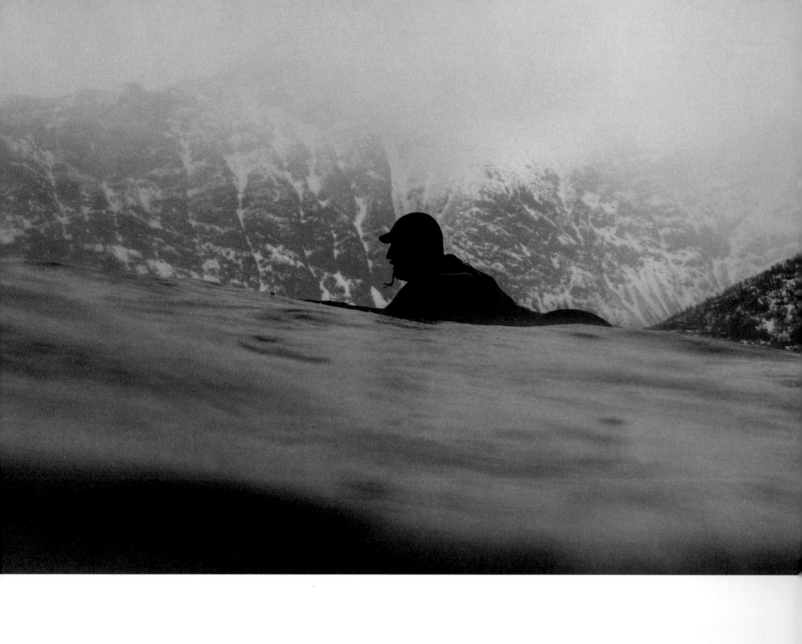

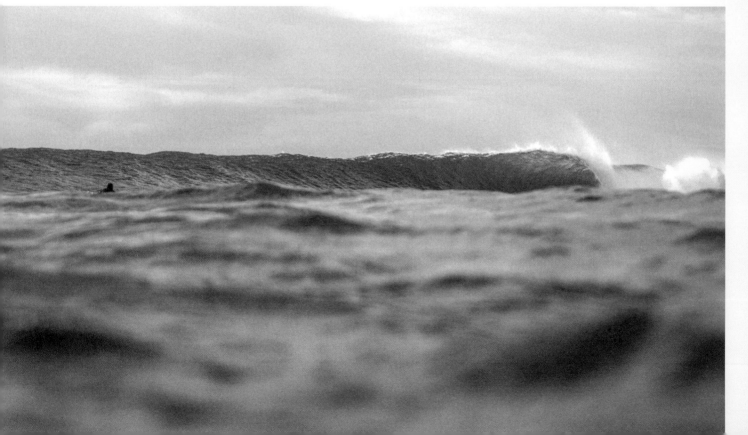

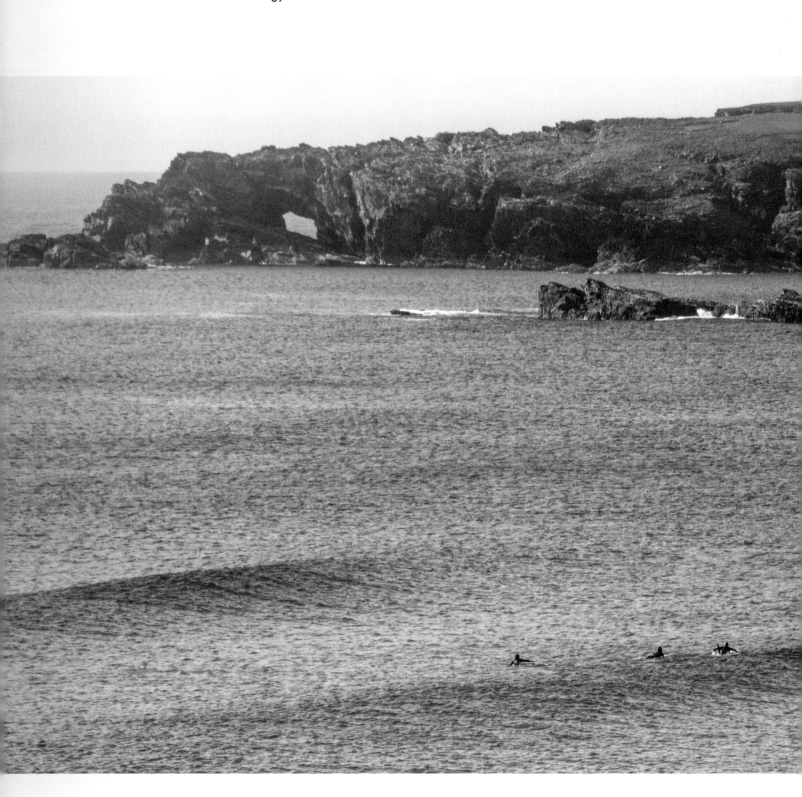

Learning to Let Go

Tao Schirrmacher finds a connective thread between surf and a thriving career in design

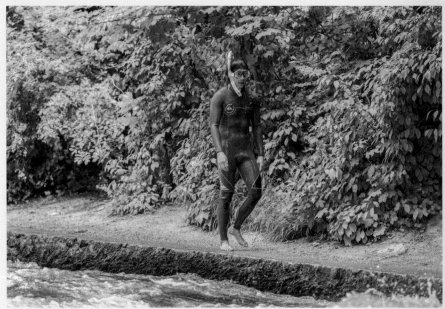

On the way to a diving session in the Eisbach river.

— Though he may be best known for his river surfing skills, Munich-based Tao Schirrmacher's love of sport has roots on solid ground. "At first, I was into skateboarding and snowboarding," he says, "but after fighting some injuries, I had enough of that damn concrete. The rivers I've been crossing became my new playground." Game for the challenge, Tao was drawn to the sport for its intimacy with nature and its ability to force one to let go. "Surfing helps me to be more responsive. You can't preview the ocean, so you take it as it comes."

As for the key differences between surfing oceans and rivers, he insists any divergence is minor. "Same emotions, great nature, good people," he says. Timing is crucial, he explains, and so is meeting one's fears head on. Emphasizing the importance of preparation and steadfast perseverance, he says, "If you overcome your fears, you'll know how to work with those emotions next time." In a cheeky aside, he adds, "I'm more afraid of missing the surf than I am of drowning."

Also commanding his attention is a flourishing career as a designer. "My father is a designer, too," Tao says. "So I've been in contact with the creative side of life since I was a little child." Drawing parallels between design and his connection to the water, he says, "Being creative, for me, means letting your mind go." That philosophy has influenced his work as part of the creative collective Studio Abigor and the surf repair brand Big Ding Shop – but when asked about his greatest adventure thus far, he demurs. "I believe there is no greatest adventure. Every adventure is unique even if it's only stepping out your door." ●

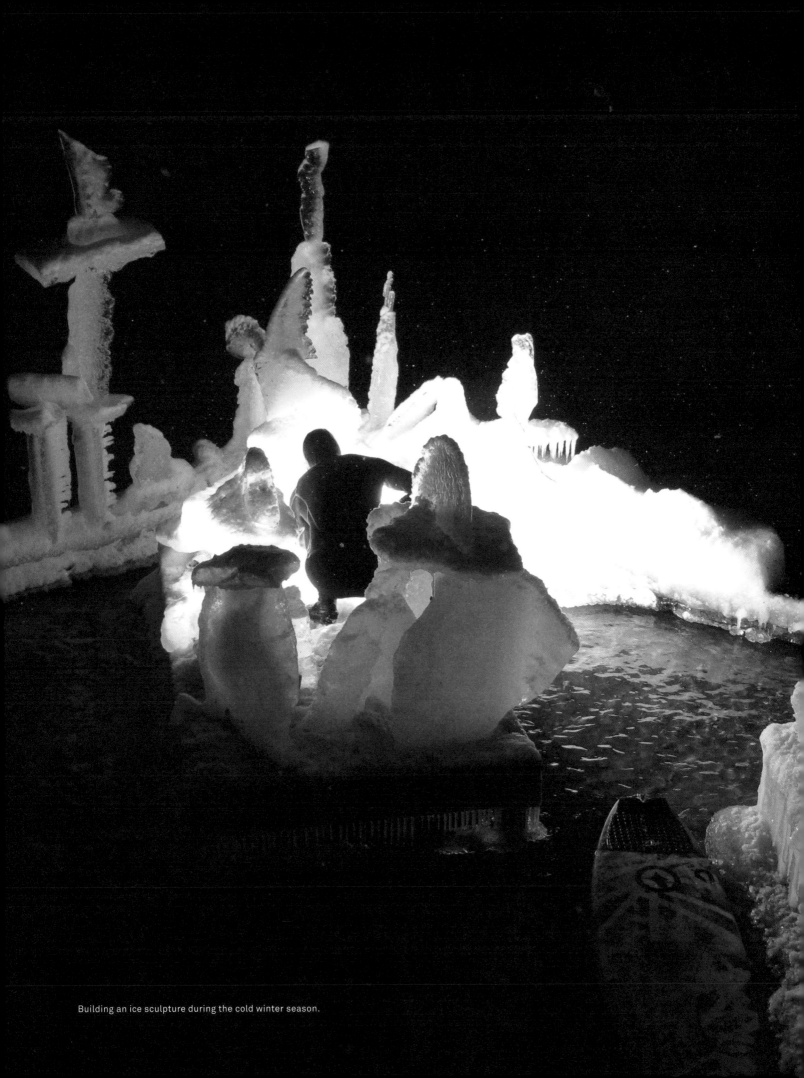

Building an ice sculpture during the cold winter season.

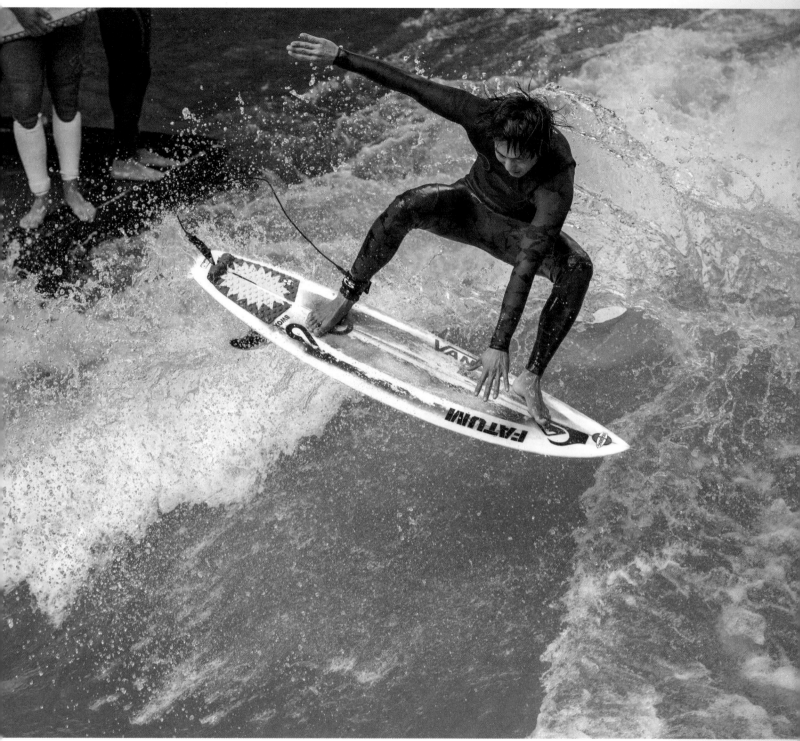

Tao showing his technical skills on the Eisbach river wave.

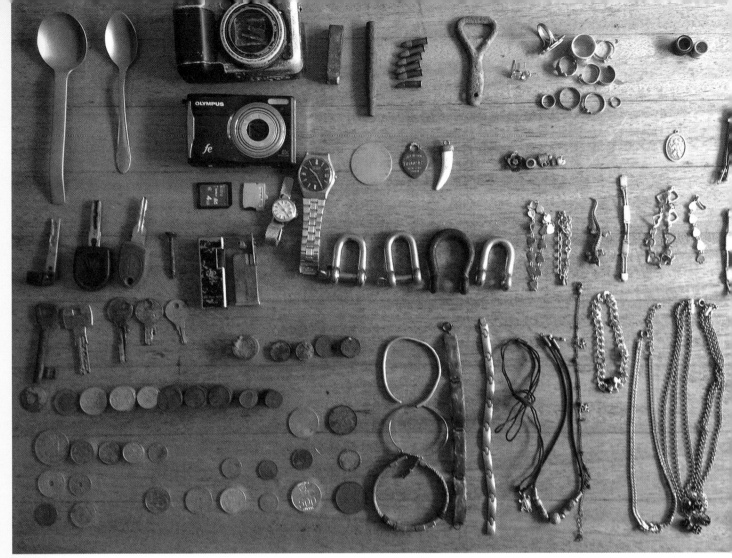

Lost & Found quarry.

These precious rings were found by Tao in the river bed.

Getting Back on the Board

Italian surfer Fabrizio Passetti doesn't let personal tragedy get in the way of wave-riding triumph

—— Fabrizio Passetti's clean and refined style on a wave can be seen from a mile away – the guy is a natural on the water. As he comes to shore, though, his one-sided gait brings attention to something very special about the Italian surfer: his prosthetic right leg.

Growing up in Varazze, Italy, one of the country's best surf spots, it was only natural for Fabrizio to take a liking to the sport. As a kid, his greatest role models were local surfers in Varazze, who took him under their wing. Surfing consumed him, and he spent just about as much time in the water as he did on land, learning from the more experienced surfers. Dedicating everything to the sport, he became a skilled surfer in no time, and competed in surf competitions in his early teens. But to Fabrizio, it was never just about earning points for tricks – even at a young age,

surfing made him feel complete as a person. However, at just 17-years old and in the middle of training for a competition, tragedy struck. A motorcycle accident left Fabrizio badly injured, his right leg amputated from the knee down. This was the beginning of a difficult period spent in and out of the hospital, fighting infections and adjusting to an entirely new life. One of the worst parts: He couldn't surf, and it would be years before he got back on a board.

However, that time did come – years later, after becoming a chef and having a son, he realized he needed to get back to the ocean to pass on the gift of surfing to his child. He began the painful process of relearning how to surf, this time on a prosthetic leg. And against all odds – and through great medical hardship – he's found himself back on the board. ●

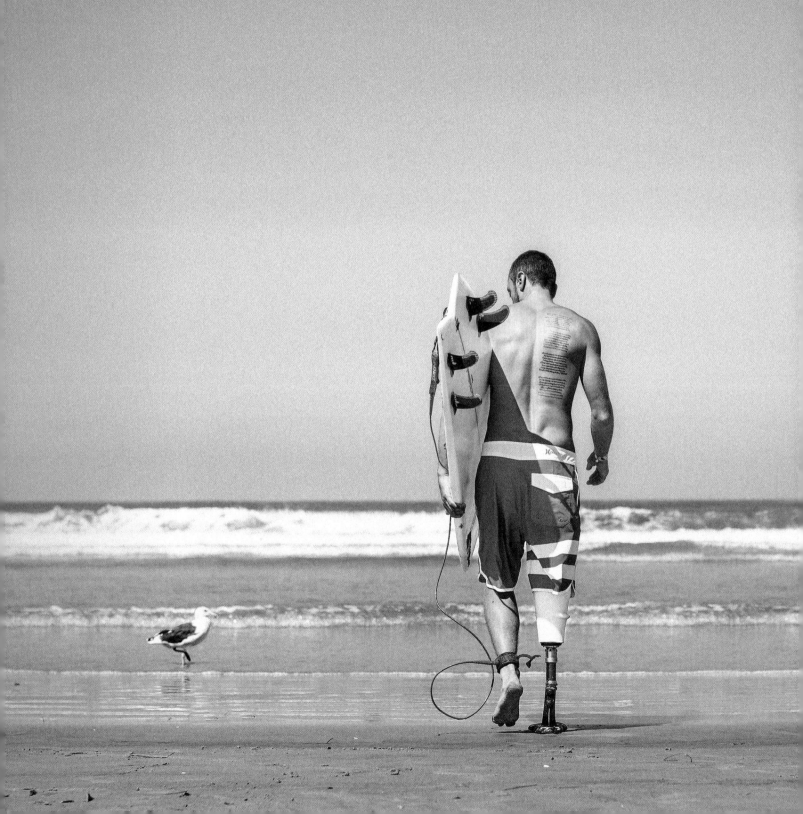

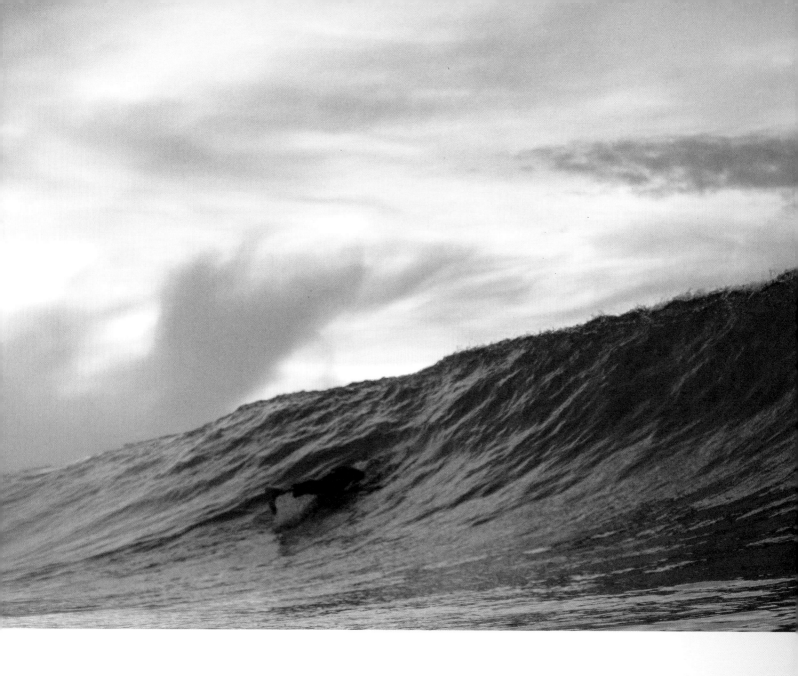

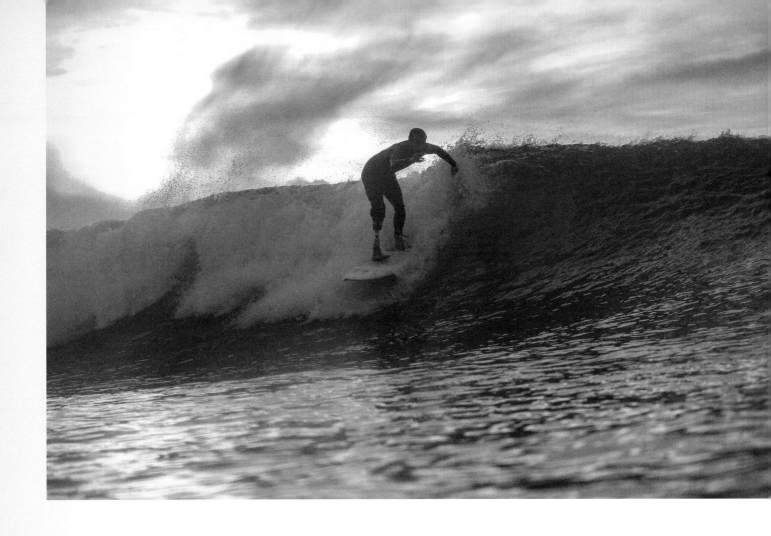

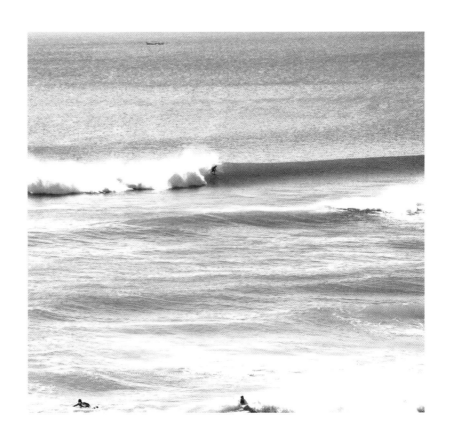

Under the Ocean's Influence

Multidisciplinary artist Andrew Kidman draws on creative
intuition born from his long-standing connection to the ocean

—— Rarely does one topic offer such a source of inspiration, but, for Andrew Kidman, a longstanding relationship with the ocean feeds into every work he creates. Whether it's surfboards, films or music, Andrew uses the ocean as his muse and his means of expression. Each new work is an attempt to feel what it's like to be around the sea and the coastline. For Andrew, surfing is a humbling experience. Being carried by something so significant, he explains, is an exercise in recognizing our limits. "It keeps me in my place," he explains. "It helps me understand myself as a person, what I can and can't do. I like being on the edge of things that frighten me."

In 1996, Andrew worked with fellow filmmaker Jon Frank on *Litmus: A Surfing Odyssey*, offering new depths to the surf film genre by weaving in surfing's darker side. Shot in colder waters in Victoria and Ireland, Litmus dims the tone of the sun-tinted sport. The inclusion of Mark Sutherland's heroin animation, *Dream*, also serves to deepen the film's context. "We thought it was important that people saw the animation," Andrew reflects. "Surfing is littered with drug casualties; it's a sad part of the culture."

In film-making and songwriting, Andrew's art persistently attempts to tell a story. No matter if the story is demonstrated through narrative, a song or a key image, "I really only want to tell stories about the beauty of life, of the hope we all have for our lives." And, for Andrew, surfing is always a part of that story.

Like many surfers, Andrew uses the action of riding waves as a means to clear his mind – or, as he puts it, to disappear from one's self. Andrew is unwilling to say whether the escapism that surfing offers is good or bad, but one thing he can confirm: "It's definitely addictive." ●

Surfer Derek Hynd in a Litmus 20th Anniversary screenprint from 2016

A 2006 screenprint featuring Garth Dickenson.

Commanding the Cold

Tom Kay leaves city life in London to create top-of-the-line wears for cold-water surfers

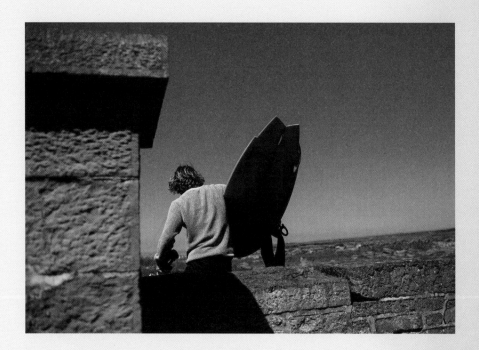

—— Founder of Finisterre surf products Tom Kay left the London corporate world in order to set out on a new adventure on the south-west coast of England. Wanting to make products for cold-water surfers, the idea at the heart of Finisterre is ingrained in the environment that surrounds their offices and studios.

As he slowly began to build his product base, Tom took all the professionalism from his past life and threw it into this new, creative endeavor. He wanted to create products for surfers who, hardened by northern seas and unperturbed by icy temperatures, would be able to use Finisterre as a rewarding companion in dark, wintry surf.

Finisterre products are not only ingrained in the geography and weather patterns of the United Kingdom, but in its history as well. The company seeks to create sustainable products, and they are committed to the longevity of their designs as they find their place in the country's manufacturing heritage. Their relationship with the Bowmont Merino wool suppliers has meant that Finisterre sources their base fabric from a Halifax spinners with decades of expertise in the wool trade, while the pen-knife Finisterre released was made in collaboration with a Sheffield steel mill that has been in operation for 300 years.

The wind-battered Devon beaches build hardy surfers; Tom and the other members of the Finisterre team count themselves among them. For this reason, the products are made by and for the surfing community. As for expanding overseas, Finisterre's logic is simple: If it can work on the northern coasts of the Atlantic, where wouldn't it take off? ●

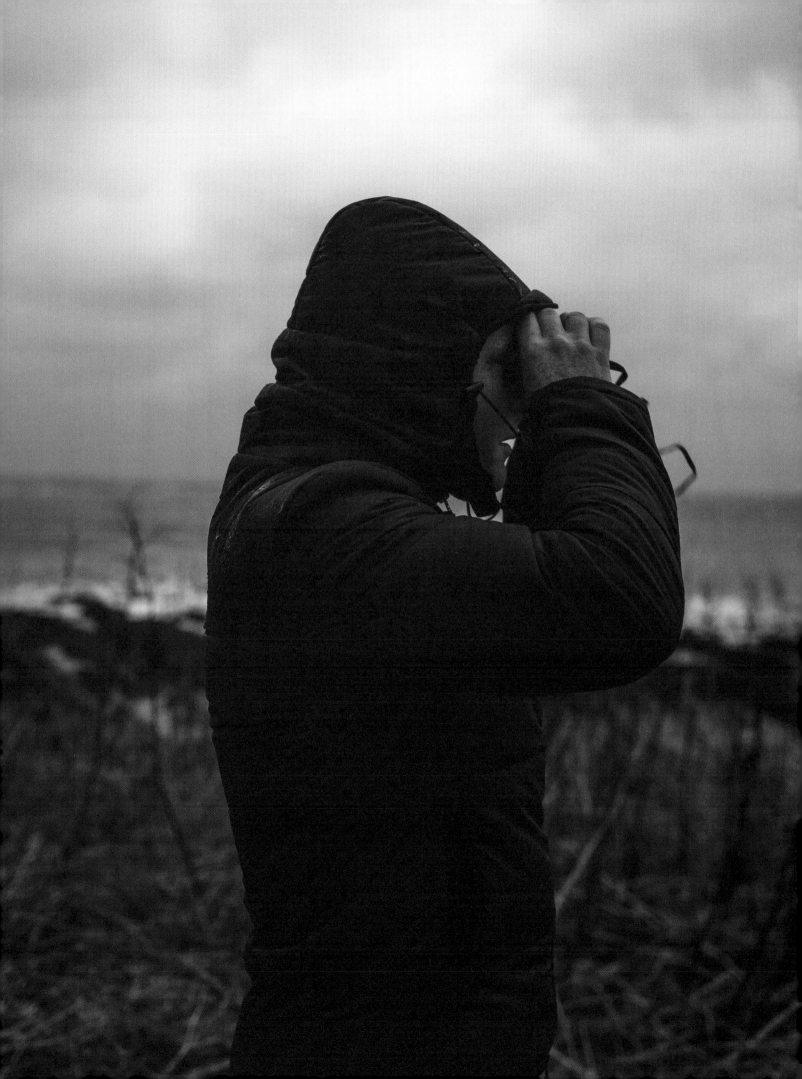

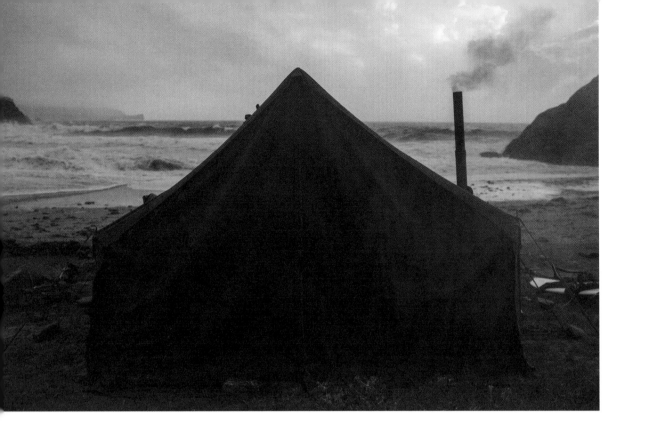
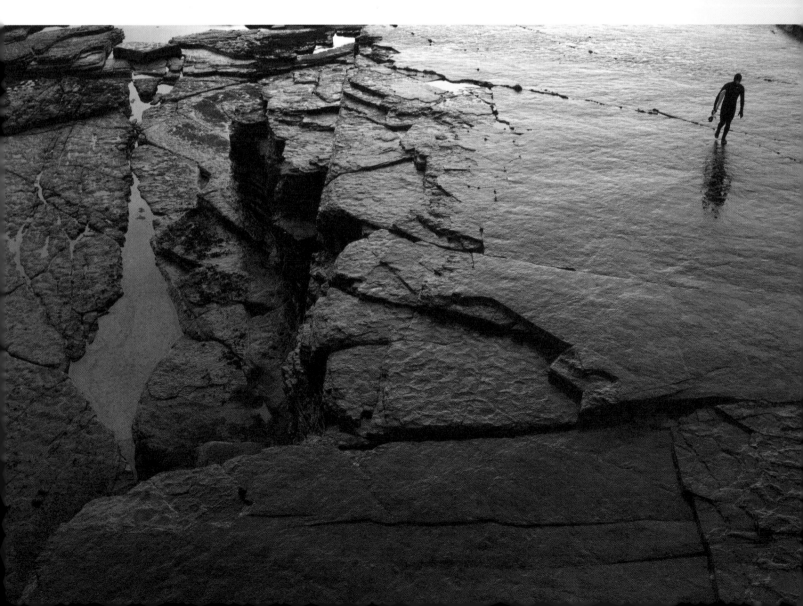

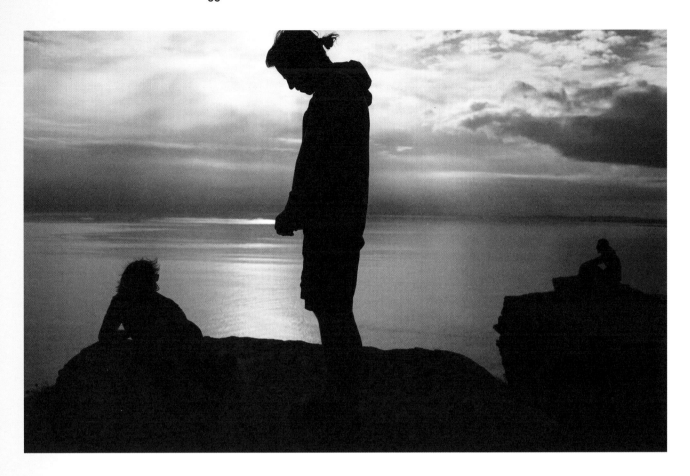

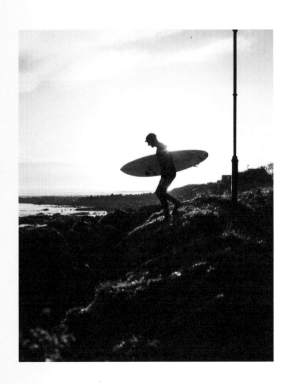

Taking the Leap

German surfer Michi Mohr trades professional life for travel, on the hunt for undiscovered waves

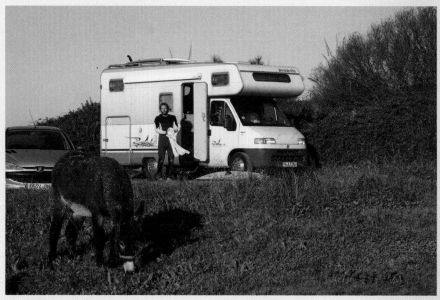

Michi enjoys a post-surf breakfast alongside a four-legged local.

—— When German surfer Michi Mohr finally took on his passion as his full-time pursuit, he knew he'd made the right decision. What may have looked like a hedonistic move saw Michi leave a professional life in Munich to get out on the road with a caravan to look for new waves.

Recalling the experience, Michi says, "The decision to leave and do different things always seems super difficult when you're in a comfort zone, but somehow it seems my life was passing by me and I didn't get to enjoy it." While difficult, Michi urges others to take the leap to pursue their true interests. "Everyone should have a look into the mirror every once in a while and check if he's doing the things he wants to do."

Michi's commitment to his passion for surfing has allowed him to experience the sport in a variety of ways that could be off-limits to the fair-weather surfer. He looks for uncrowded waves and travels at unseasonable times in order to get the most of his surfing experience. In winter, you can find Michi in the bracing atmosphere of Portugal's Atlantic islands, in search of peaceful, isolated surf.

"I was never a fan of doing things half-arsed," he claims. Indeed: Instead of placing his love for surfing on the sidelines, he dove in and hasn't looked back. ●

"When you wake up every day at a prime spot at the beach,
you realize how overrated houses are," the surfer says.

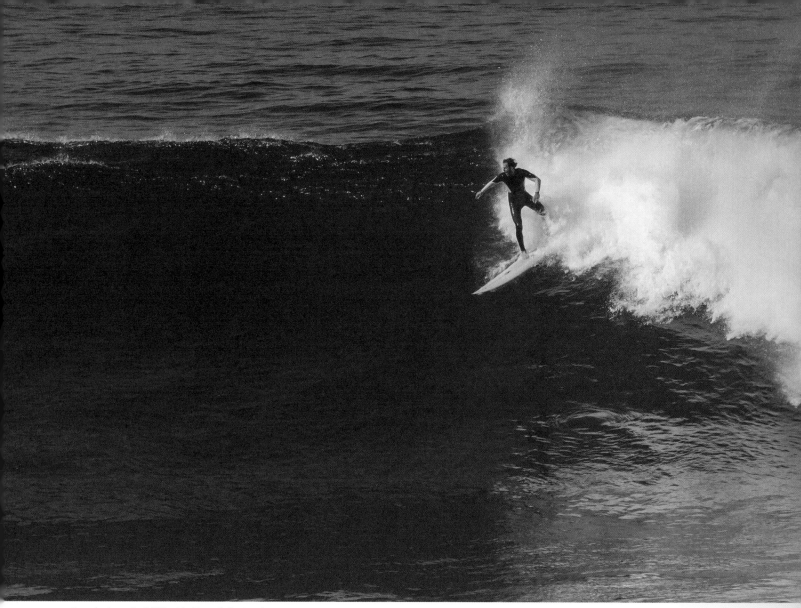

A perfect swell of 15 feet in Nazaré, Portugal.

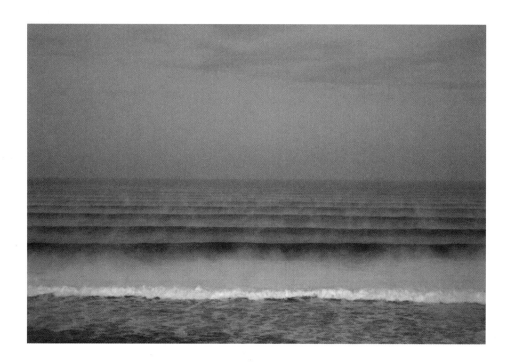

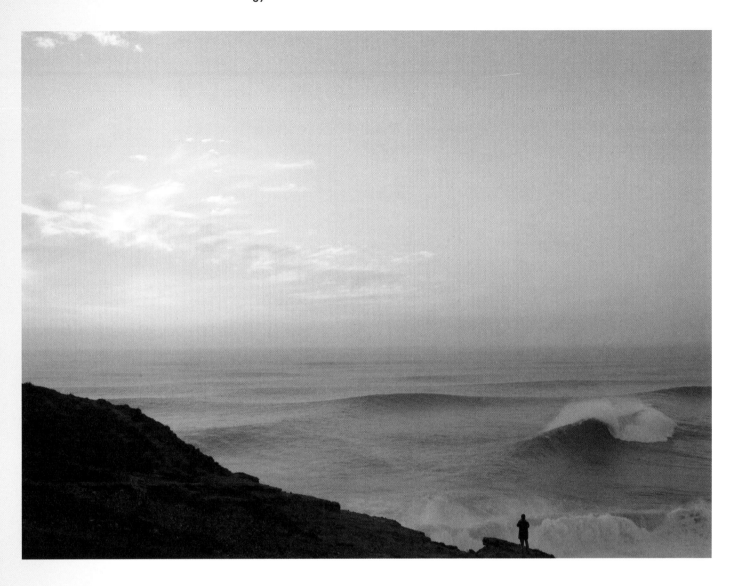

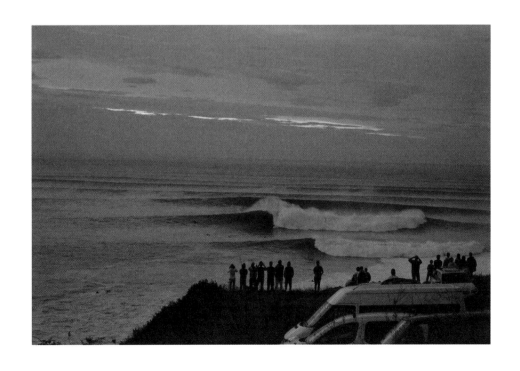

Catching Waves, Capturing Catharsis

Filmmaker, surf photographer and musician Mickey Smith produces art that pays tribute to the magic of the ocean

— Mickey Smith was born in Penzance, on the United Kingdom's Atlantic coastline: the perfect place to begin a lifelong love affair with surfing. As a young musician, Mickey traveled between London and Cornwall, slowly establishing a creative connection between the regions.

As he continued to surf, Mickey started to capture his experiences on film. His photography became renowned, winning him several awards and claiming the interest of major publications including *National Geographic*. It became clear that surf photography could become his livelihood, as he moved into contributor positions within that realm.

But Mickey never lost sight of his passion for music; instead, his love of surfing has informed much of his work. Composing soundtracks to BBC nature documentaries, Mickey's experience on the surfboard clearly influenced his other creative pursuits.

This connection to the ocean is perhaps most clearly evident in his film *The Dark Side of the Lens*. Instead of capturing a fun-loving, frivolous side of the sport, the film shows the intimidating power of the waves that Mickey himself has attempted to conquer. He made the film in response to the death of his sister, Cherry, and throughout, his relationship to the sport – instead of representing escapism from grief – is used a way of interpreting his loss. Dark waves and epic landscapes present the filmmaker in the context of much more powerful surroundings. As Mickey narrates the film, he details the hardship that goes hand-in-hand with a passion for surfing. Waves crash over the screen as he says, "Raw, brutal, cold coastlines for the right waveriders to challenge – this is where my heart beats hardest. I try to pay tribute to that magic through photographs." Here, Mickey describes the sea's dual draws, as adrenaline junkie and creative soul, both an actor and witness to the ocean. ●

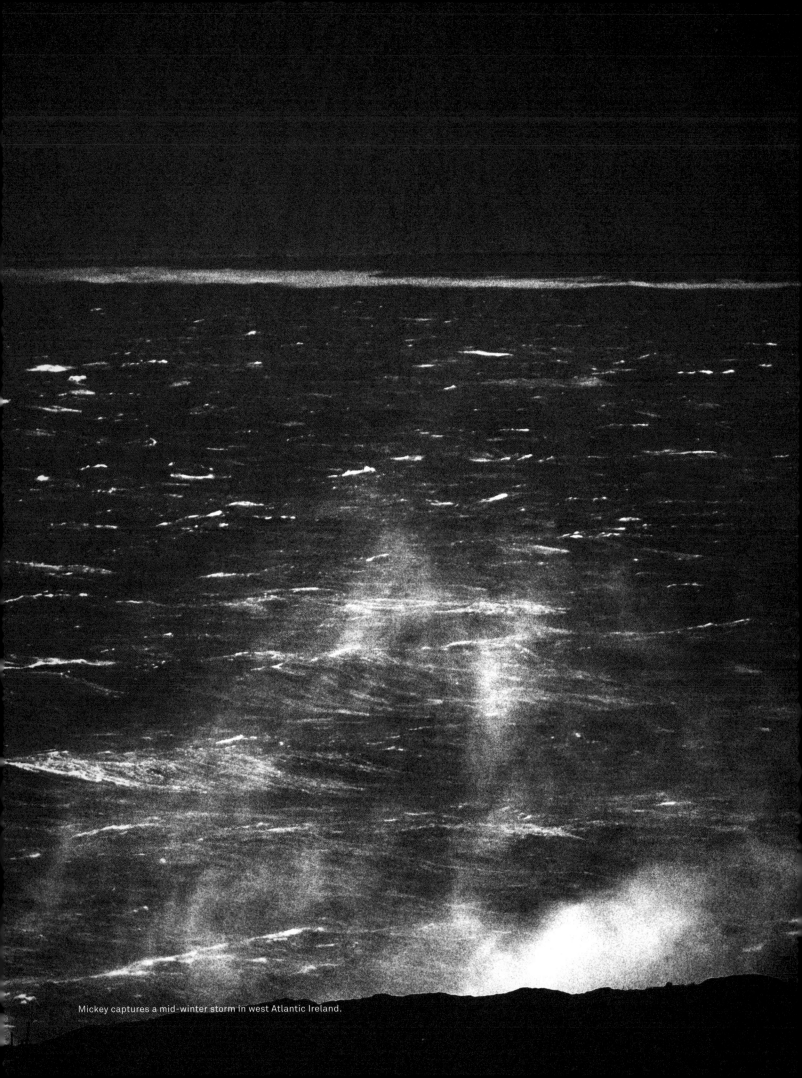

Mickey captures a mid-winter storm in west Atlantic Ireland.

Ireland's dark crystal waters evoke mood and mystery.

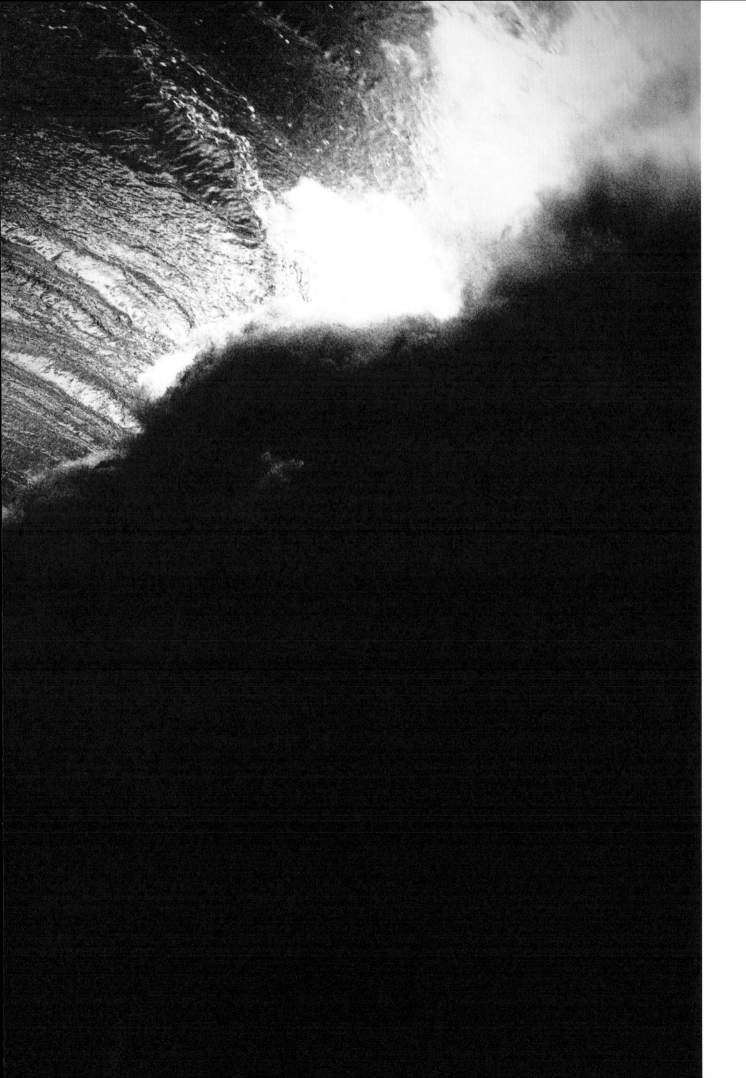

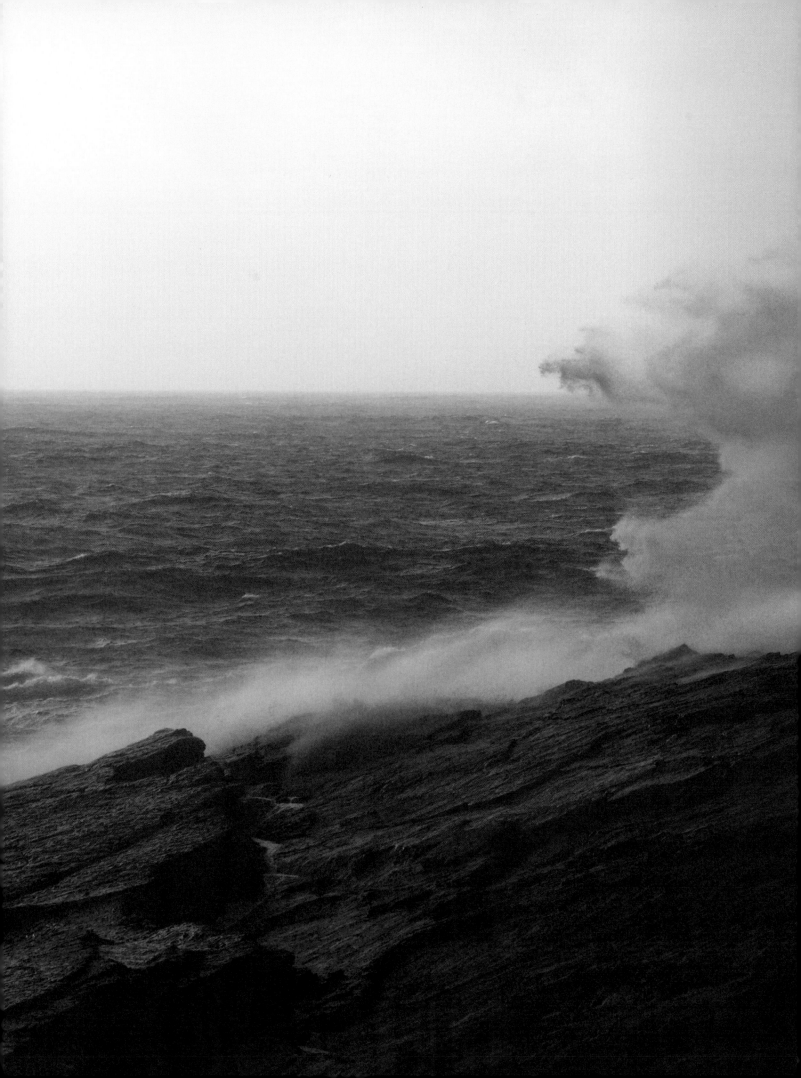

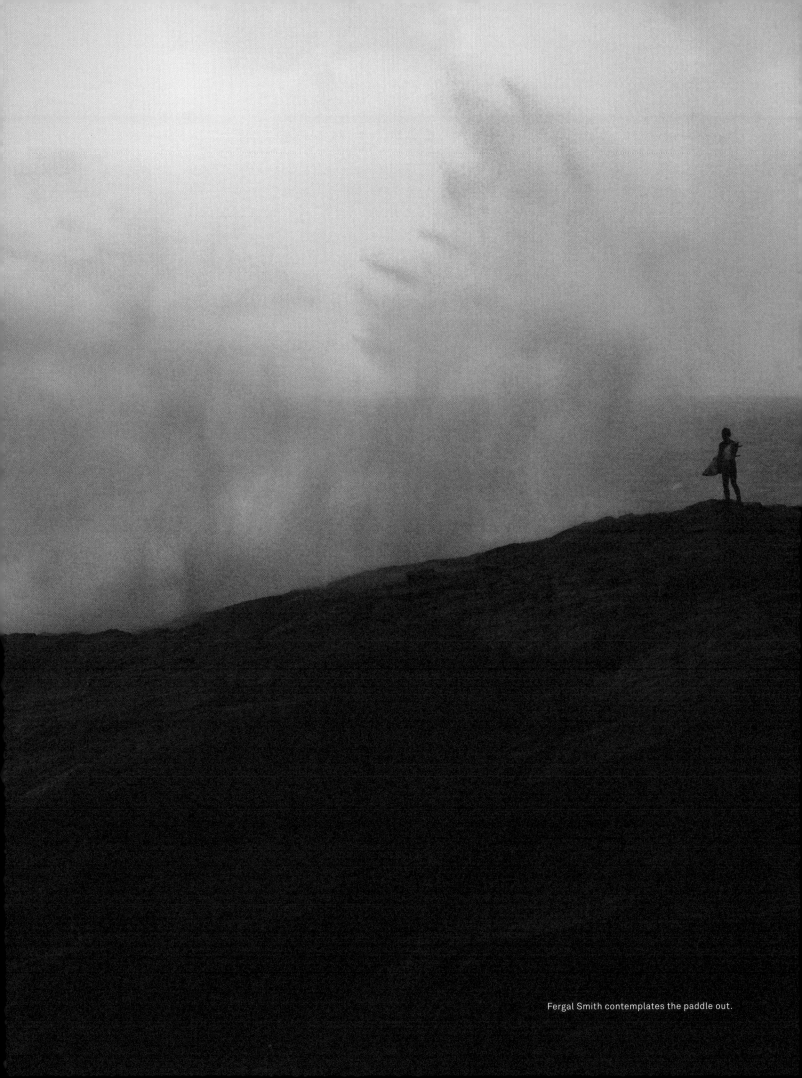

Fergal Smith contemplates the paddle out.

Connecting Craft with Community

Multitalented artist Conny Maier finds her place among a growing creative community with a passion for surf

"Woman on the Beach of Baleal, Getting Heavily Tanned," 2006.

— Conny Maier is a painter. She's also one-third of the team behind the popular streetwear label Looky Looky; a sometimes DJ; a frequent traveler, and – thanks to a chance encounter with a women's surf magazine while on a cycling trip to France – an avid surfer. "I did a two-week beginners' course in 2000 in Portugal, and the next summer, I stayed for a few months," she says. "Since then, surfing has become a big part of my life." Remembering her first time on the board, she adds, "It was something I just absolutely wanted to be able to do. I like that you really need to want to surf." Although her home city of Berlin keeps her far from the ocean, traveling to and from various seaside destinations has brought unexpected benefits to her creative practice. "When you travel, you have lots of free time to dream. And of course you see a lot of different things: colors, smells, attitudes, cultures."

She applies what she learns to a collection of work that bursts with color, humor and personality – a true reflection of her myriad inspirations. An upcoming logo collaboration with surfboard brand Mighty Otter, for instance, combines her love of art and the water, and cements her place in the creative movement steadily growing within the surf community. "The energy of creating something gives you a special feeling," she muses, attempting to explain what connects the two. "And surfing is an act of absorbing pure energy. So there's a boost of energy and confidence in both things." The sheer bliss of being immersed in the waves, however, is something that's difficult to articulate. Says the artist: "There is nothing like feeling the real joy of a great surf." ●

"Raum und Pool," oil painting, 2015.

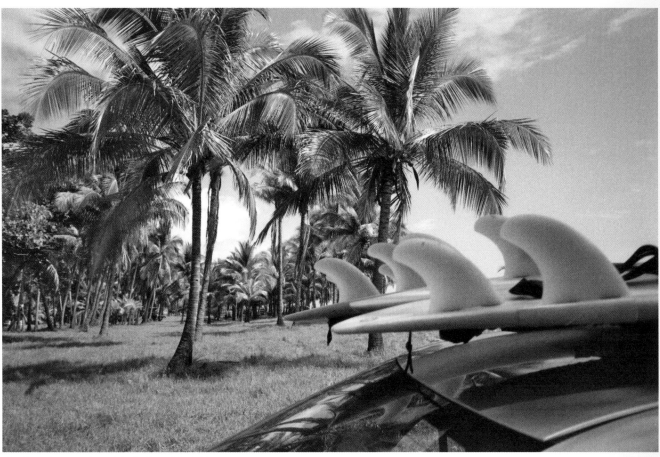

"Surfboards at Our Rental Car in Costa Rica," 2015.

"One of My Best Friends Alex, Almost Surfing Me Over in Portugal," rio print and oil color, 2016.

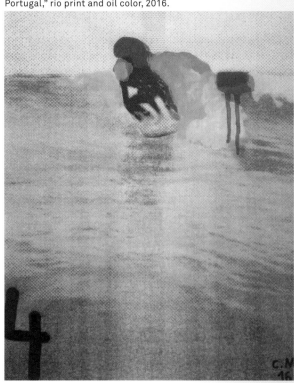

"I'm in Love With the LOLO," fanzine, risoprinted 2015.

BRIGHT Tradeshow summer campaign artwork, 2016.

Bringing Surf Fashion to a Fishing Village

A design duo make clothing inspired by Barcelona's small (but passionate) surf scene

— When Marc Lite and Anton Pinyol moved their communication and branding agency, Firma, to the fisherman's neighborhood La Barceloneta, they had one thing in mind: being able to catch waves in between work. The design duo are just as enthusiastic about their business as they are about surfing, a fact that was the driving force behind the decision to create Firmamento, a clothing brand that combines their two talents. The project is dedicated to Barcelona's small but passionate surf scene, and their garments have a certain neo-retro charm to them, taking visual cues from the classic styling of the t-shirts and sweaters worn by Barceloneta's Nautical Club.

Unfortunately for Marc and Anton, the sad reality is that the swells only arrive on Barcelona's shores a few times per year – usually on windy days during the winter. (You can find references to this tiny window of surf on clothing branded with the words "Surf Petit" and "Amateur Surf.") The surfable waves are often small, but the love they have for the sport makes up for it in spades.

What's more, in spite of the region's non-ideal surf conditions, the two show no signs of leaving and take great pride in the area. "Barceloneta is a neighborhood where people love celebrating traditions, and a place where you can find a new anecdote every single day. From its history and idiosyncrasies we take many references to work for the design of the Firmamento items," they say. The result: working in partnership with local craftsmen and artisans, they bring the charm of their village to the homes of each person who buys their goods – no matter where they may be. ●

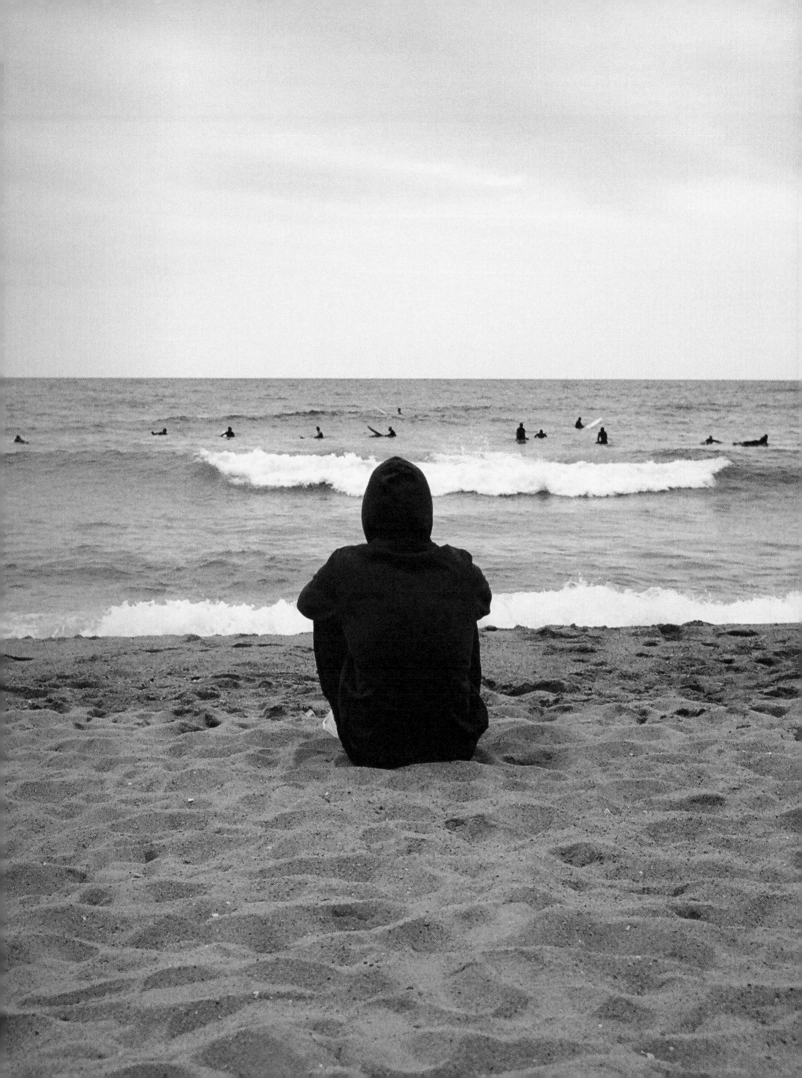

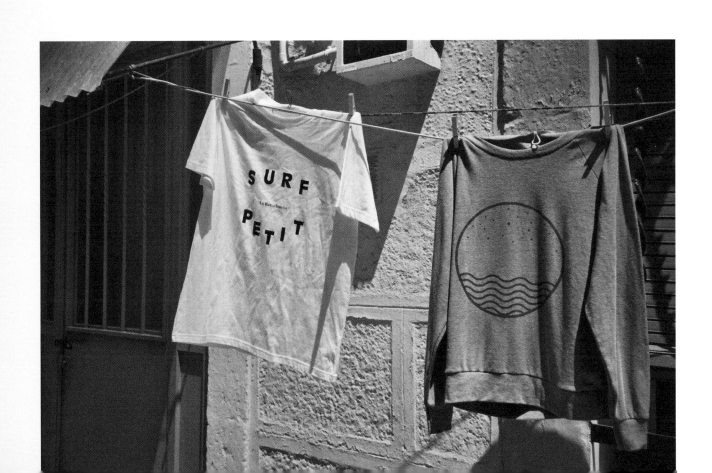

Forging Future Heirlooms

From California: timeless pieces imbued with a craftsman's care and commitment to quality

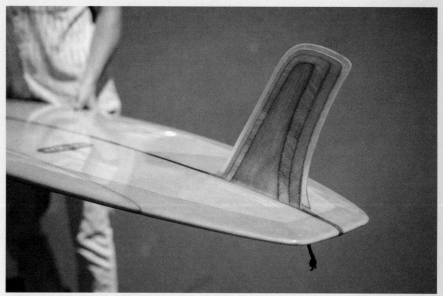

A handmade plywood Huck Fin.

— Watching the Almond Surfboards crew as they shape their boards is visually gratifying and utterly hypnotic. In the hands of the craftsmen, the router swims across the board, smoothly scoring beautiful lines as if cutting soft butter. Foamboard shavings are scattered about like shredded coconut, and slowly you begin to recognize the characteristic form of a surfboard as it assumes more and more definition. Carefully choreographed moves give birth to "almond-shaped" objects ready to glide on salty water.

California native Dave Allee, the founder of Almond Surfboards, strongly believes in creating things that genuinely spark his enthusiasm, an element that's obvious in his board-making process as well as in his dedication to the craft. Every single surfboard is handmade with one predominant goal in mind: to create timeless pieces ingrained with the craftsman's care and meticulous work. Investing time and committing to the process are key characteristics of the brand's mentality, as is their uncompromising approach to quality and performance. The team is not interested in creating disposable items; they're in it for the long run: "We truly hope that the surfboards we build today will be passed down as heirlooms to the next generation." ●

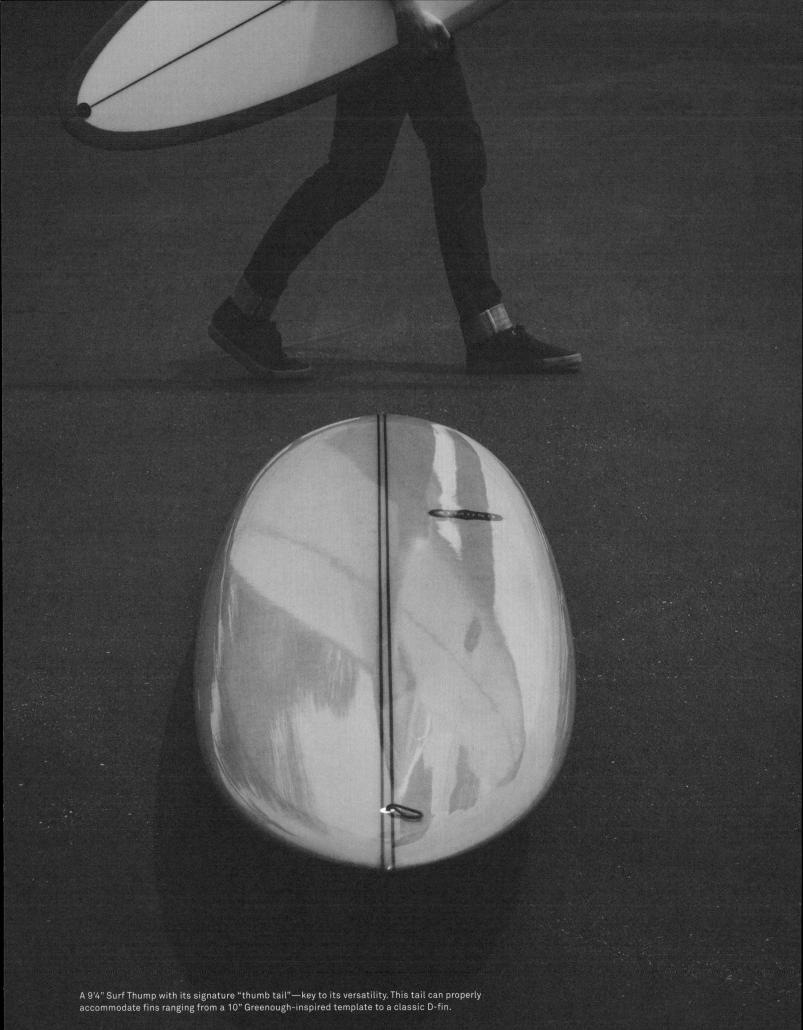

A 9'4" Surf Thump with its signature "thumb tail"—key to its versatility. This tail can properly accommodate fins ranging from a 10" Greenough-inspired template to a classic D-fin.

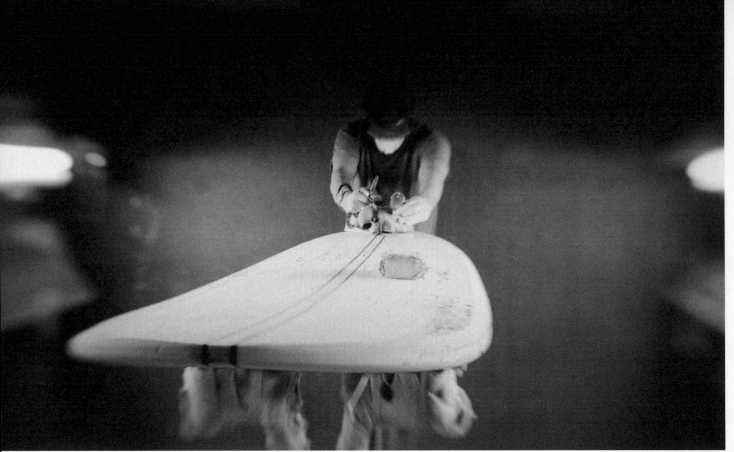

Almond Surfboard shaper Griffin Neumann-Kyle spends hours on each board.
The pencil scribbling on the bottom of each board is his.

A pristine line-up at the Almond
Surfboards shop in Costa Mesa.

A 5'3" custom Sea Kitten.

Discovering "Cold Hawaii"

A Danish knitwear brand reflects the spirit of a small fishing village whose every day centers around the sea

— When one thinks of surfing, Denmark is certainly not the first location that pops to mind. However, in Klitmøller, a small fishing village often dubbed "Cold Hawaii," surf's up amid a raw Nordic landscape.

The area's denizens have always had great respect for the ocean, as it used to be – and still is – the main source of income and sustenance for their families. Having experienced this profound connection to the natural element throughout his life, Robert Sand, a local, decided to start Klitmøller Collective, a knitwear brand that would reflect the village's heritage as well as his own family story. Generations upon generations of sailors and fishermen have fed Robert with heaps of inspiration for his signature woolen sweaters, which are both aesthetically pleasing and functional. Solely using natural, locally sourced materials, Robert tries to resuscitate the village's age-old traditions and usher them into a modern context where classic knitting patterns are up for reinterpretation. Some ideas come from old photos of fishermen in workwear, and others from personal items found in closets. Robert's best finds are a 50-year-old sweater procured from his father's cupboard and a shirt with a characteristic inside pocket intended for storing pipe and tobacco.

More than just a clothing brand, Klitmøller Collective is about the community that revolves around the ocean and the lifestyle associated with it – the sea is the powerful glue that binds all aspects of their lives and ideals together. "I couldn't even begin to imagine a life without waves; it's what has shaped my life and made me who I am today," says the founder. In addition to water, it seems, local history and passion for the outdoors are as closely intertwined as the threads of Klitmøller's knits. ●

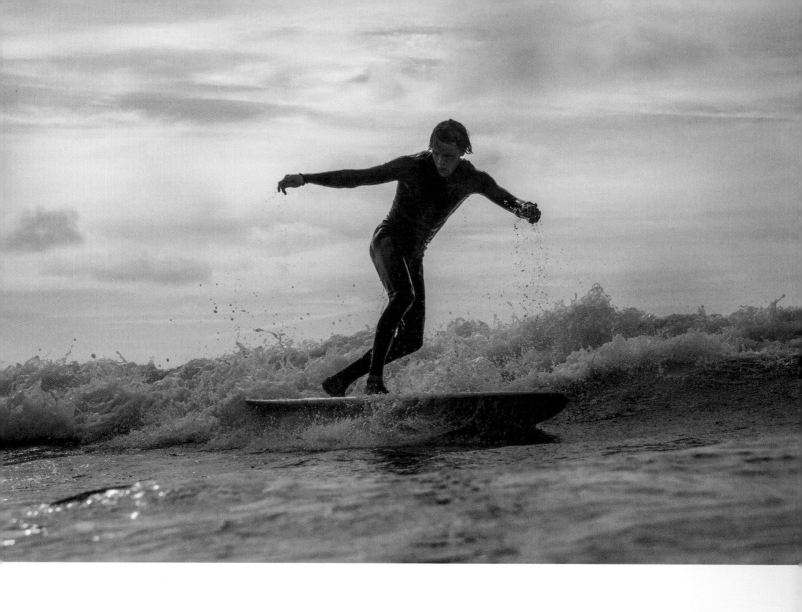

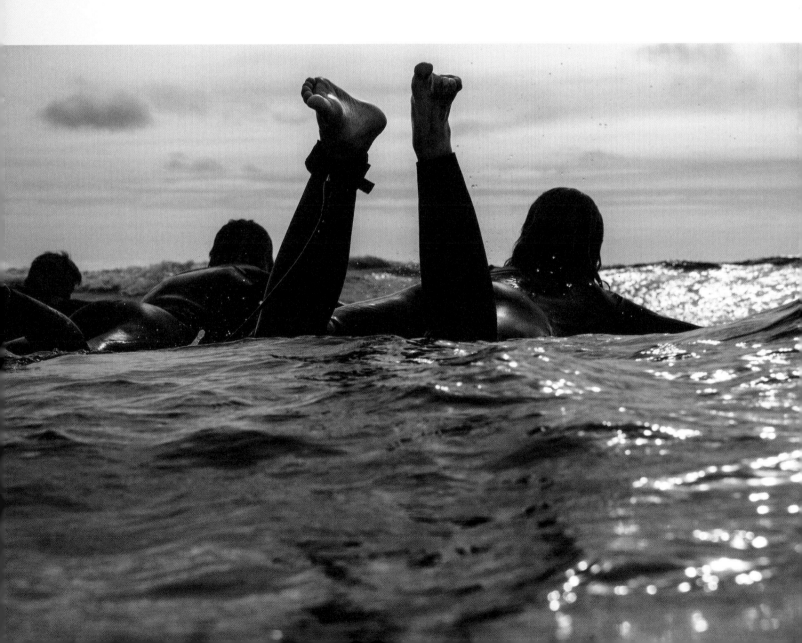

Choosing Nature Over 9-to-5

The Handsome Collective profiles those who choose to live outside the box by embracing the surf lifestyle

— Travelers, photographers, yogis, surfers, husband and wife and founders of the website Handsome Collective, Micka and Tracee Annetts glow with an easygoing, positive charm that is absolutely infectious. The pair have made a living together traveling around the world connecting with fellow surfers and documenting their easygoing lifestyle – while also finding time to catch some of the best waves out there along the way. From the beaches of Bali to the Byron Shire, the pair have made quick work of exploring the world and avoiding the 9-to-5 grind. They met in 2001 while working for an airline: Tracee's plane had just touched the ground in Sydney, and she opened the door to find Micka standing there. Exchanging meaningful glances with one an- other, a special chemistry was felt – and they've been together ever since. Eventually they decided to drop the airline gigs and adopt a different lifestyle, pursuing the things they love most: surf, yoga, music and travel. Living in Bingen, Bali for a nine-month stint, the pair carved out their own slice of paradise and learned a lot along the way. Setting into a life of simplicity, finding inner happiness through their favorite activities, the pair brought their minimalist lifestyle back to Byron Bay. There, both Micka and Tracee found themselves in the middle of the vibrant surf community and were able to step away from the norm and tap into their talents – photography, meeting people and, of course, surfing. Their website, Handsome Collective, profiles the interesting characters they meet on their travels, who are also living outside of the corporate world and embracing the surf lifestyle. They're pursuing the things they love most and making a living doing it – isn't that the dream? ●

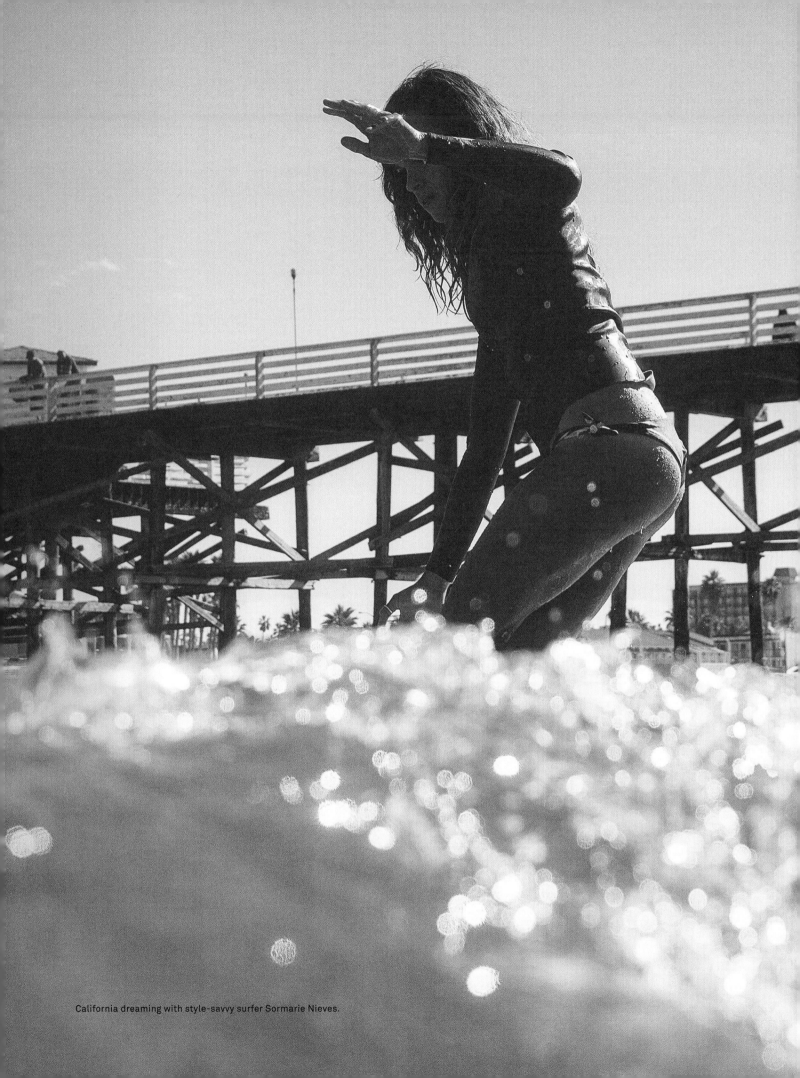

California dreaming with style-savvy surfer Sormarie Nieves.

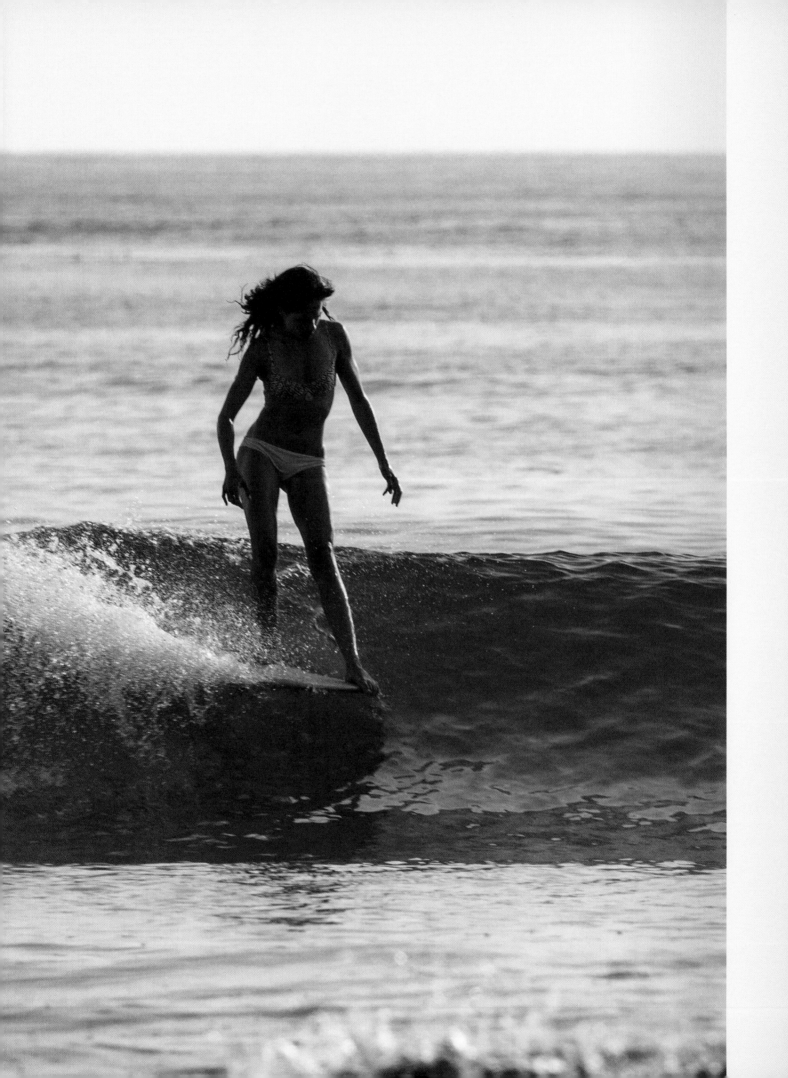

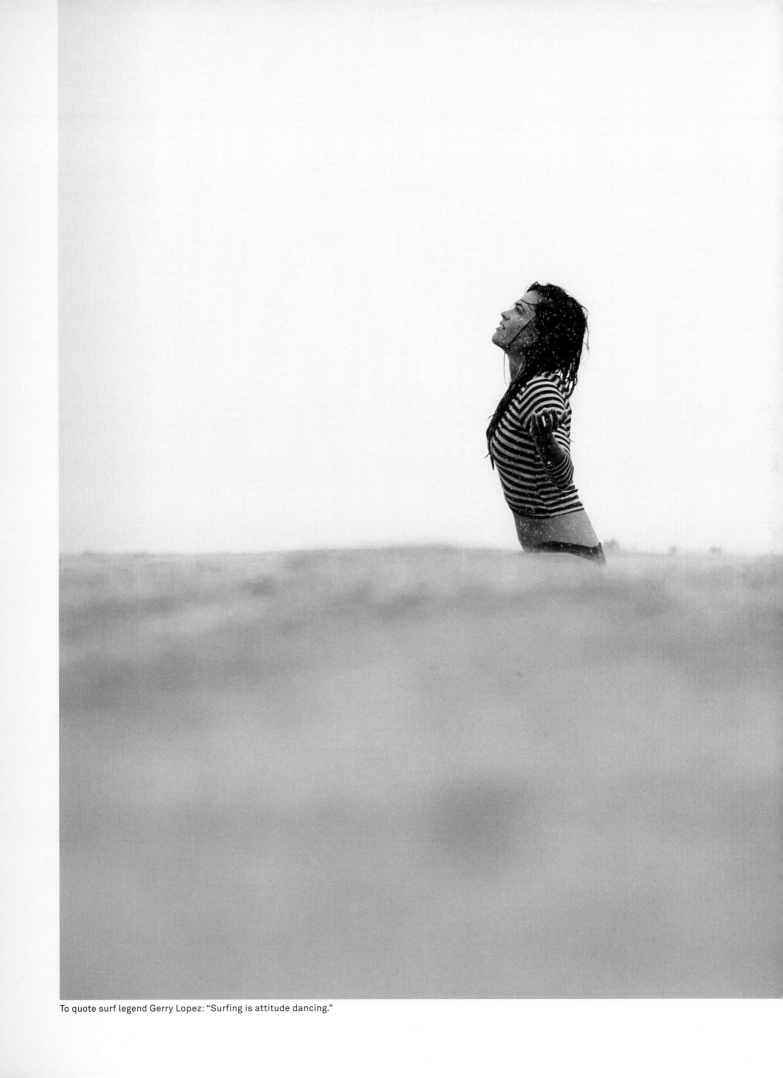

To quote surf legend Gerry Lopez: "Surfing is attitude dancing."

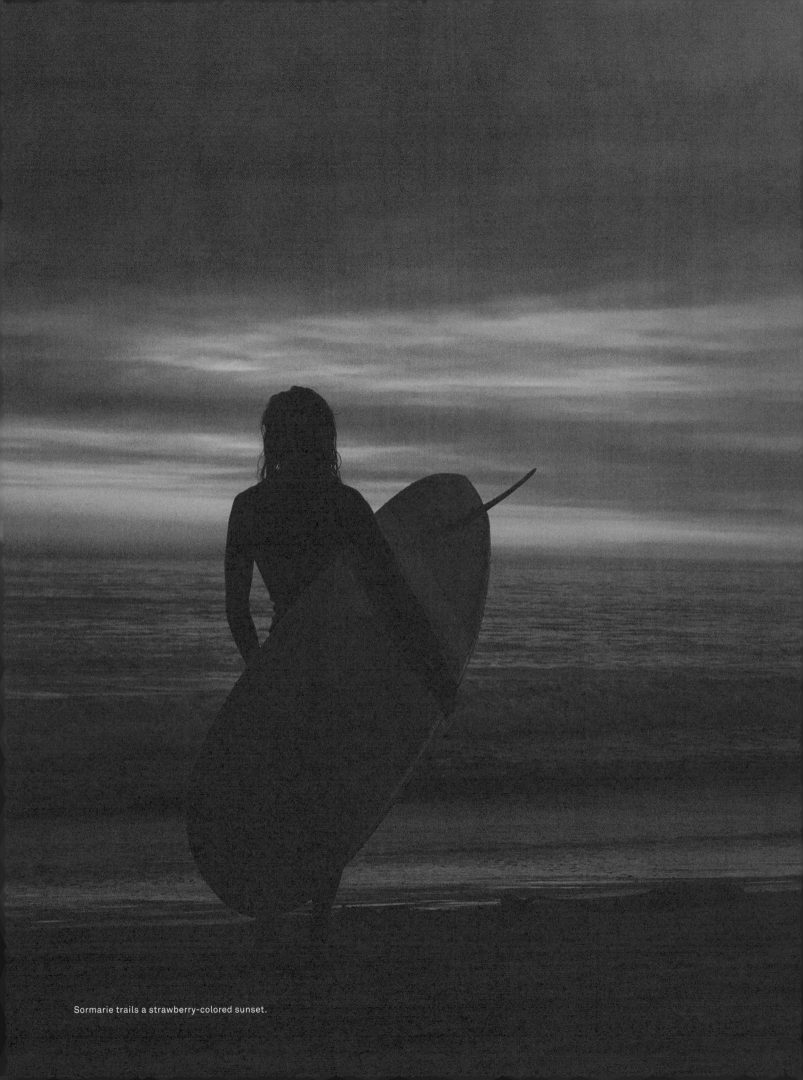

Sormarie trails a strawberry-colored sunset.

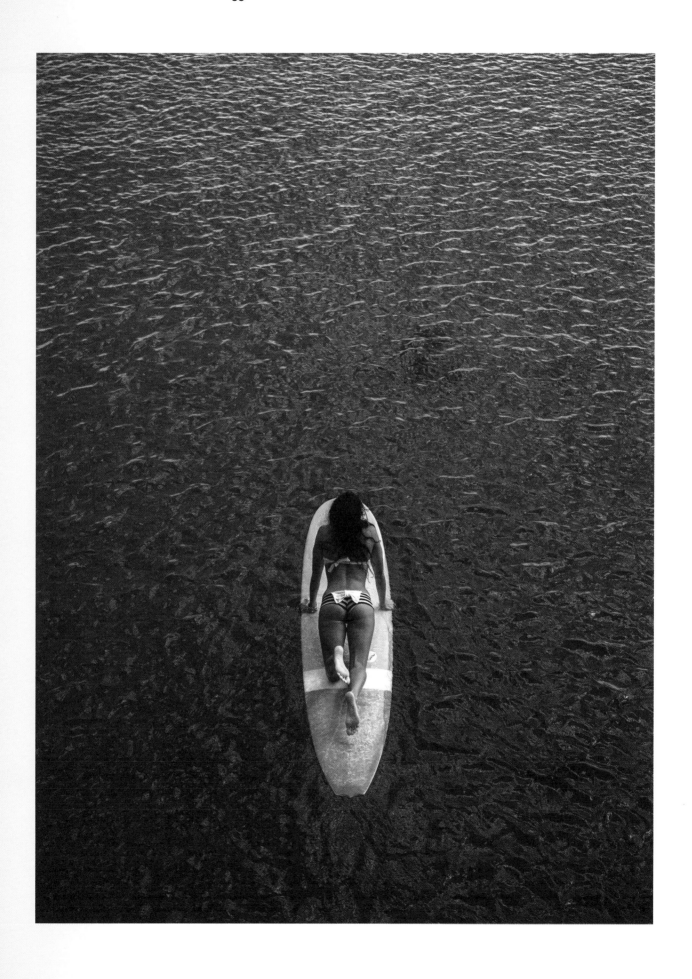

Cruising Curves on Concrete

In Malaga, Spain, BMX biker Ruben Alcantara recreates the experience of surfing — on dry land

— When Ruben Alcantara – better known for his prowess on a BMX than a surfboard – decided to construct a concrete wave in his hometown of Malaga, Spain, the news, unsurprisingly, drew a great deal of interest. Having received his first bike at the age of seven, Ruben has always known the best places to play in Malaga – and in building the park, he has tied his love for extreme sports into his passion for his hometown. Building the BMX/ Skate park within the city allowed him to inscribe his own experiences of the bike, the skateboard and the surfboard into the Spanish town. The concept was to create the experience of a wave on dry land, on a different type of board. Ruben wanted skaters and bikers to be able to feel as if they were surfing through a barrel, far away from the Malaga skate park. The part of his park dubbed "The Wave" has attempted to mirror surf itself. Riding a BMX on the Wave is to acknowledge the connection between the sports, and Ruben's own passion for both the bike and board. Instead of the hard, common shapes usually found in such parks, Ruben has brought the natural curves of the coastline into a concrete playground. ●

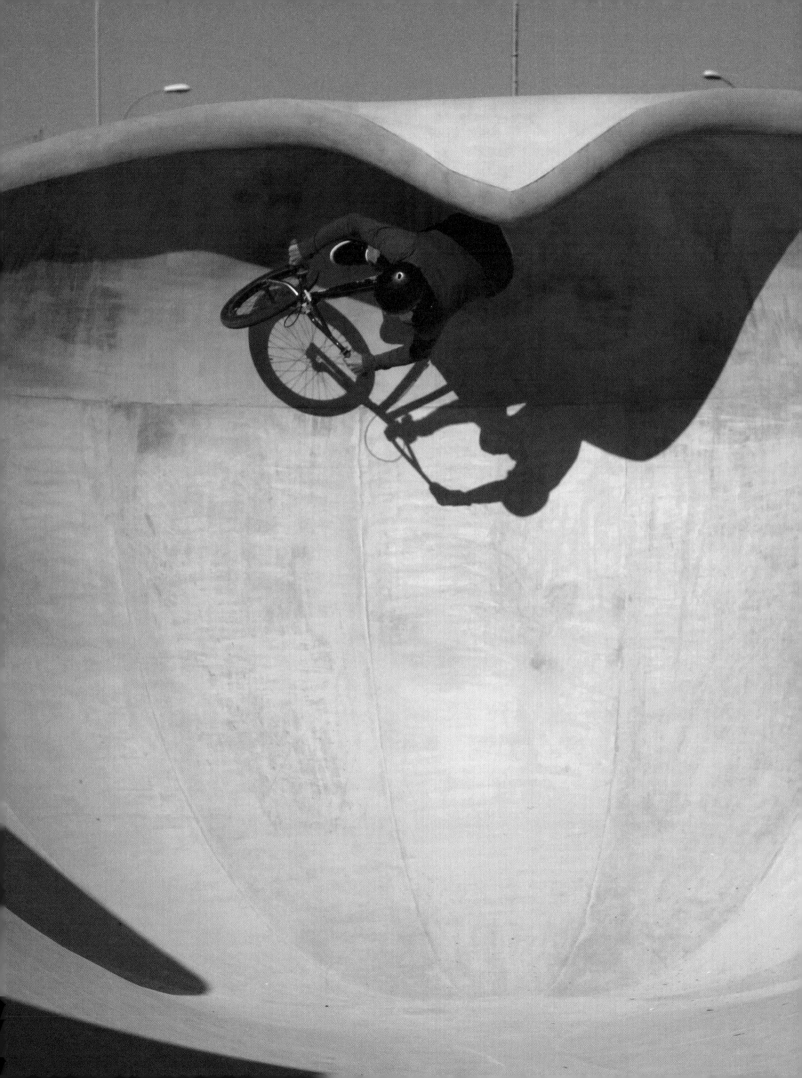

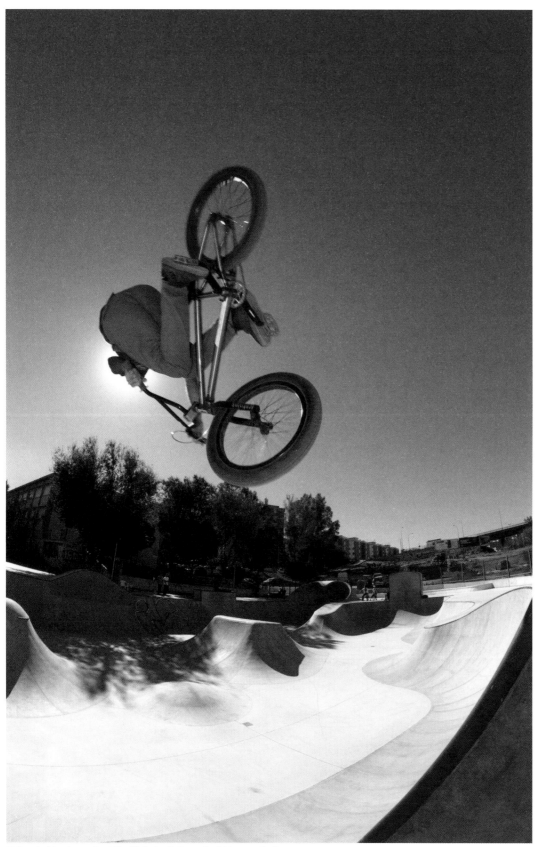

Ruben in his element, at the Malaga skate park of his own design.

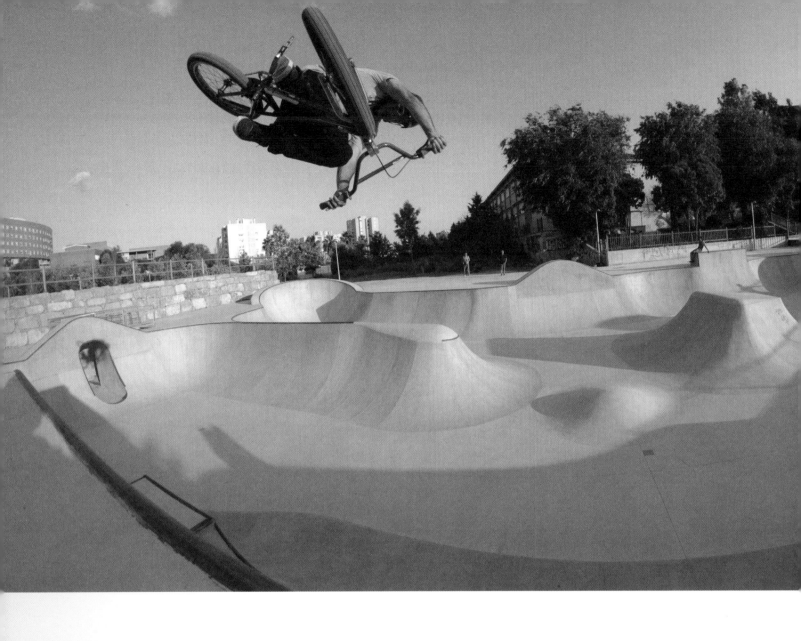

Trading wheels for waves on the "Coast of Death" in Galicia, Spain.

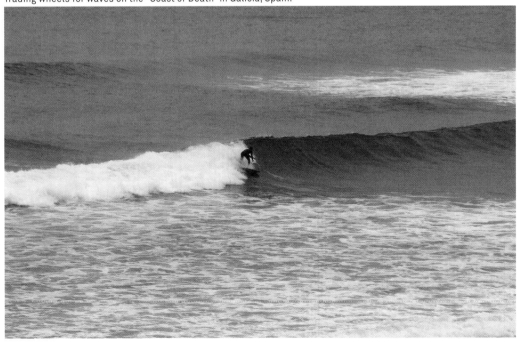

Empowering an International Community

The Critical Slide Society, a brand based in New South Wales, devotes itself to surf culture and those who embody its alternative viewpoints

— Launched by surfers and artists Jim Mitchell and Sam Coombes in 2009, Australia's The Critical Slide Society is a wide-ranging label and platform dedicated to surf culture and the individuals that define the alternative movement within it. What started as a humble blog drawing inspiration from surf, fashion and art has now grown into a full-fledged brand of clothing and unique, surf-related items. Committed to empowering craftspeople and surf lovers from around the world, TCSS collaborates with artists, photographers, designers, filmmakers and – of course – surfers who share their same passion for the water. The main goal? To develop and support an international society of people connected through surf, creativity and an open mind. The crew's attitude is directly reflected in their creations, which are all about effortless style, impeccable execution, unabated originality and, more than anything, a good amount of humor. After all, when it all boils down to the core of their vision, surf culture, they say, is "less about the winner's podium and more about the simple joy of a deeply engaged surfing life." ●

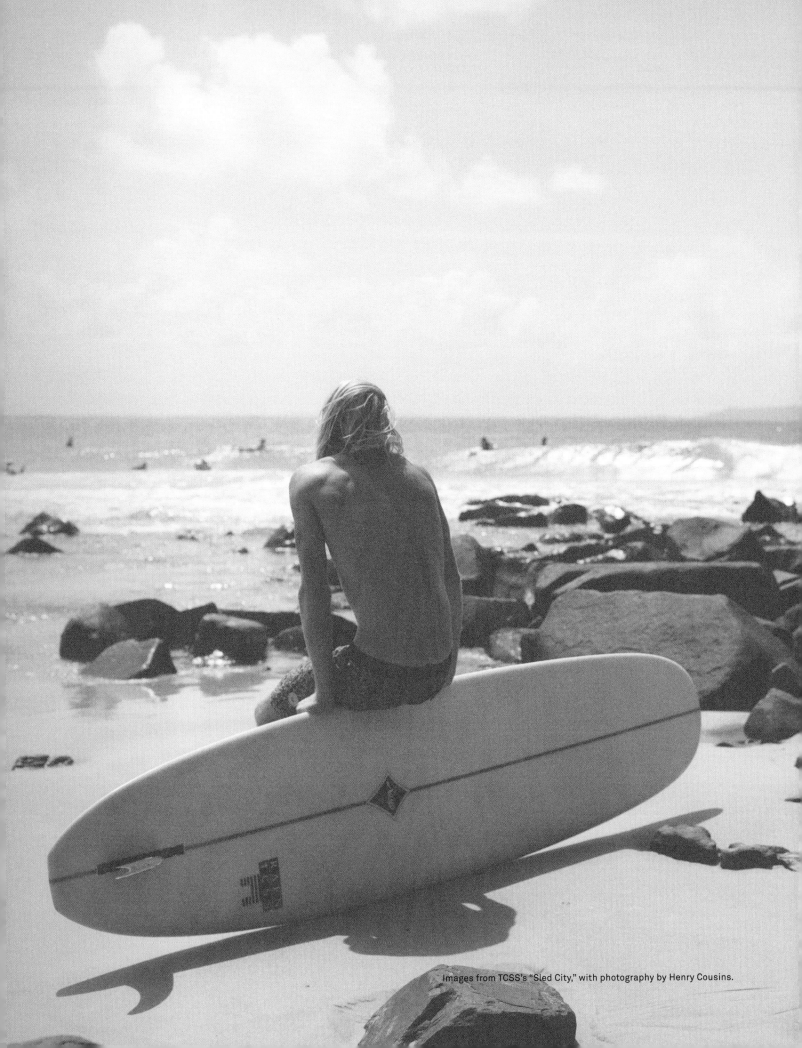

Images from TCSS's "Sled City," with photography by Henry Cousins.

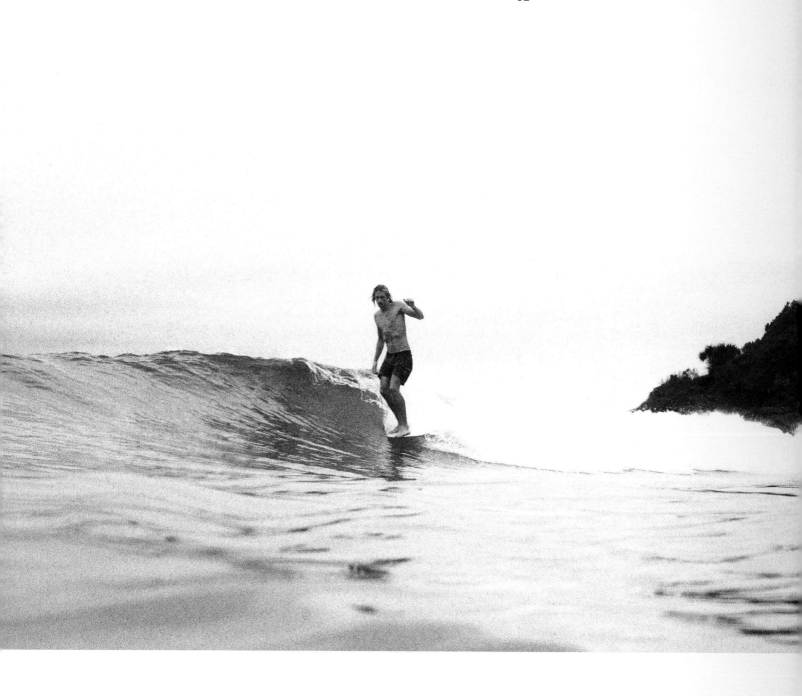

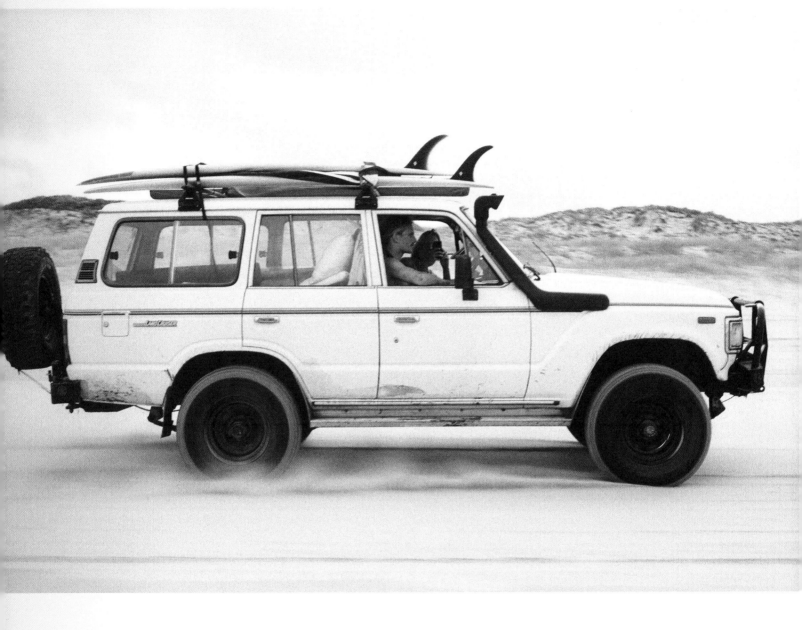

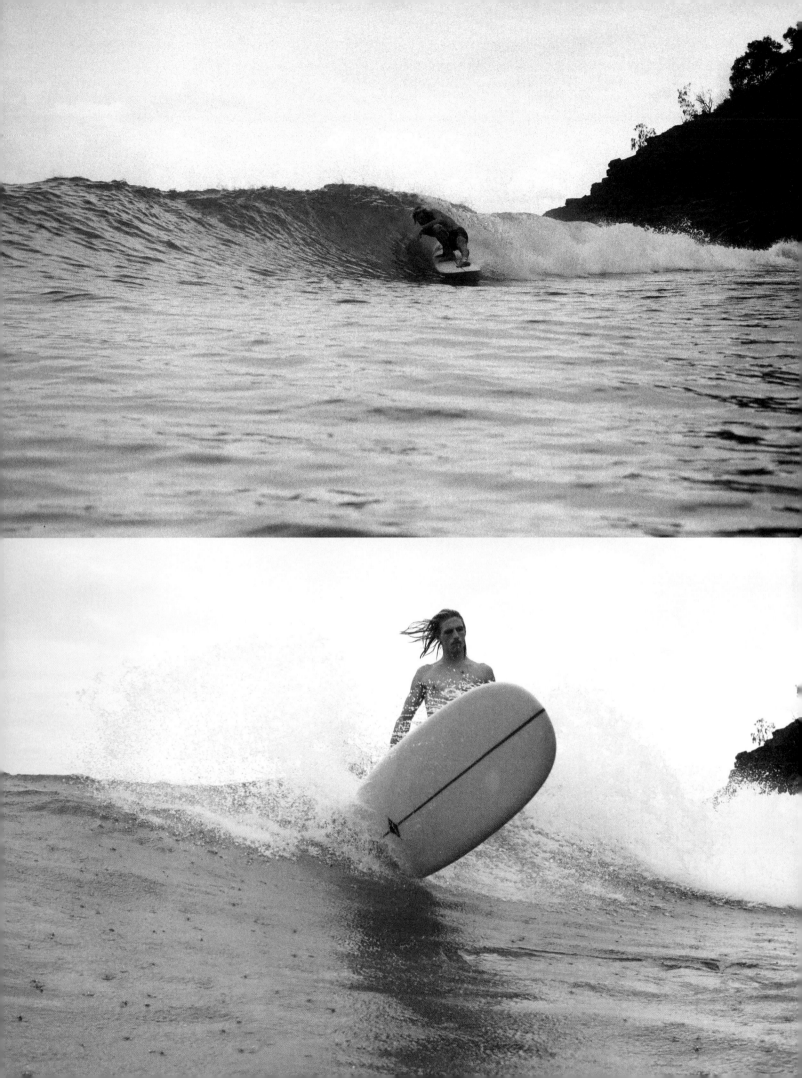

Two Passions, One Trip

Aline Bock and Lena Stoffel conquer both mountain and wave with a journey to Norway's Lofoten Islands

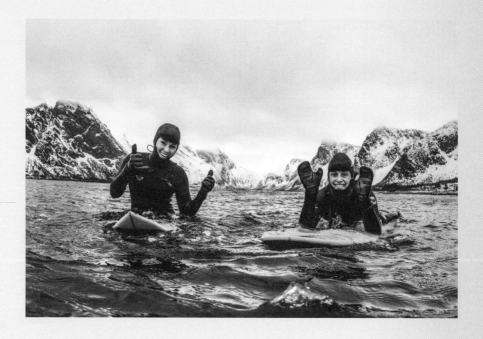

— The 48-hour drive through Norwegian landscapes best sums up the experiences of surfers Aline Bock and Lena Stoffel. In Norway's Lofoten Islands, Aline and Lena were able to fulfill twin passions of surfing and snowboarding by setting off on one epic journey. Their trip was relayed to audiences by way of the film *Way North*.

Recalling the journey, Aline says, "As we both retired from competition riding, we wanted to do our own thing and had the idea to combine our two passions in one trip: the mountain and the wave." Their choice to surf in temperatures that also attract snow sport junkies has hardened Aline and Lena against some of the worst that Europe's weather patterns have to offer. "I think in skiing and in surfing, it's the nature and the elements you play with," says Lena. "You really have to be in the moment to make the right choices on the mountain and you really have to be in the moment in the ocean, as well."

Coming from landlocked Innsbruck, Lena loves the traveling that surfing demands of her: the nature, the countries and the people to whom she's introduced. Aline shares her friend's love of travel, and noticed surfing was a way to expose herself to new surroundings. "I just love the ocean and the beach. It motivates me and gives me energy to refill my batteries after a long winter season," she says. "To me, surfing is enjoying each moment in the water and getting out of the ocean refreshed and positive." ●

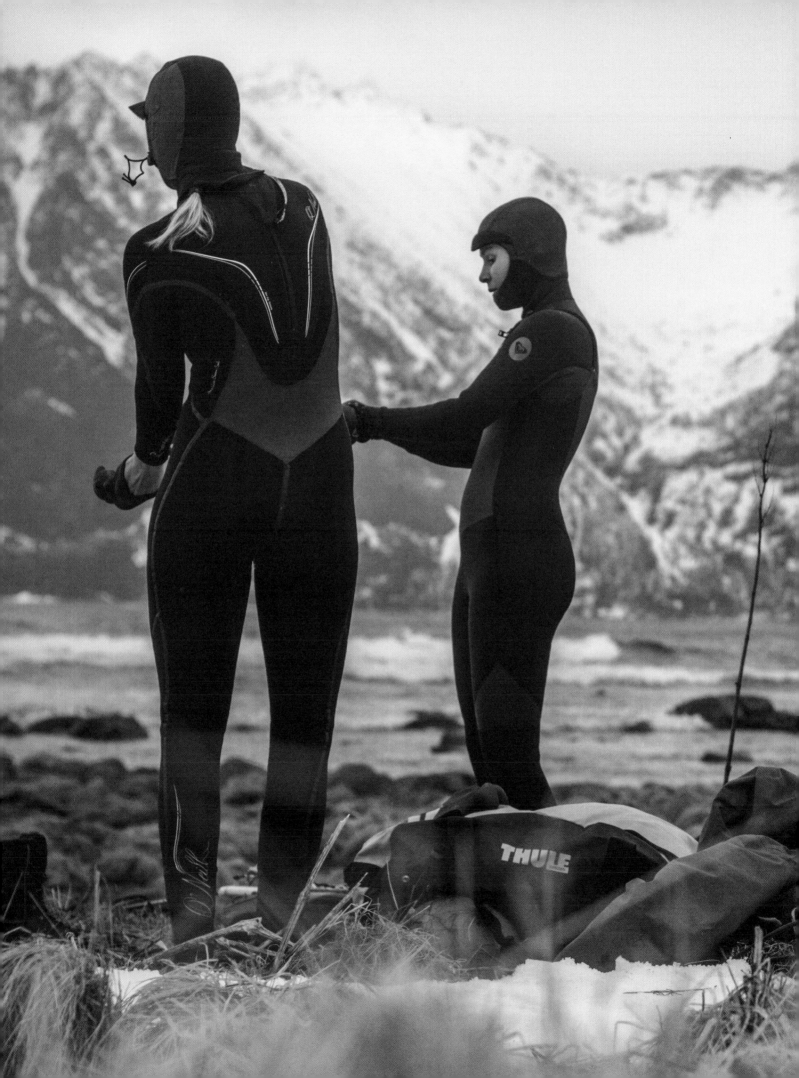

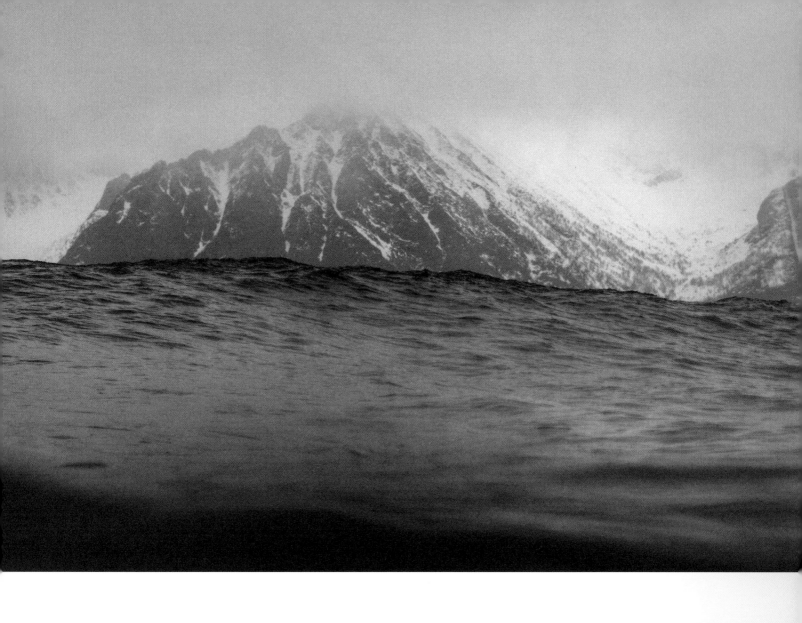

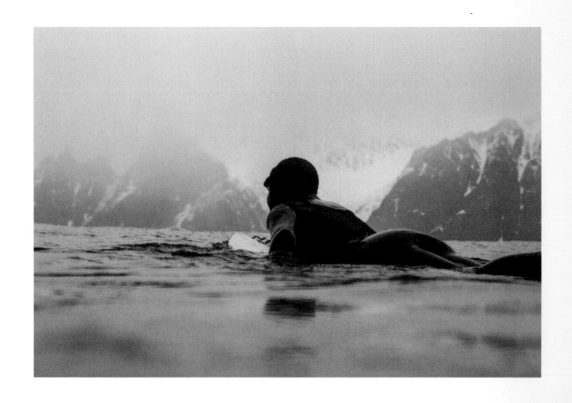

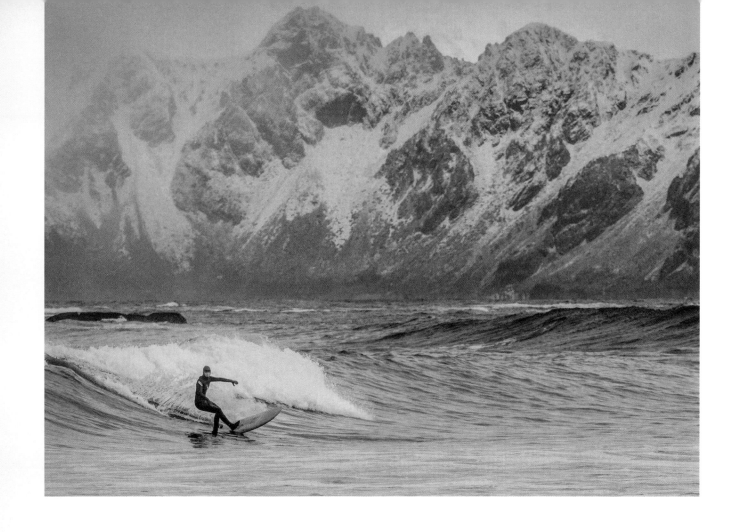

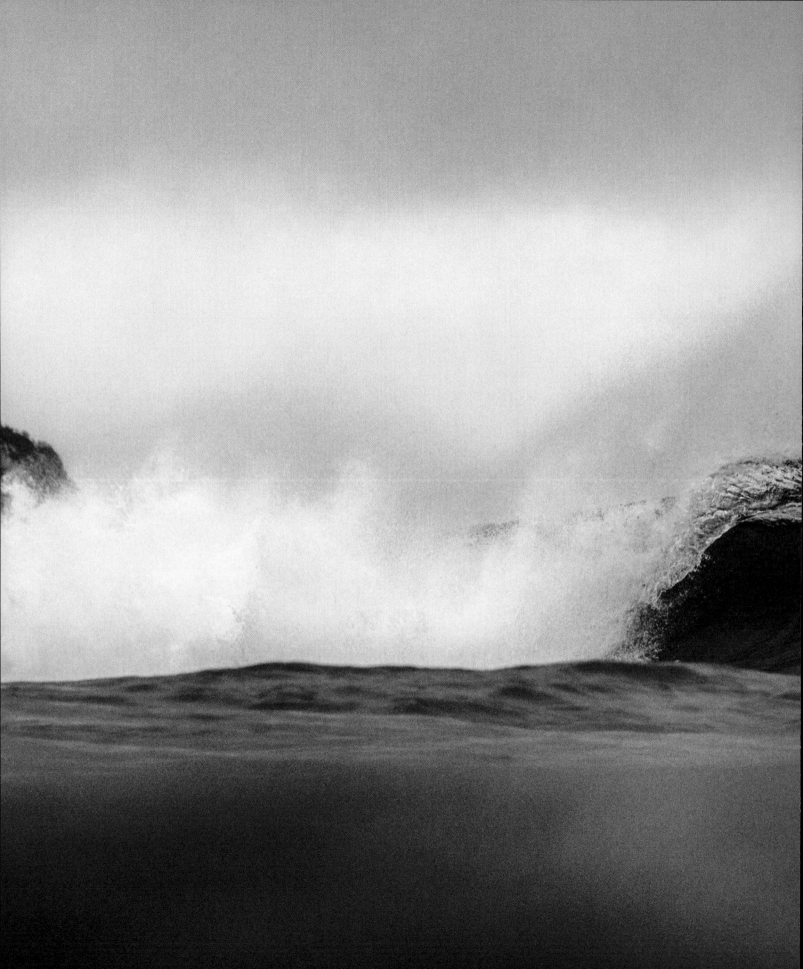

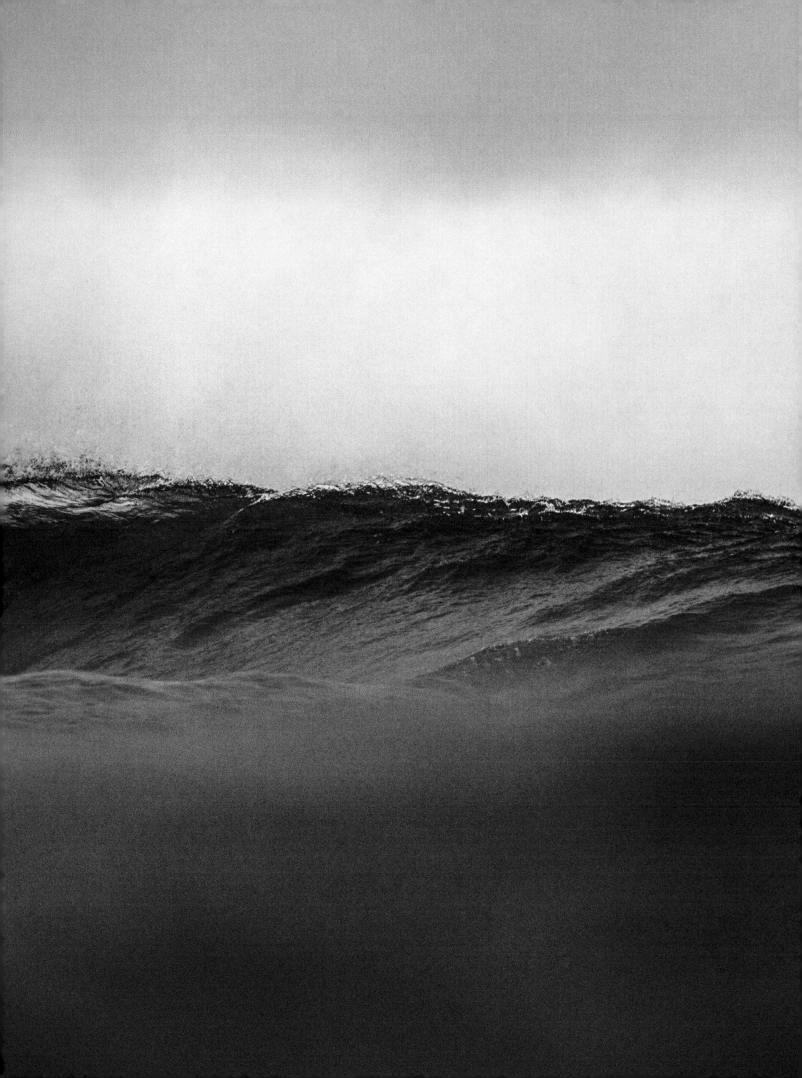

Taking the Long Way

Artist and surfer Richard Bull finds value in patience, persistence and relishing the creative process

— For anyone who has heard the phrase "patience is a virtue," know that surfer and artist Richard Bull has taken it to heart. Just as searching for the right wave takes time, effort and buckets of patience, so does the art that it inspires.

Richard first began creating art just before the start of the digital age, when patience no longer seemed like a virtue worth pursuing. "There was always a delete button," he says, "so there was never the ultimate heart-on-sleeve commitment." However, in his later work, Richard shied away from the digital, favoring the physical instead. "My initial goal was to reconnect with the physical and explore the fallow musings I'd had in those 20 years behind a screen."

As a result, instead of sticking with the importance of the end result, Richard Bull has become an artist who relishes the process. Maintaining that he likes to make work a "journey", Richard has allowed for lengthy experiences to be had with each one of his pieces before the end product is ready for others. "The journey within my work might not be obvious at first glance," Richard concedes. "Work that reveals itself over time interests me. "

As he continues to surf, the journeys in Richard's art also find inspiration in nature. The amount of travel that surfing demands has allowed for him to incorporate the sport into his pieces. "Without doubt it is a mental escape," he says. "Connecting with physical movements learned when life was simpler, and being receptive to the endorphins and nourishment that are being triggered can only elevate one as a whole." ●

"Falls" 2013 - Acrylic on Canvas
76cm x 90cm Vertical Fathoms Series 1

Sixes & Sevens" – 2014
'Seis y Siete. Cero Uno' / 'Seis y Siete. Cero Dos' / 'Seis y Siete. Cero Tres'
3 x Acrylic on Canvas 60cm x 100cm

"Let's Be Honest" A Study of Wave Height vs Ego.
Acrylic on canvas. 35cm x 46cm (x4) – 2014

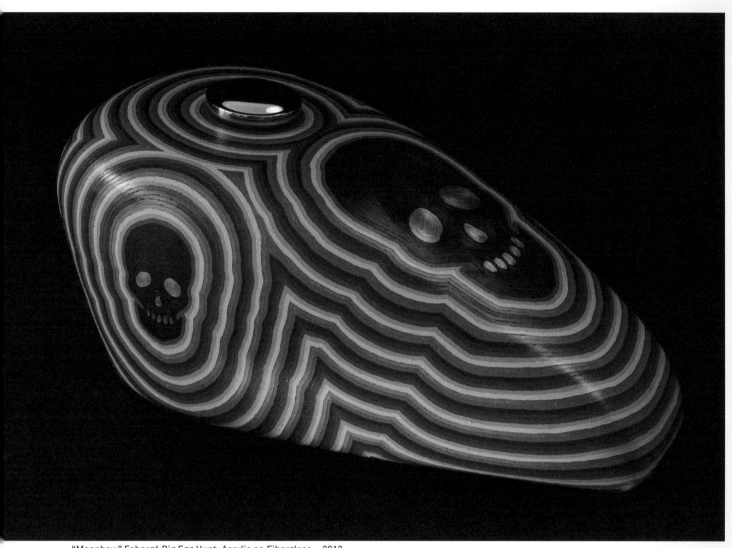

"Moonbow" Fabergé Big Egg Hunt, Acrylic on Fiberglass – 2012

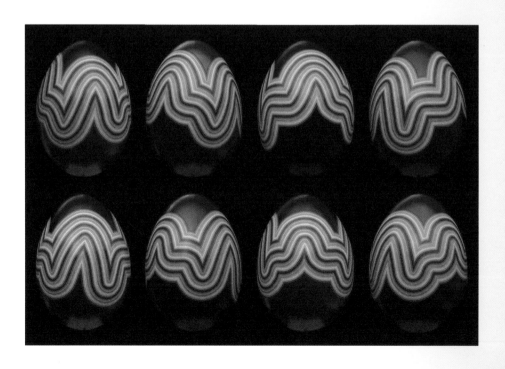

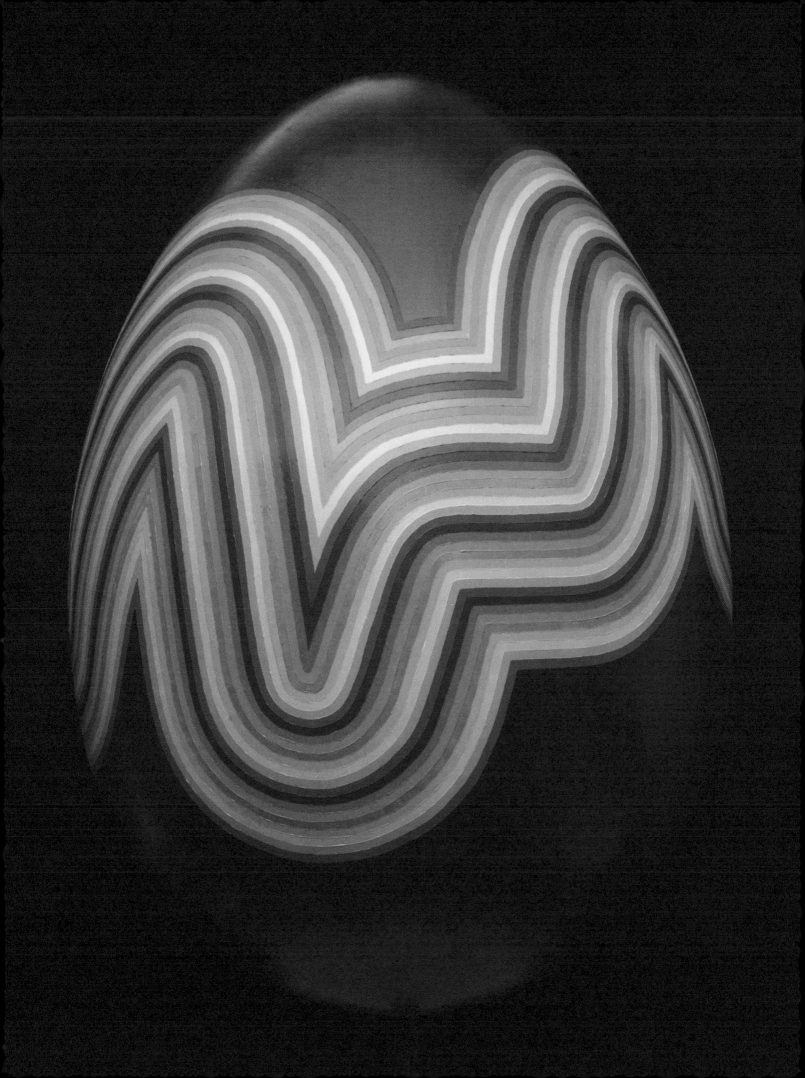

Satisfying a Sweet Craving

Munich's wild, illegal-to-ride river waves break in the outer reefs

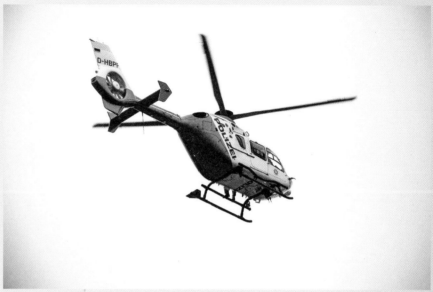

A police helicopter chases surfers, who may be fined if caught riding waves during floods.

— Once in a while, what looks like masses of cascading chocolate milk calls Munich's urban surfers to its frothy breaks. Singing a siren song that no wave lover can resist, these illegal-to-ride swells of floodwater are wild and impossible to restrict, just like the true adventurous spirit of surfing. Those who want to escape the crowds of the now-famous Eisbach river seek their thrills in the outer reefs whenever they're brought to life by "sweet" barrels of mud. The face and shape of each wave, as well as the scenery, are constantly changing, always in flux. With every modification, new lines beg to be explored while a hard-to-ignore stench reveals the story of the water's prior journey.

These river waves break rarely and when they do, mayhem ensues. Tourists passing by, caught in the action, often panic when they see people riding the swell, calling police to their rescue. Needless to say, the police detest the surfers' go-getter attitudes and all those who try to harness nature's untamed release into the city. But they should know better: There's not much that can restrain a surfer from claiming his next precious ramp – and with the prospect of scoring a fine wave, regurgitated filth is seen as decadent chocolate.

●

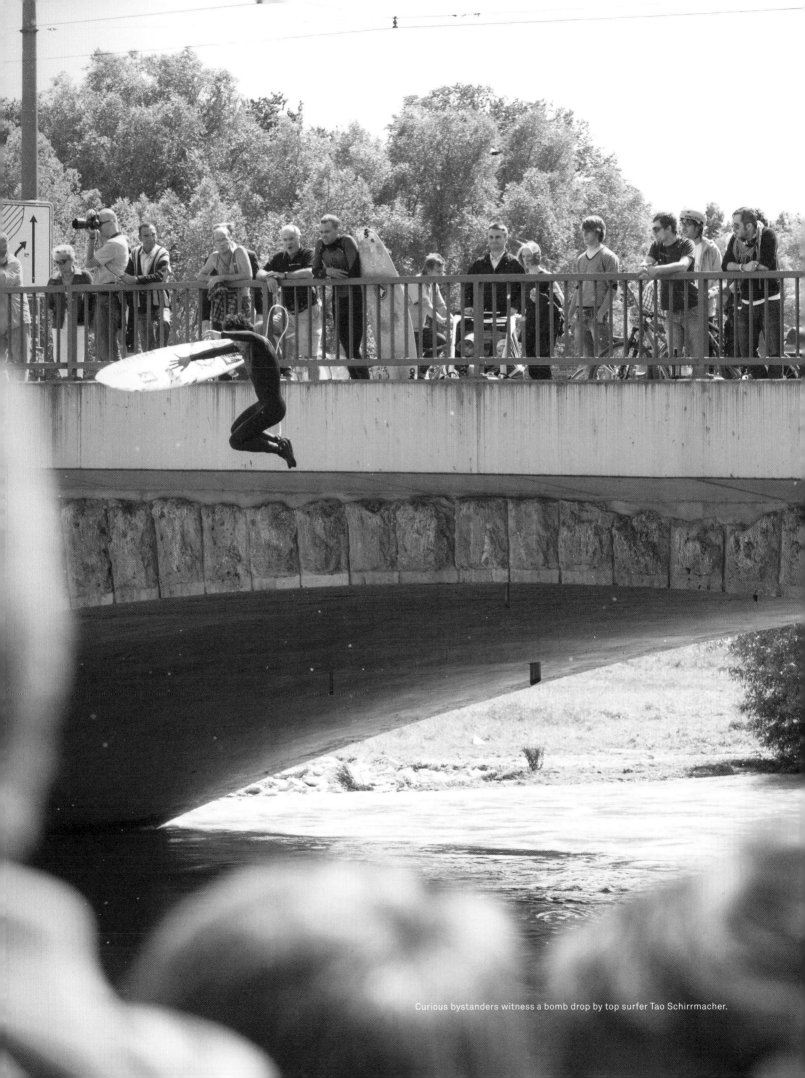

Curious bystanders witness a bomb drop by top surfer Tao Schirrmacher.

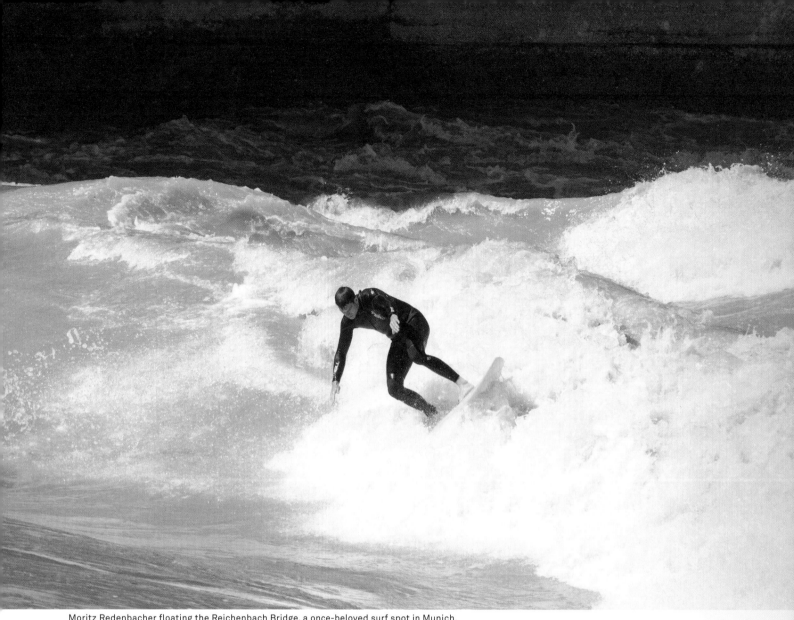

Moritz Redenbacher floating the Reichenbach Bridge, a once-beloved surf spot in Munich.

Flori Kummer getting fined by "the boys in green."

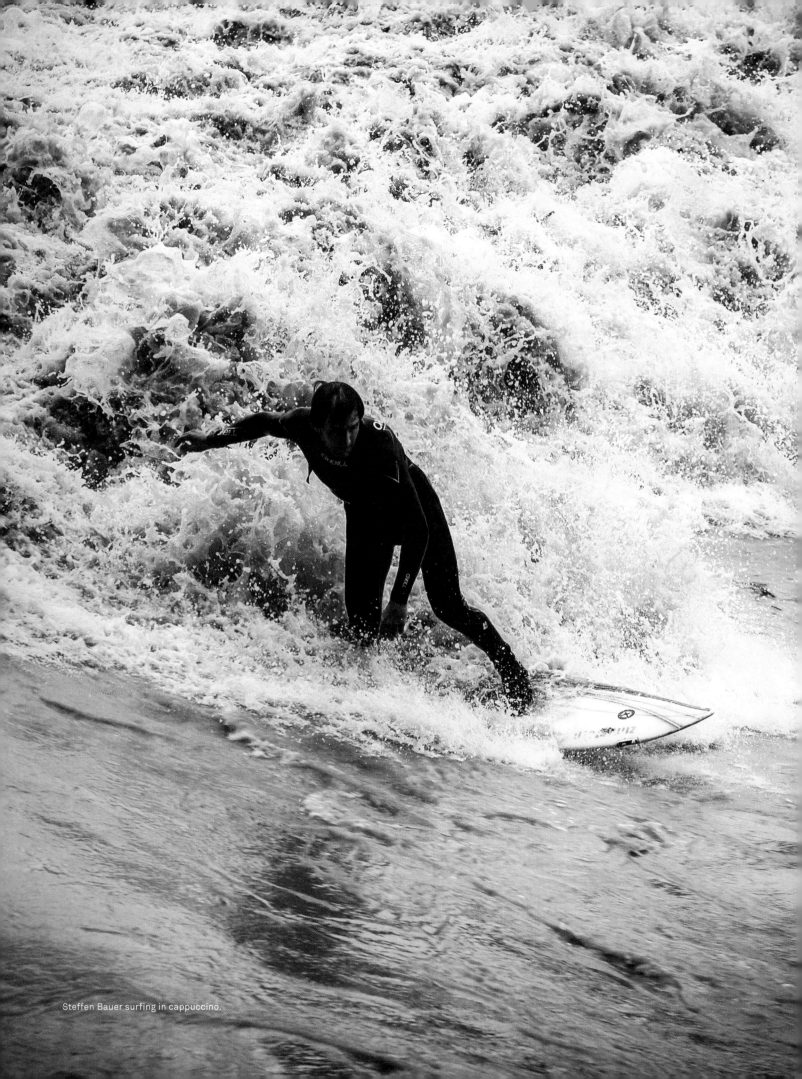

Steffen Bauer surfing in cappuccino.

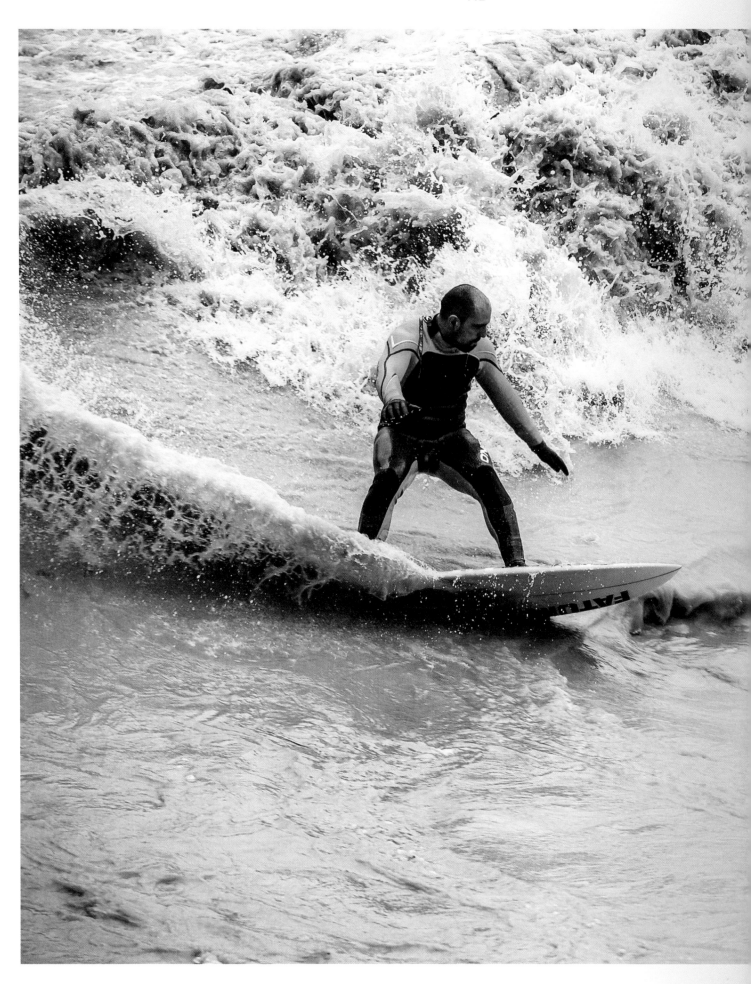

Flori carving the Reichenbach Bridge.

Safeguarding the Sea

A surf-clothing brand uses organic materials and local production to promote a sustainable, responsible and proactive perspective

—— To protect what you love is a salient piece of advice that surprisingly, not everyone seems to follow when it comes to the way we treat our planet. The aptly named brand Two Thirds, which refers to our planet's vast expanse of ocean, was born out of a desire to minimize our impact on the environment and to promote a proactive, eco-conscious attitude. Based in Barcelona, the surf clothing brand uses organic materials and local production sites to craft sustainable products that are meant to have a long life and, eventually, leave no traces on Earth's ecosystems.

Lutz Schwenke, a devoted surfer and the company's founder, believes that the surfing community is more than capable of raising environmental awareness on a larger scale: "Surfers are in the water most of the time and get to experience all the negative shifts first-hand. If they don't make noise for the oceans, who will?" Two Thirds are purveyors of living in harmony with nature – they appreciate the joy they derive from the sea and recognize our responsibility to respect it and keep it clean in return. "Each person has a choice as a consumer. Do I take the car or the bike? Do I buy large quantities of cheap clothes or fewer essential objects that are durable and have been ethically produced? We all have to do our bit, as every action has an effect on the overall situation." ●

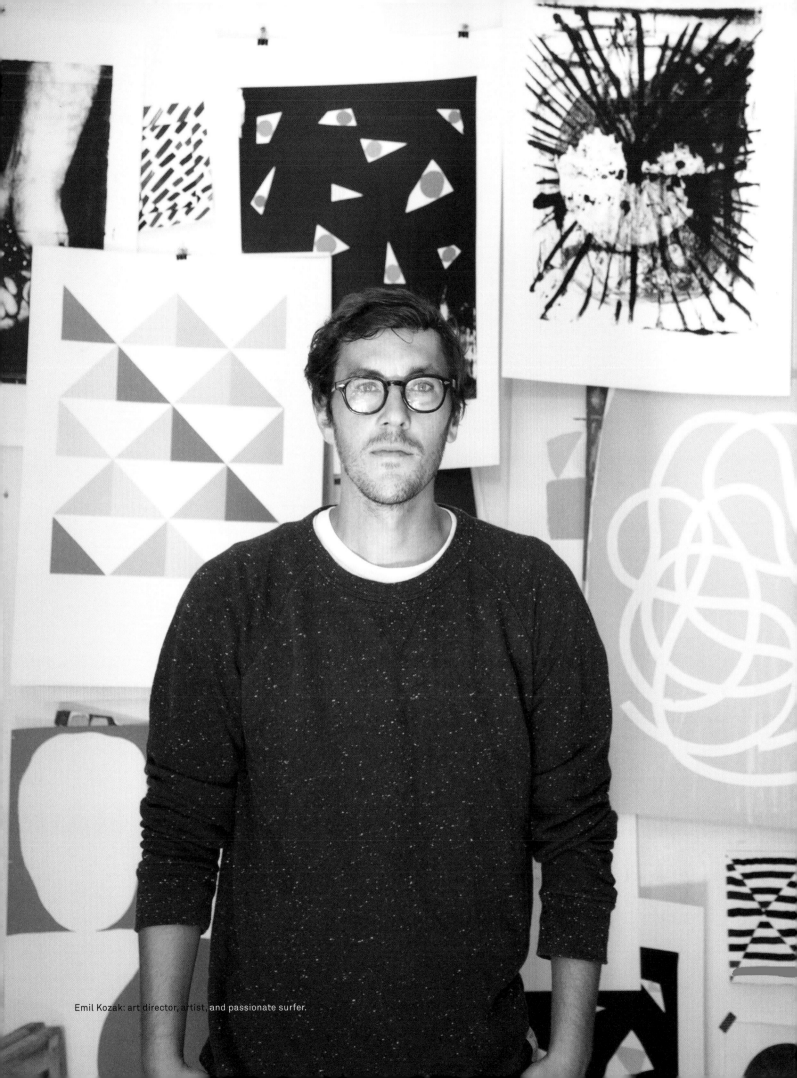

Emil Kozak: art director, artist, and passionate surfer.

Emil works on an installation on the beach with painted flotsam.

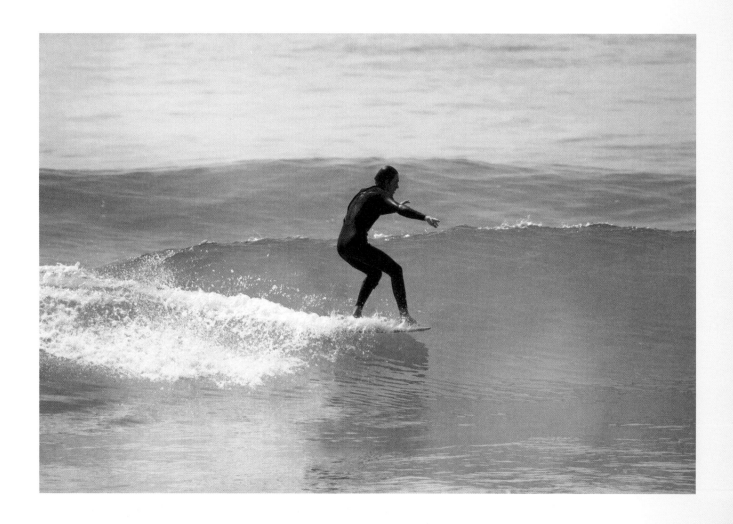

Taking the Lead

Quirin Rohleder, a river surfing pioneer from Munich, reflects on the sport's unforeseen rise to popularity

— Munich-born Quirin Rohleder spent his formative years in a city hours from the sea. But after cycling past the Eisbach (or "ice river") at the age of 13, his curiosity for surfing was piqued – and later, with practice and to the bewilderment of his family, he developed a style all his own. No one could have known then that Quirin would be celebrated in adulthood for almost single-handedly transforming river surfing into the phenomenon it is today. From acid drops to aerial maneuvers to 360s, he was the first to perfect the sport's most challenging tricks. He was also the first of his kind to receive a sponsor, setting the bar for up-and-coming youth just hitting their stride in the water.

Quirin's love of river surfing has led to multiple related career opportunities as years have passed. In addition to participating in high-level competitions in the world of ocean surf, he's worked for Reef and Billabong, and served as a German editor for *Surf Europe Magazine*. He's also a Patagonia Ambassador, as well as a sports agent and one of three partners at FRIDAY Media & Management, a company that combines content creation with talent management worldwide.

Through it all, his love of chasing waves has endured and expanded. And, to his delight, the land-locked city of his youth has warmed to the sport he's responsible for popularizing. It's no longer a startling sight, it turns out, to see passersby with surfboards tucked beneath their arms. "If you start surfing here and you like it, it's the perfect spring-board to want to discover more and to get out there," Quirin tells filmmaker Matt Payne in a short vide for Red Bull. "The river wave is just a part of the city. It's ingrained in the culture now." ●

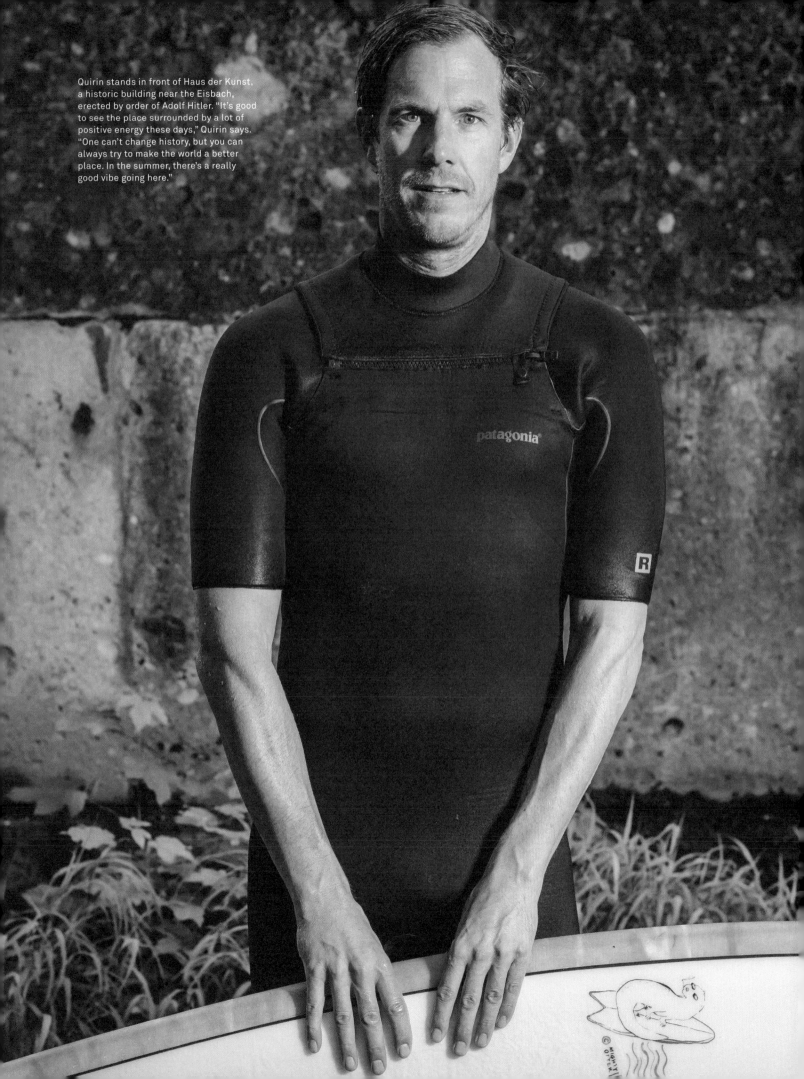

Quirin stands in front of Haus der Kunst, a historic building near the Eisbach, erected by order of Adolf Hitler. "It's good to see the place surrounded by a lot of positive energy these days," Quirin says. "One can't change history, but you can always try to make the world a better place. In the summer, there's a really good vibe going here."

"This was on a trip I took for the brand Bogner to St. Moritz," Quirin says. "It's one more example of how lucky a person I am to have started surfing the river at 13. The opportunities I have had – and still have – are simply amazing."

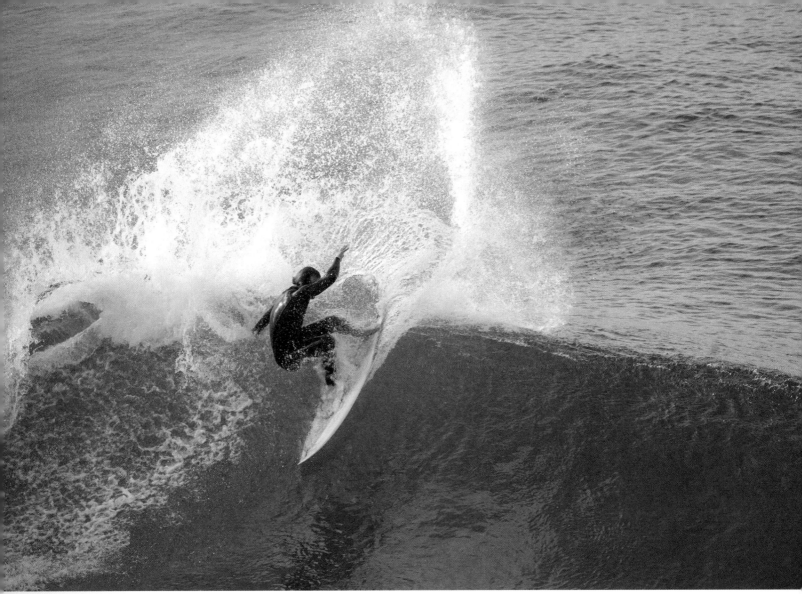

On a trip to the Algarve with friend and fellow surfer Marlon Lipke, this powerful wave
took Quirin into the lens of photographer Ricardo Bravo, perched on a cliff above.

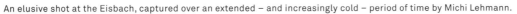

An elusive shot at the Eisbach, captured over an extended – and increasingly cold – period of time by Michi Lehmann.

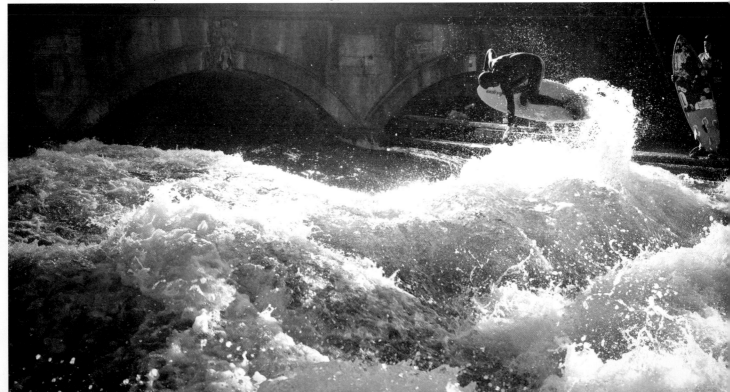

Embracing the Challenge — and the Chill

Freddie Meadows makes the most of Sweden's spartan surf by acknowledging its many rewards

— When thinking about countries with surfing cultures, Sweden is rarely the first one that comes to mind. But having discovered surfing in Portugal with his childhood friends Melvin and Marlon Lipke, Freddie Meadows began to carve out his own appreciation and expression of the sport. In his own words, surfing raised him. "Surfing is a selfish and egotistical sport, yet somehow it teaches you the importance of sharing, respect for others, respect for what has been and what is to come, appreciation and connectivity to nature. The list goes on."

Without the clichés of blue skies, bright oceans and warm weather, surfing in Northern Europe has forced to embrace the sport in a way that wouldn't be possible for a fair weather participant. It's not the cold that affects him, maintains. "The heartbreaker is the lack of daylight during the prime surf season," he says. The best swells and conditions are few and far between, and in winter, the sun dips out of sight sometimes as early as 2pm. It requires dedication: "Trying to surf heavy waves when cold and fatigued and an hour's walk from the car makes you think again on certain occasions."

Despite the tough conditions, Freddie says, "I dig deep and try to think of the reward and opportunity. I think of how little time I have before the swell runs out, so I have to make the most of these bomb sets marching in."

For those who stick with it, surfing up north can reap incredible rewards. Along with other fellow Swedes, is willing to go far and wide, driving for hours just to find the right conditions to get on his board.

For the last ten years, Freddie has spent a great deal of time away from his home country, finding better environments in which to surf. But returning home can still be an adventure. Five days before he was bound for the World Championships in Peru, Freddie headed back to Sweden to meet a swell, then another. He hasn't stopped since. ●

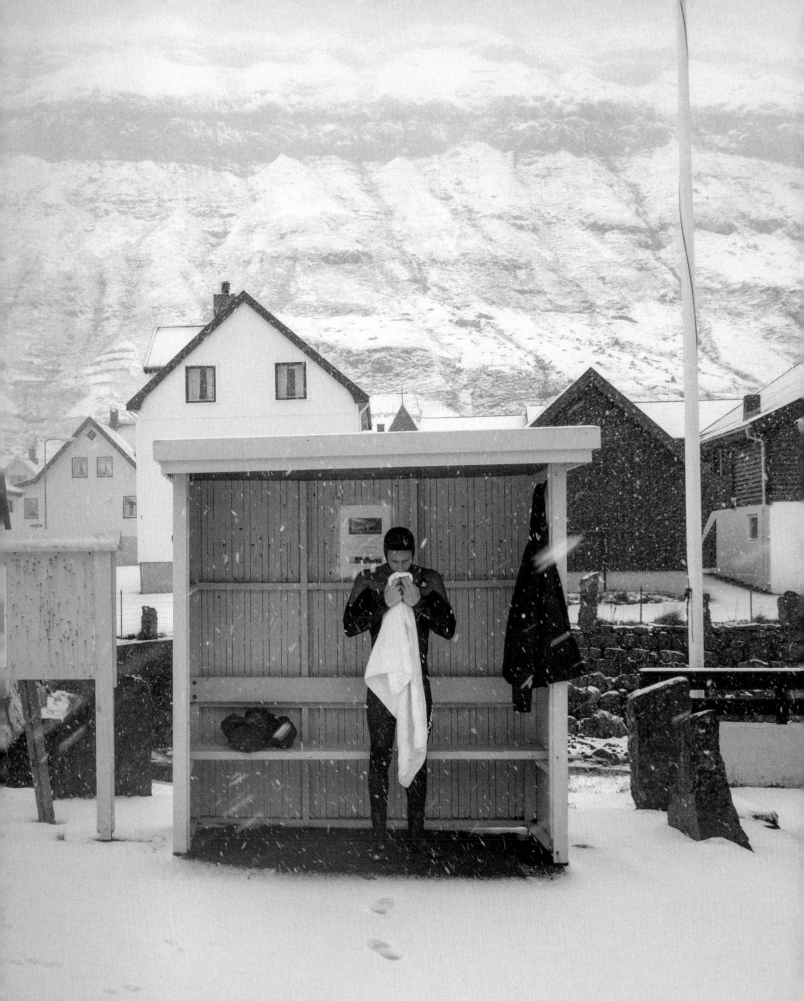

Freddie at a bus stop in the Faroe Islands.

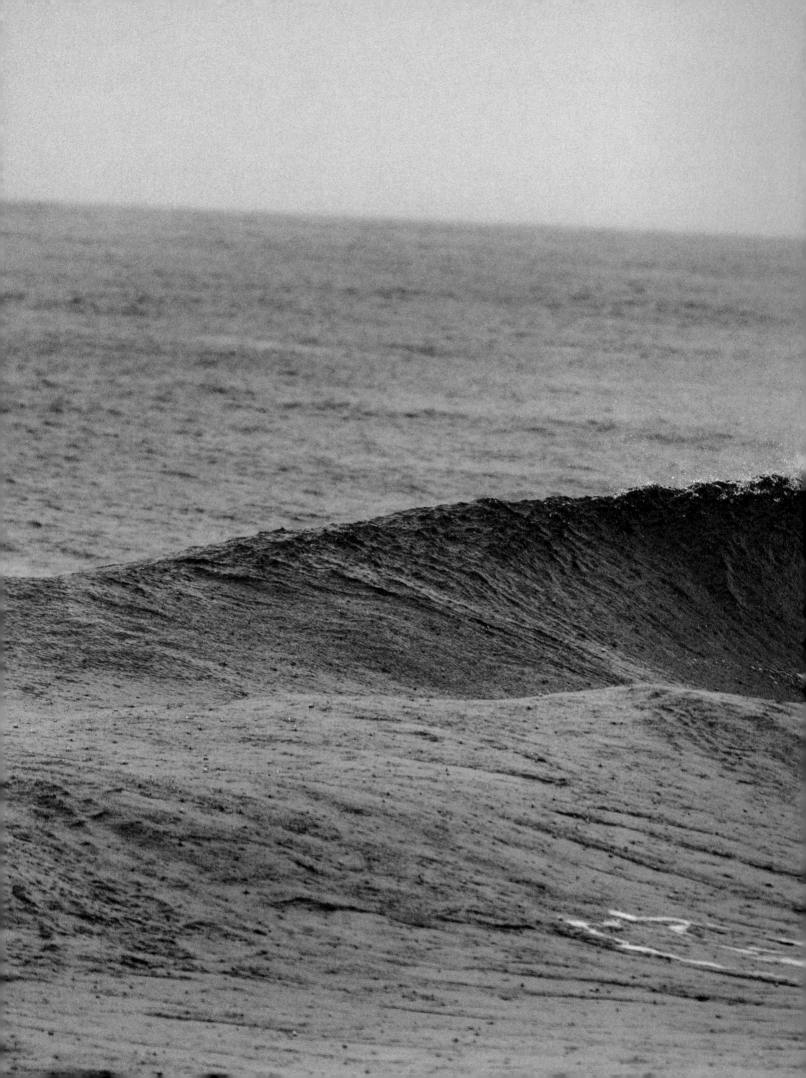

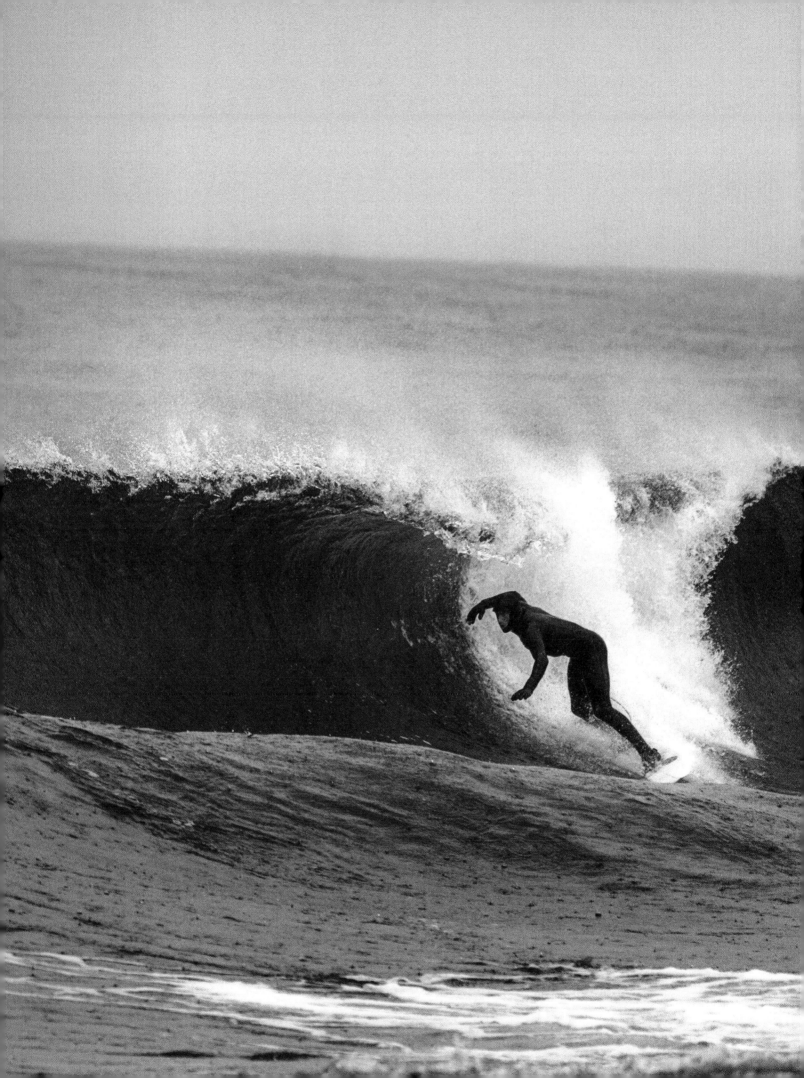

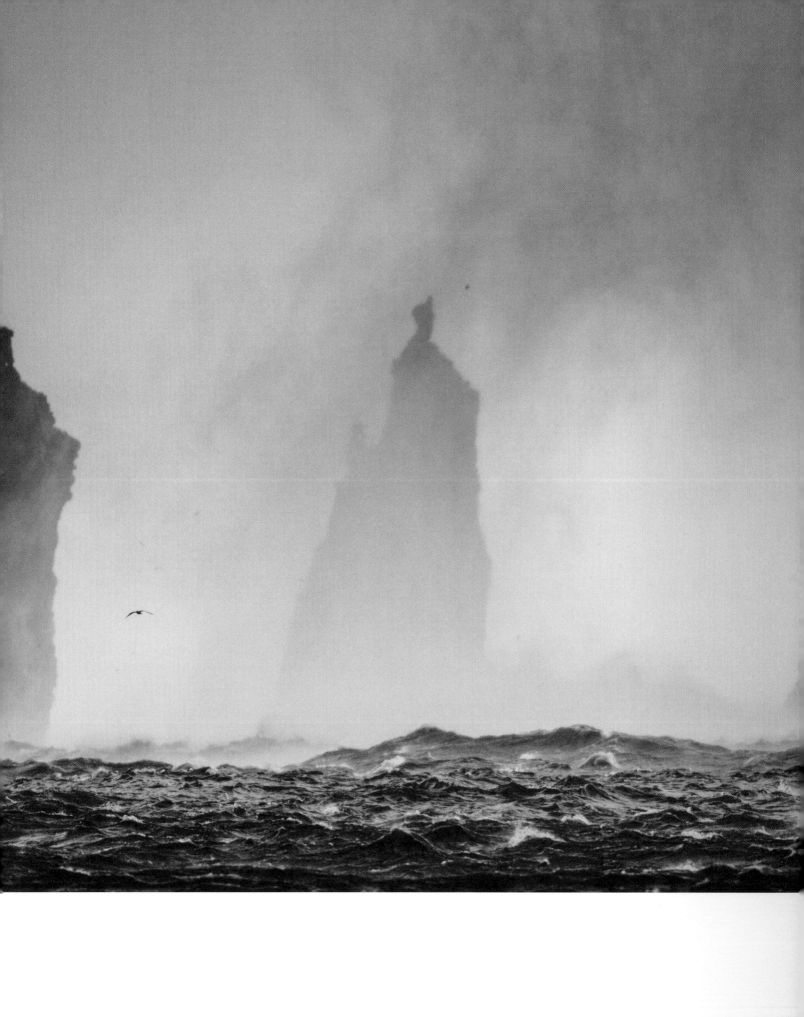

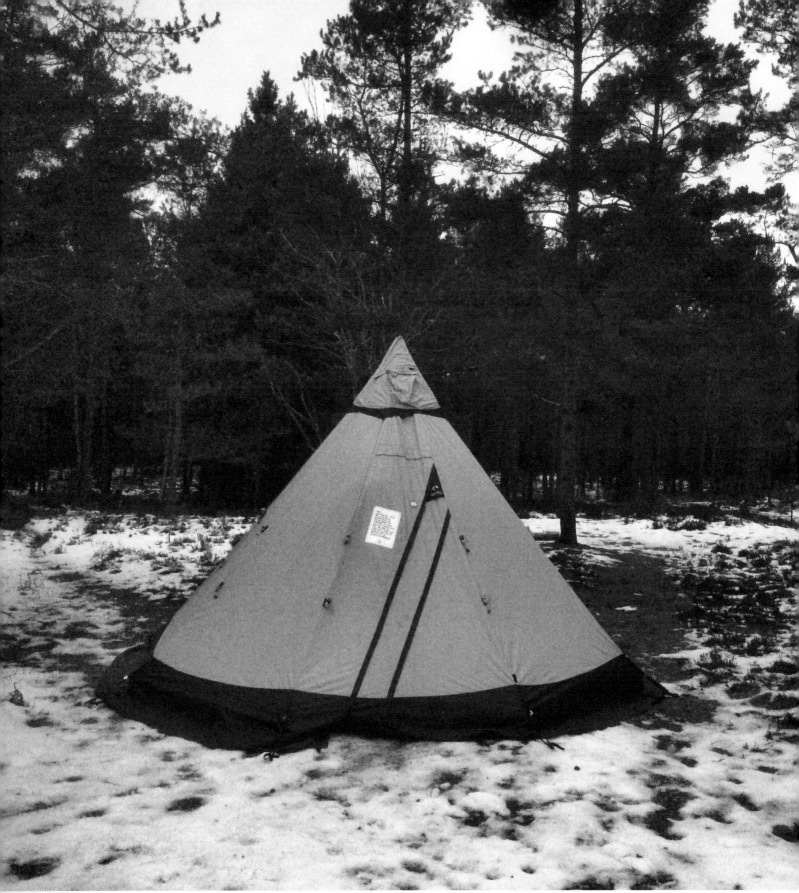

A Nord tent and heater provide warmth when suiting up to chase winter surf in Torö, Sweden.

Making Standout Statements

Bold patterns and bright color are an artist's trademark – and a representation of his global roots

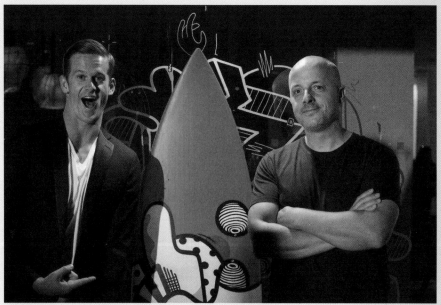

Surfer Nic Lamb and French artist Mambo unveiled their surf art collaboration at the Mondrian Hotel in Hollywood.

—— Flavien Demarigny, aka Mambo, was born in Chile to French and Hungarian parents and currently lives in Los Angeles, where his art reflects his global roots. He paints large, colorful murals embedded with tiny symbols and hints of the world he lives in. "The core theme of my work is humanity. My portraits are about human reactions and emotions – in my abstract networks, it's more about the brain and what's inside of it," he says. The artist's career has spanned decades, yet he continues to explore new modes of expression. Recently, he collaborated on a special board with surfer Nic Lamb. "We got along really well and we decided to create something together, just by ourselves, no brand involved. I took inspiration from the WWI Dazzle paintings that were applied on battleships at that time and included it in my style."

The camouflage was meant to disguise boats with confusing, perspective-based patterns. But the board Mambo designed for Nic does anything but camouflage – its bold colors and patterns help him stand out among the crowd. As one of the best upcoming big-wave surfers (winning the Titans of Mavericks event at Half Moon Bay in 2016), it's an apt fit. ●

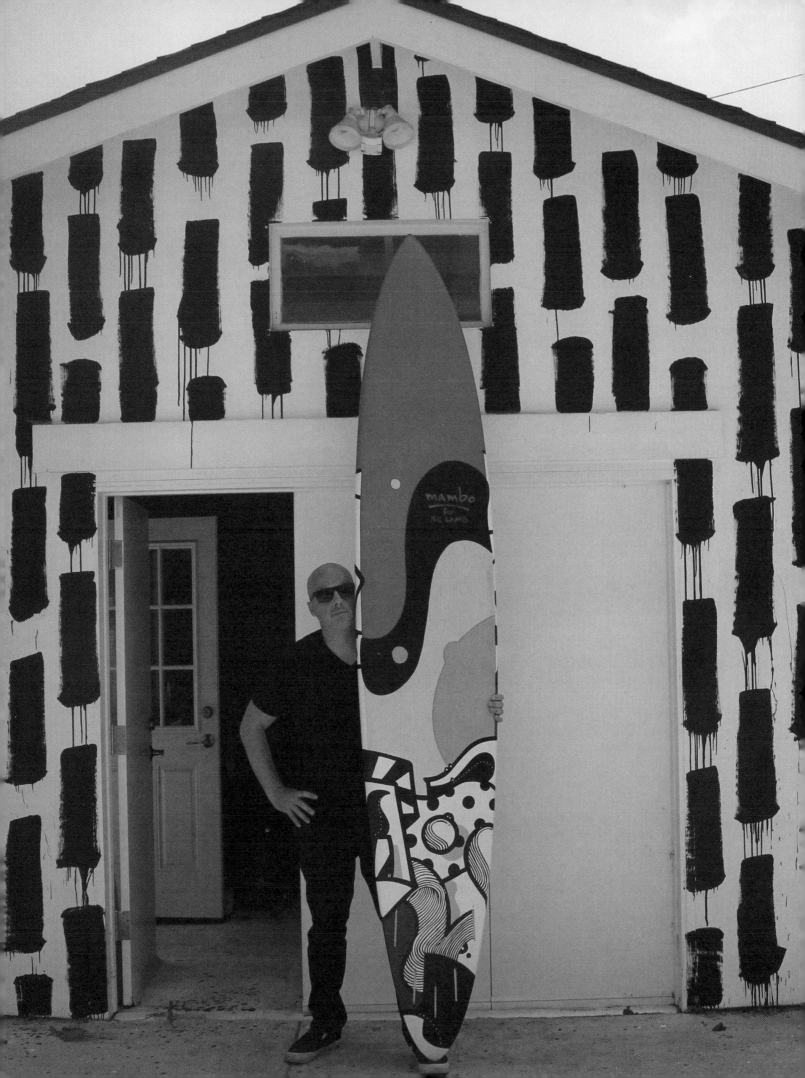

The result of the first-of-its-kind collaboration: a custom-designed surfboard and
matching wetsuit, both created using Mambo's signature abstract patterns.

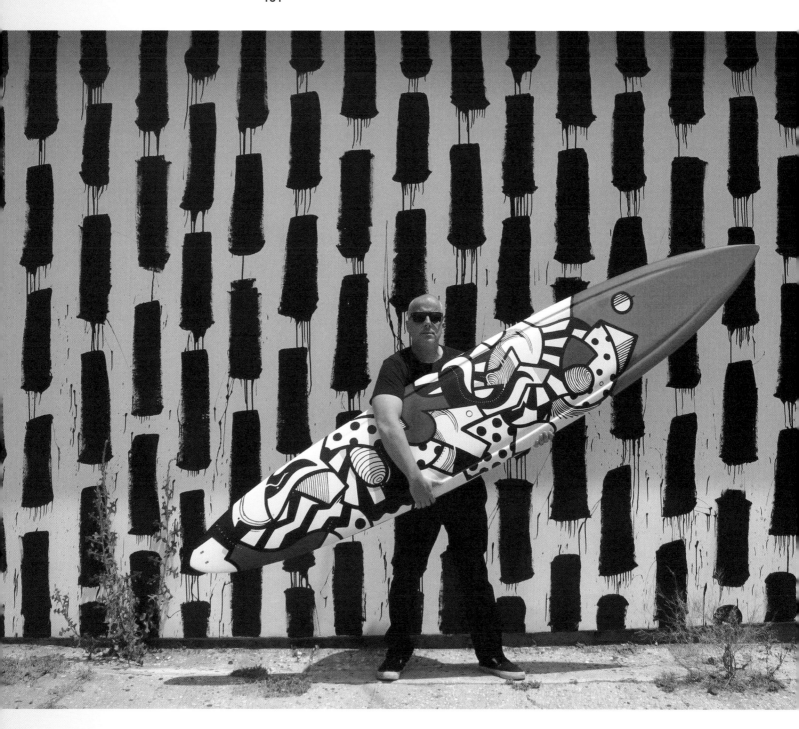

Championing the River

Portlander Elijah Mack strives to bring recognition to the sport of river surfing

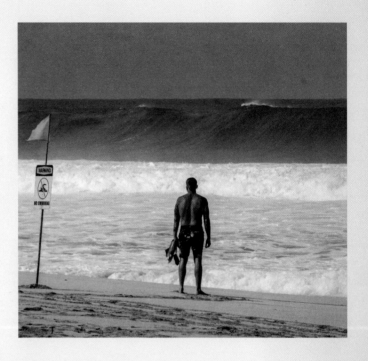

—— The name "Elijah Mack" is synonymous with river surfing – and for good reason. Growing up in San Diego, Elijah came from a lineage of legendary surfers and lifeguards, so he felt right at home the first time he stood up on a board, immediately feeling a deep connection to the sport. In his own words, he says, "When I say I was born into it, I don't mean I was born into a surfing family. I mean surfing was bred into my DNA, into my soul."

In the late 90's, though, Elijah stumbled upon a river wave in Chico, California and was hooked on the feeling he got carving on standing waves of different shapes and sizes. At the time, there was not much information available about the art of river surfing, and since then, he's had to fight an uphill battle to legitimize the sport. After documenting the rivers of America looking for the best waves, he set his sights on international waters – specifically, the Zambezi River in Africa. Battling to find sponsorship and promotion for a trip to the Zambezi, Elijah finally managed to find his way there in 2005. "The Zambezi was a turning point for me. That trip represented the raw beauty and untapped potential of the sport of river surfing. The wave itself is the most beautiful river wave on Earth; the Zambezi river is like the garden of Eden. It's amazing."

Having founded the World River Surfing Association in 2003, Elijah is one of the greatest resources on the sport of river surfing, and continues to push its boundaries, even teaming up with researchers from Colorado to create the "perfect river wave." He now lives in Portland, Oregon with his wife and four kids; when he's not chopping it up on the Deschutes, he works as a barber. ●

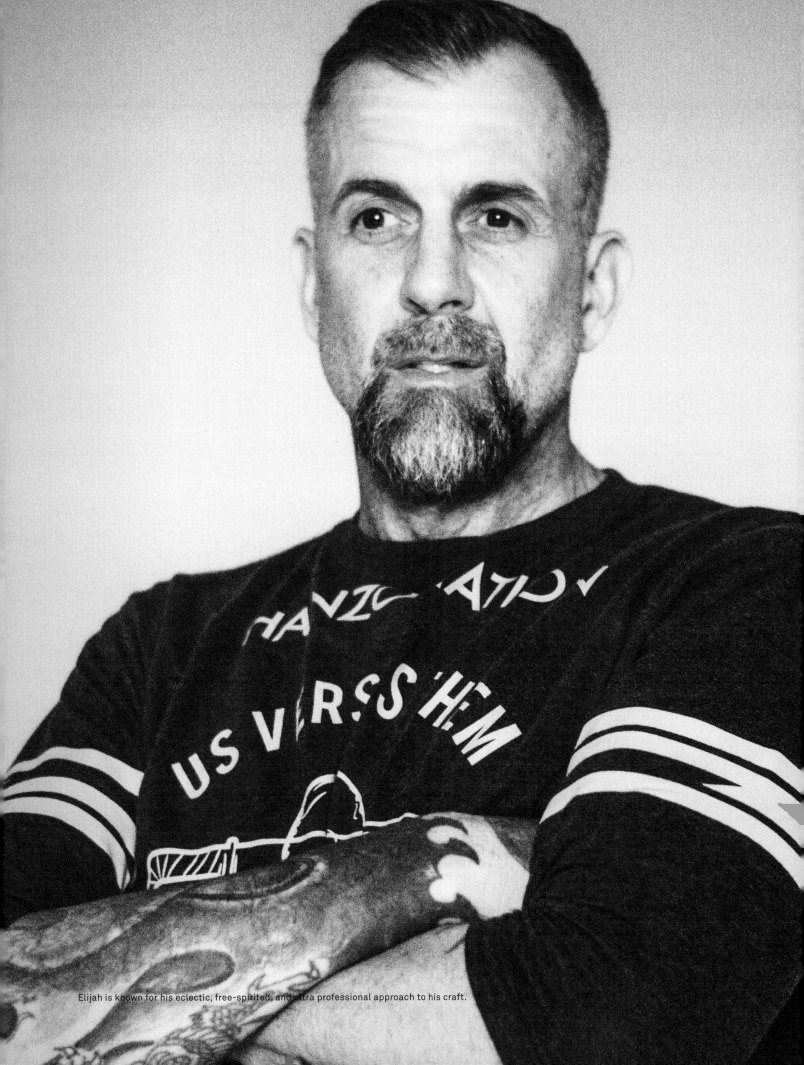

Elijah is known for his eclectic, free-spirited, and ultra professional approach to his craft.

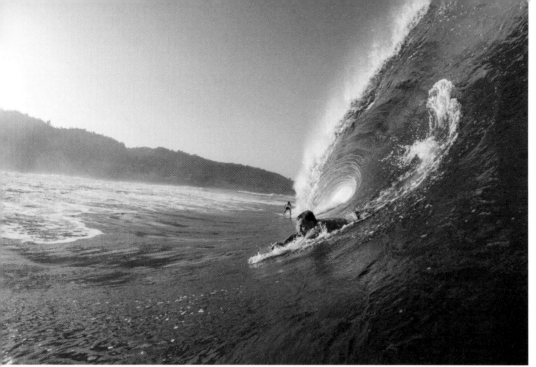

Elijah body surfs Rocky Point on Oahu's North Shore.

Ripping Tubesteak Wave at the Skookumchuck rapids in Canada.

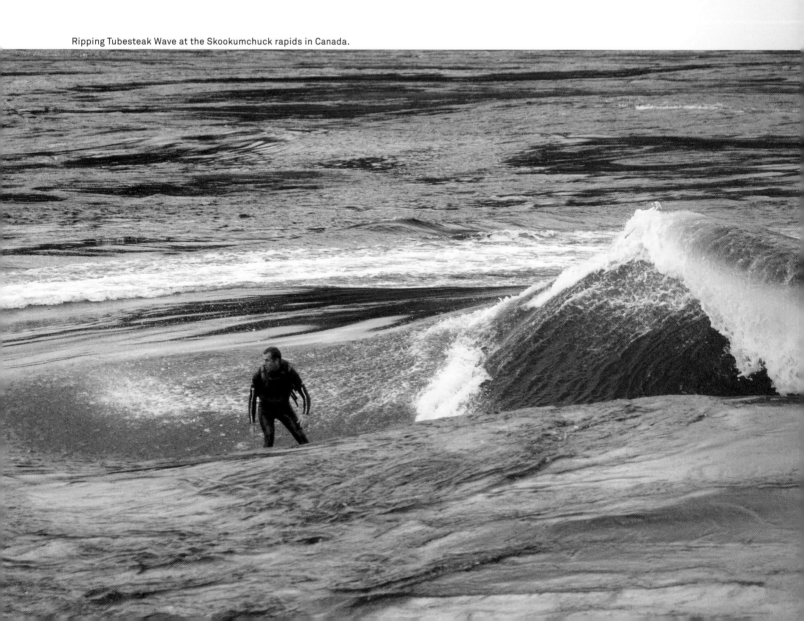

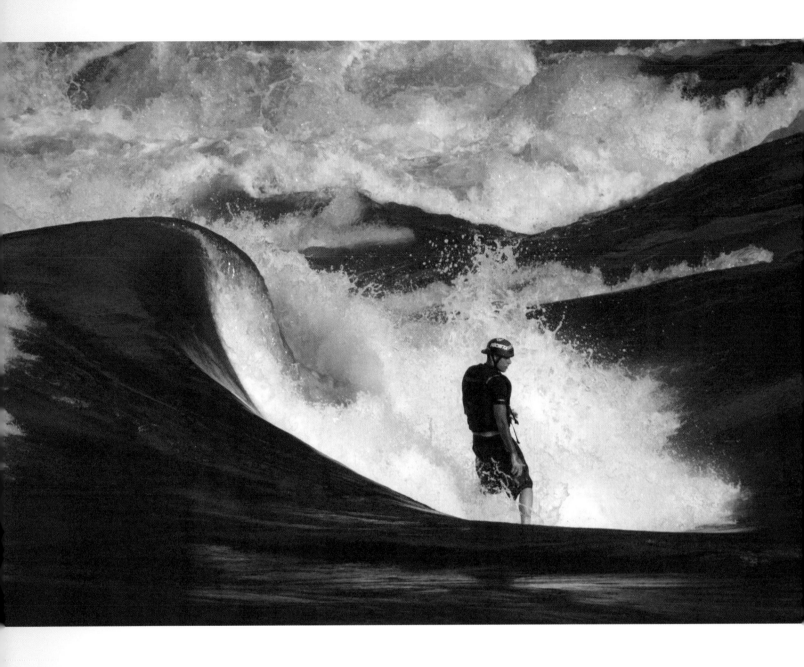

Serving Fellow Surfers

A small band of creative surfers designs handcrafted boards intended for their peers

—— When Mathias Rosendal and the group behind the surf blog collective Shredsled Society tried to move into the world of handcrafted surfboards and surf gear, Copenhagen's surf community was extremely receptive. After a small exhibition in a newly opened gallery in the Danish capital, this small band of craftsmen and creatives sold out of their handcrafted boards. Mathias saw that they were offering something new, and the idea for Oh Dawn was born.

As surfers themselves, Mathias and his collaborators only want to offer products that they, as surfers, would search for. Mathias maintains that the whole experience has been a learning curve, adding to its authenticity. "We've always valued the process just as much as the outcome," he says.

Although the team behind Oh Dawn concede that Denmark is no classic surf country, they use this to their advantage when developing their style, aiming to unite the famous Scandinavian design heritage with the concept of being a surfer. Bringing their heritage into the brand, Mathias sees individuality shine through. "I'm not sure how other brands do, but compared to those big corporate players, the whole hands-on approach that we're rolling with is definitely a big difference."

Drawing on the hard outlines of Scandinavian design and the limitless environment that surfing exposes, Mathias and his friends have used an individualized form to find experiences on the waves. "Our main thought has always been to make products that we'd like ourselves."

All passionate surfers, the inspiration for Oh Dawn's designs come from the team's lifestyle. As Mathias and the others skip between the urban surroundings of Denmark's capital, the exposed environment of her beaches and the murky, cold waters of Scandinavia, the sea always finds its way back into their workshop. ●

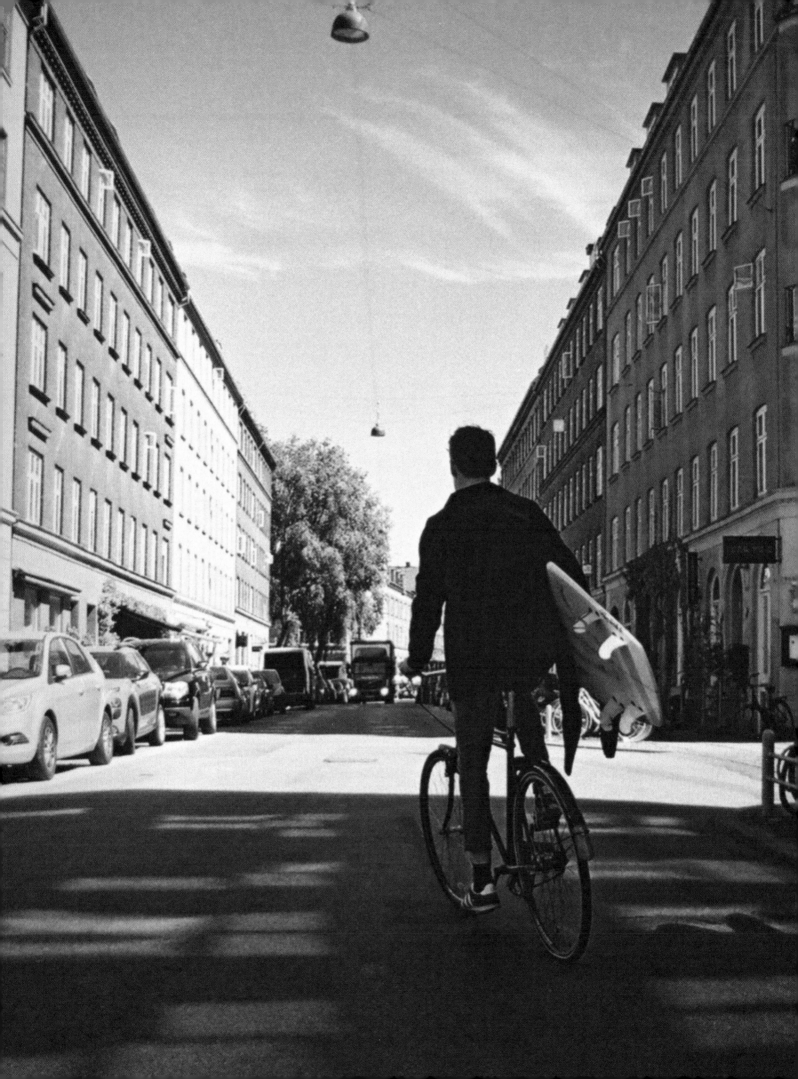

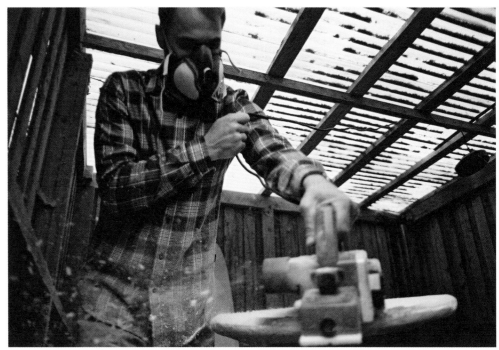

Backyard shaping in Copenhagen.

A cold water session in Northern Zealand.

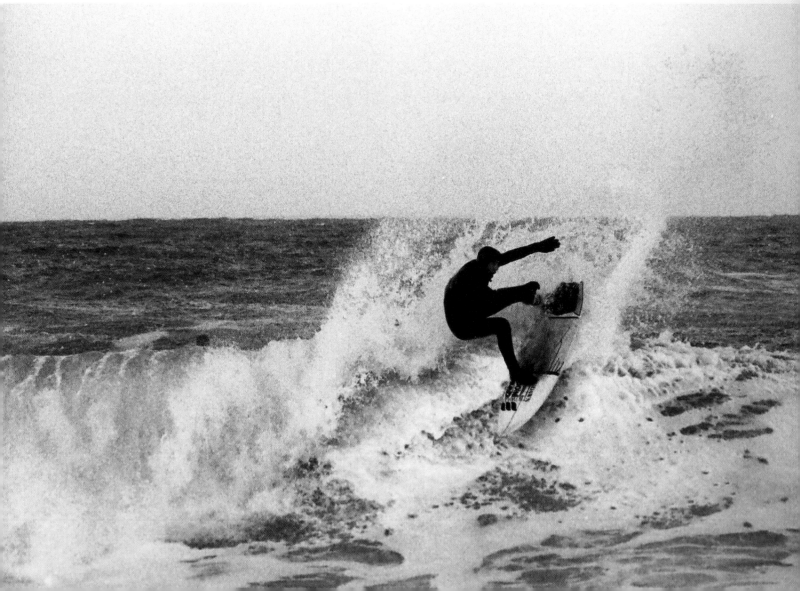

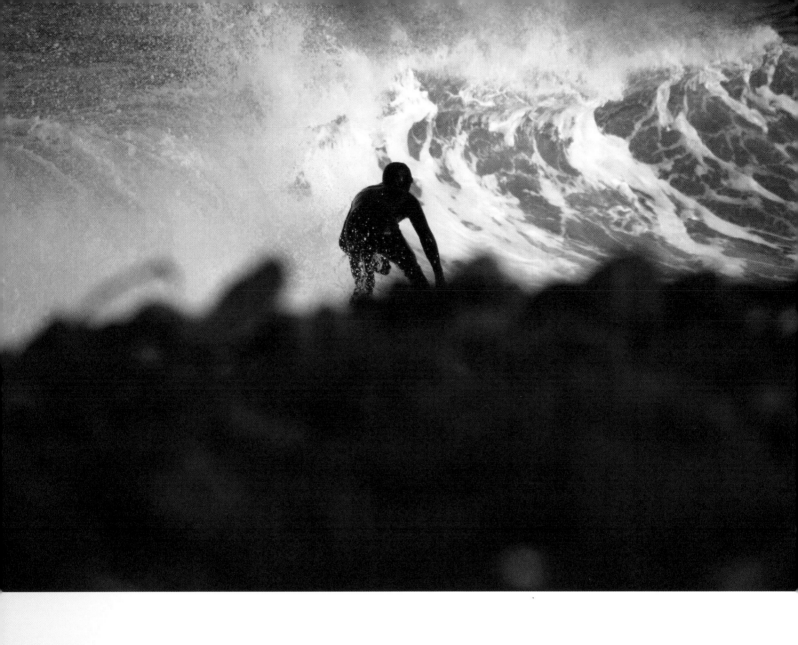
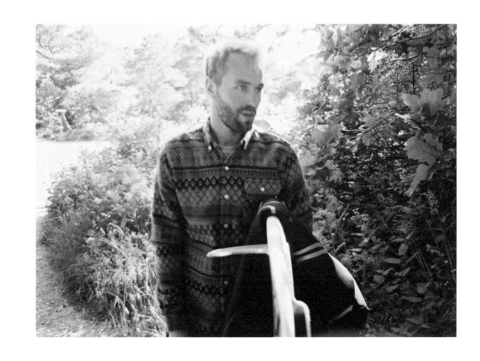

Putting a Lens on Life in Rio

An eye-opening film tells the story of two teenage boys who seek refuge from favela life through surf

— Rio de Janeiro attracts surfers from around the world, who come to try their hand on the shores of the southern Atlantic. Tourists, sun-seekers and pro-surfers can all be found on the city's famous beaches. But so can the locals. Filmmaker Justin Mitchell set out to explore the worlds of two Rio-born teenage surfers in the film *Rio Breaks*, which sees 12-year-old Naama and 13-year-old Fabio take daily trips to Arpoador Beach from their home in one of Rio's notorious favelas.

The Favela do Pavao, nicknamed "Vietnam," is the part of Rio that Naama and Fabio call home. It stands in stark contrast to areas of the city most frequented by jet-setting surfers. But *Rio Breaks* offers viewers a new perspective on Rio as a surfing city. Oriented around the Favela Surf Club, which was opened as half surf school and half social project, the film details the lives of the teenage boys as they evade the hard realities of their hometown by getting on a surboard.

Lesser known than Ipanema or Copacabana, the boys' daily trips to Arpoador show the viewer a surfing culture rooted not in Rio's tourist industry – but in the city's culture itself. ●

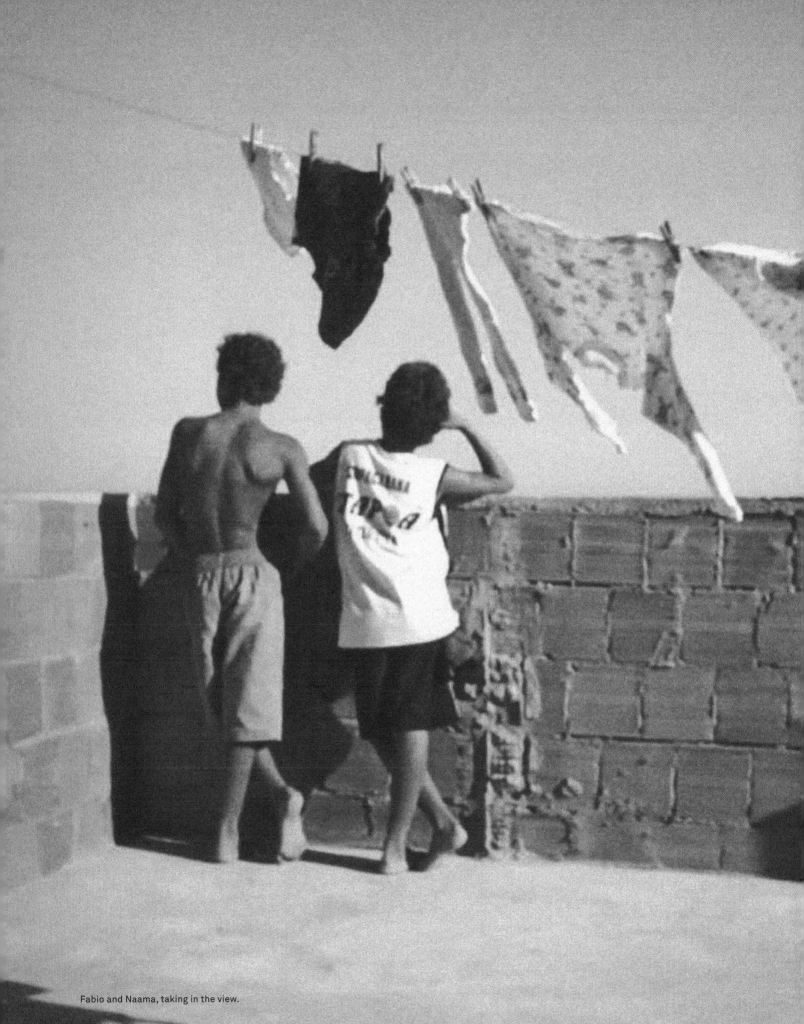

Fabio and Naama, taking in the view.

The teenage surfers discuss their dreams, high atop the favela.

The view from Cantagalo.

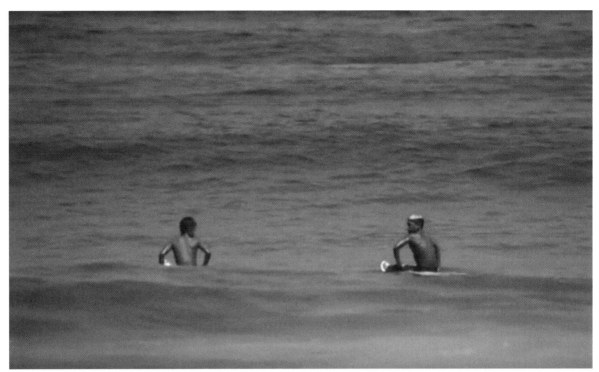

Waiting for waves.

Linking the Like-Minded

A surf shop in Ericeira brings a tight-knit community closer

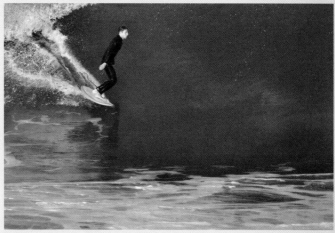

Pedra Branca, Ericeira captured on a winter morning.

— From boards and wetsuits to literature and music, Magic Quiver is the kind of shop that embodies the multifarious character of surf culture. The store's main philosophy is to introduce people to a different side of surfing, veering away from mainstream stereotypes and bland associations. "I see it as a niche, a subculture within a subculture of sorts. I try to offer something unexpected and take visitors by surprise. I love it when people walk in the shop and look slightly perplexed, and then curious to rummage around and familiarize themselves with our concept," says the owner, Mario Julian Wehle. The eclectic medley of elements is representative of the community's creative output and reflects a genuine love of surfing that's more than just the physical act of riding a wave. "Put all these different objects into a 40-square-meter room and it feels like some sort of shrine dedicated to surfing."

If someone had to pinpoint a protagonist inside Magic Quiver, it would have to be the surfboards, which come in all sorts of different shapes and sizes. Mario is interested in a rich diversity of boards and doesn't just focus on those built for high-performance athletes and competitions – the only criteria he adheres to without fail is that they're all handmade, original pieces. In addition to the different craftsmen with whom they collaborate all over the world, each year they invite guest shapers to Ericeira to create boards for the shop in a local factory. At the forefront of the concept store lies a deep sense of community which has transformed the space into a meeting point for like-minded people to exchange ideas. "I've always enjoyed bringing people together. The shop has turned into a platform for all that, and we also host events like movie screenings, small exhibitions and parties. That's when the place truly comes to life. Some people go to a bar to drink and watch a football game, others go to the local surf shop to talk surf and all sorts of irrelevant things."

An adamant supporter of the alternative movement within the surf world, Mario celebrates the joy and freedom inherent in the act of surfing, disconnected from the highly competitive side of the sport. "I'm not against high performance at all. But, when it comes to the average surfer, it should be about having fun – why else would you spend all that time and money on surfing if not for having a good time?" Fun and games aside, surfing is a deeply empowering activity that has taught Mario a great deal of life lessons and has influenced his mentality. "Scoring good waves is not just about luck or coincidence. When you're in the water you need to be alert to read the conditions, be able to gauge risk, overcome some fears and make quick decisions. Experiencing the force of nature can be humbling and you learn how to deal with defeat. Most of all, it taught me perseverance. You can go through so much shit, and then finally you get one good wave and all the hassle pays off in an instant."

"Surfing is all about good vibes. Clear your mind, play, dance, fool around, allow yourself to get thrilled – do what makes you happy." ●

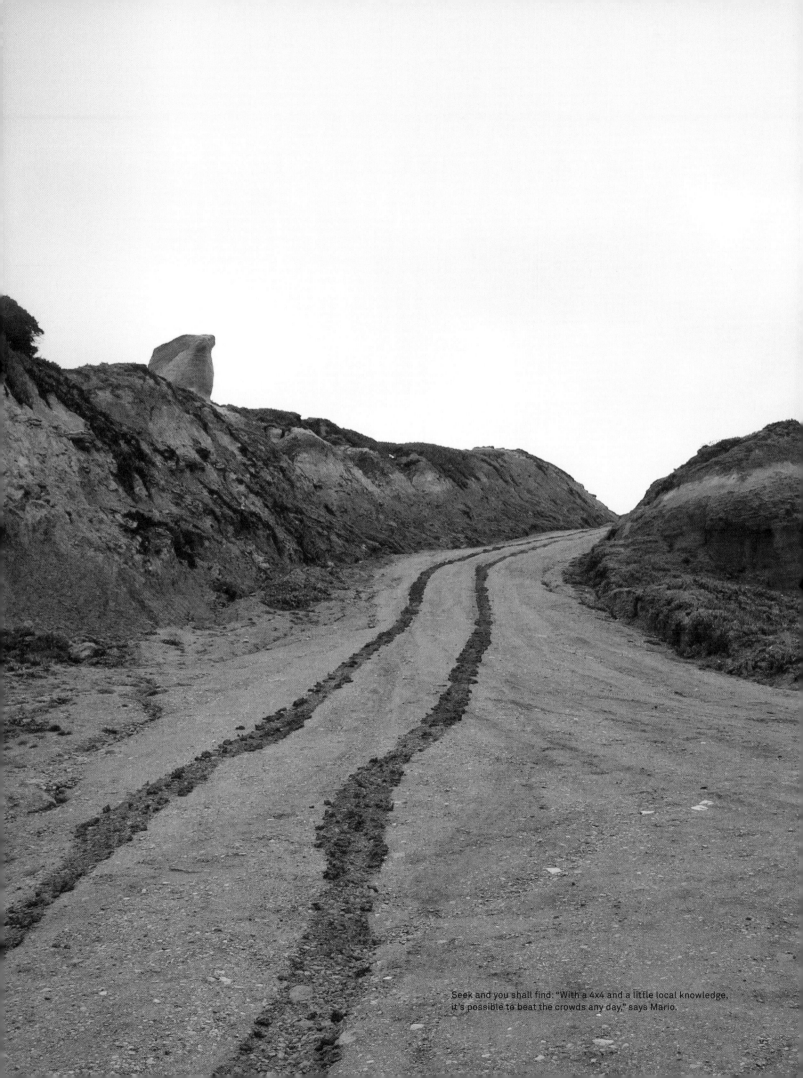

Seek and you shall find: "With a 4x4 and a little local knowledge, it's possible to beat the crowds any day," says Mario.

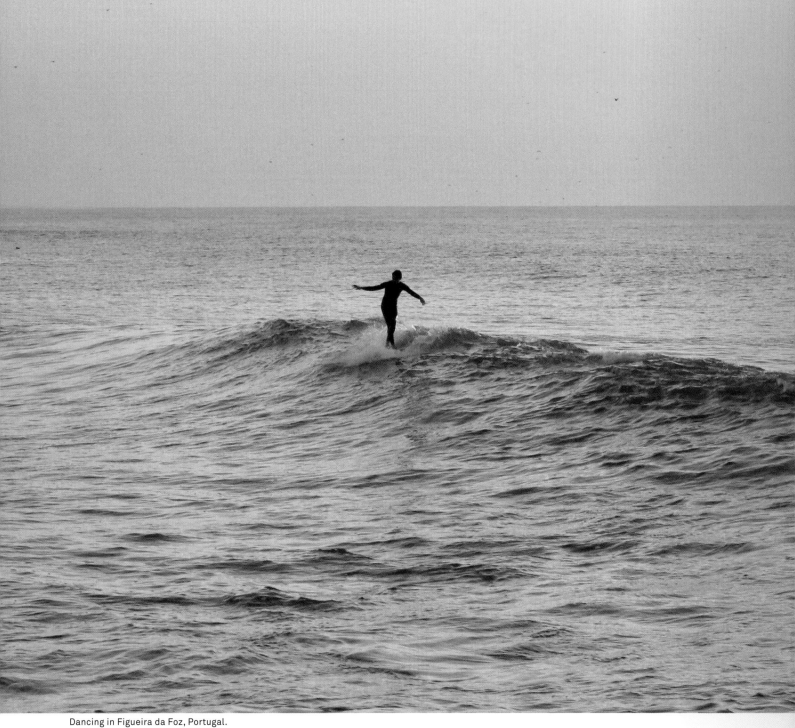
Dancing in Figueira da Foz, Portugal.

Mario in the shop.

A homemade shelter for family days on the beach.

Hand-shaped surfboards at the store.

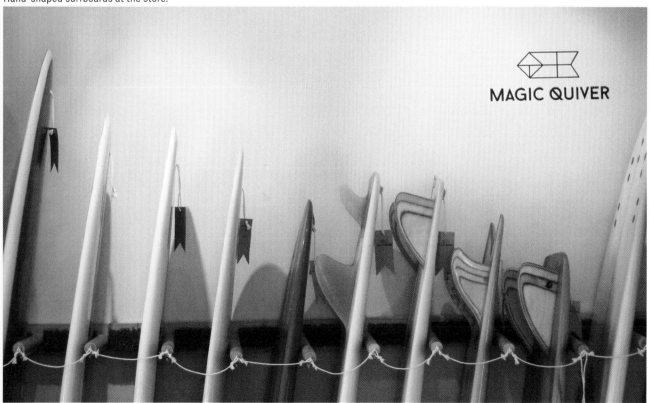

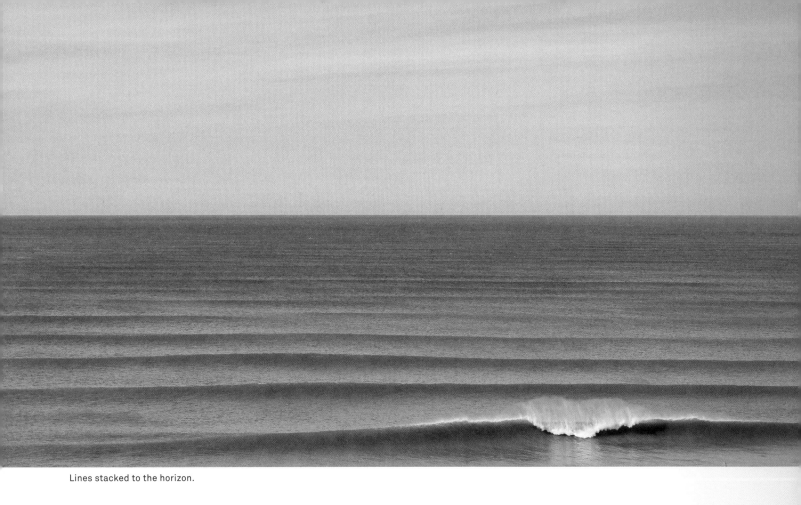

Lines stacked to the horizon.

The Magic Quiver's first "surf shack" (called the Swallow's Nest)
houses mementos from surf trips across the globe.

Refurbished theater chairs sit in wait at
another of the company's surf shacks.

Making Art of Adventure

Photographer James Bowden has stories to tell — and the images to prove it

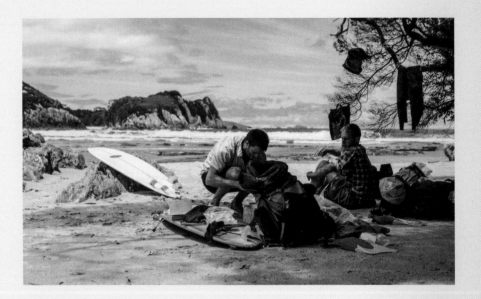

— James Bowden is unashamedly an adventurer. With each of his photo projects, he details an explorative, intrepid attitude with which he treats the work and its subject matter.

From first learning how to surf on the southwest coast of Great Britain, James's love of the sport informed his need to travel. As he traveled more and more – in search of different oceans and new waves – he began to document his journeys. As surfing took him to very photogenic locations, what began as innocent enjoyment became a legitimate career.

However, instead of being part of a focused career path, James presents his transition to "professional photographer" as an effortless progression, something that occurred by chance. With every new journey, there was more to show friends and family, more to document and more tales to tell. James chose to retell these stories on film. The photography that finds its way onto his online journal, Latitudinal Tales, shows the stark presence of natural surroundings within his work. Although much of James's work is, essentially, portraiture, the human subjects are never given precedence over their natural surroundings. By stepping back from his subjects (who often have their backs to the camera), James allows their environment to encompass them, a choice that creates a humbling perspective for the viewer.

The environment frames and encapsulates the people standing in it. Such humility within the presence of barren beaches and raw surroundings is a common trope in surf photography. But by using the surf as a landscape backdrop for portraiture, James's subjects are also made to experience the ocean's imposing presence in each photograph. ●

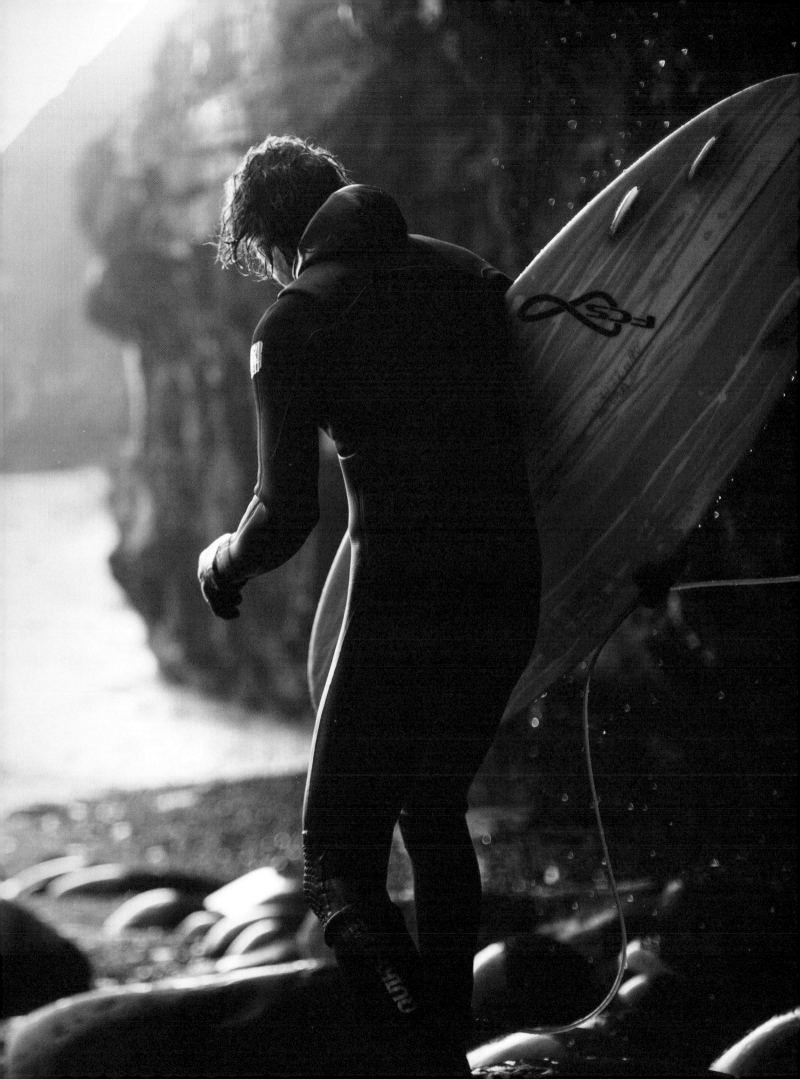

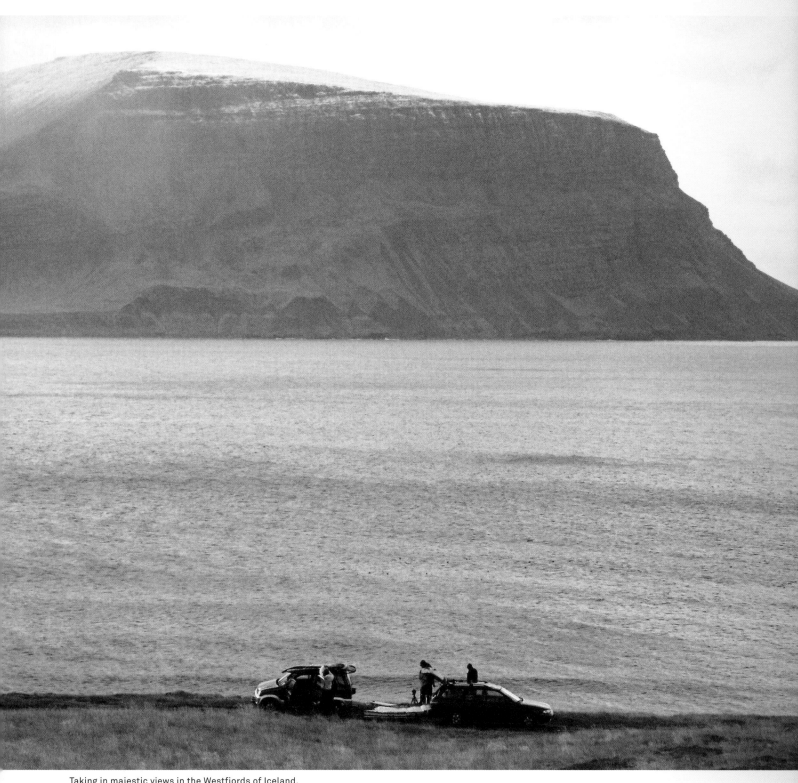

Taking in majestic views in the Westfjords of Iceland.

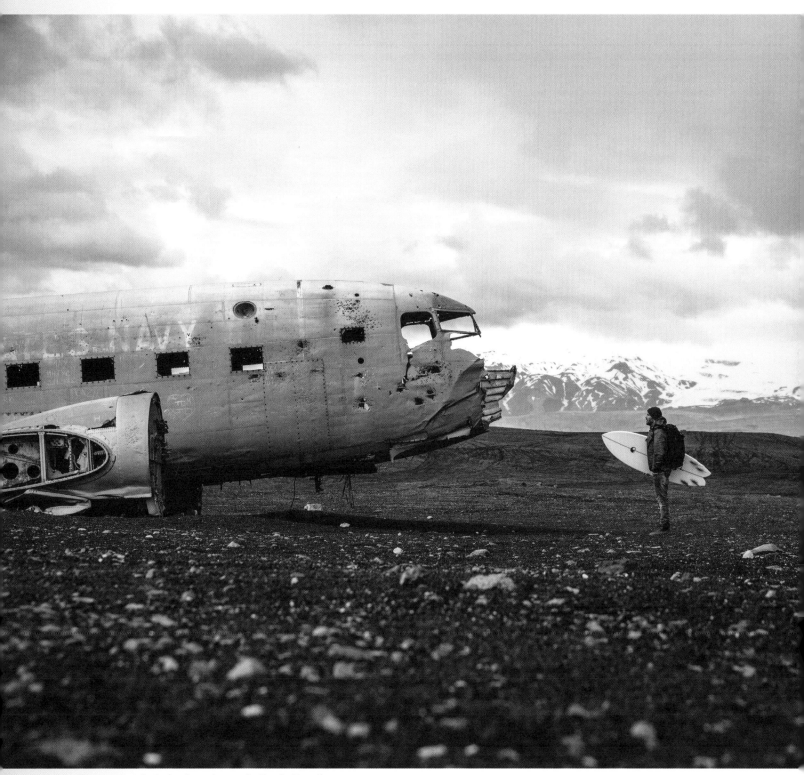

Documenting the Icelandic surf scene for Easyjet Traveller.

Making Adventure Accessible

A Sumatra surf camp offers a one-of-a-kind thrill to all

— Among the frequently asked questions posed by prospective visitors to Bonosurf – a camp in Sumatra for those looking to surf one of the world's most famous tidal bores – is one having to do with the region's abundance of crocodiles, snakes and mosquitoes. The answer, courtesy of the camp's founder and *World Stormrider Guide* author Antony "Yep" Colas, is to-the-point: There's a chance you may encounter one or all of these things, but you came in search of real adventure, didn't you? Long known to be one of the planet's most dauntless surfers, Antony first happened upon the Bono, as it's called, in 2010. Since then, the bore – an example of a natural phenomenon in which ocean tides create large waves that travel up rivers, against the current – has become prized among surf fans and professional wave-riders alike for its accessibility and its see-it-to-believe-it power. (The name "bono" translates to "it's true," a nod to the bore's almost inconceivable virtues – including the fact that the wave can travel up to 50 kilometers.) Now, thanks to an organization Antony calls Bonosurf, anyone interested in experiencing the thrill of the Bono can sign up to visit the Kampar River as part of an expertly organized trip that accommodation, food, boat rental and more. Run-ins with local wildlife – welcomed or not – aren't guaranteed, but the company promises participants once-in-a-lifetime excitement: "No doubt, whatever your skill [level] is," Antony writes, "you will catch the longest rides of your life." For those interested in specifics: As of 2016, the world record-setting ride was achieved by Australian surfer James Cotton, who traveled just under 17 kilometers. ●

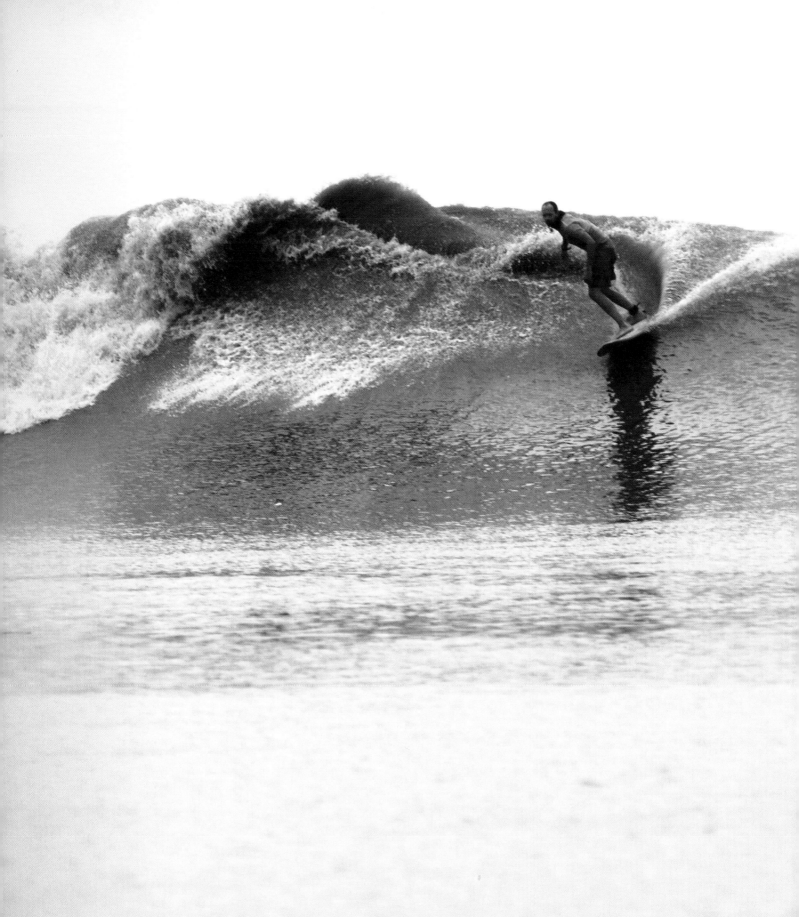

David Badalec surfing the Bono wave.

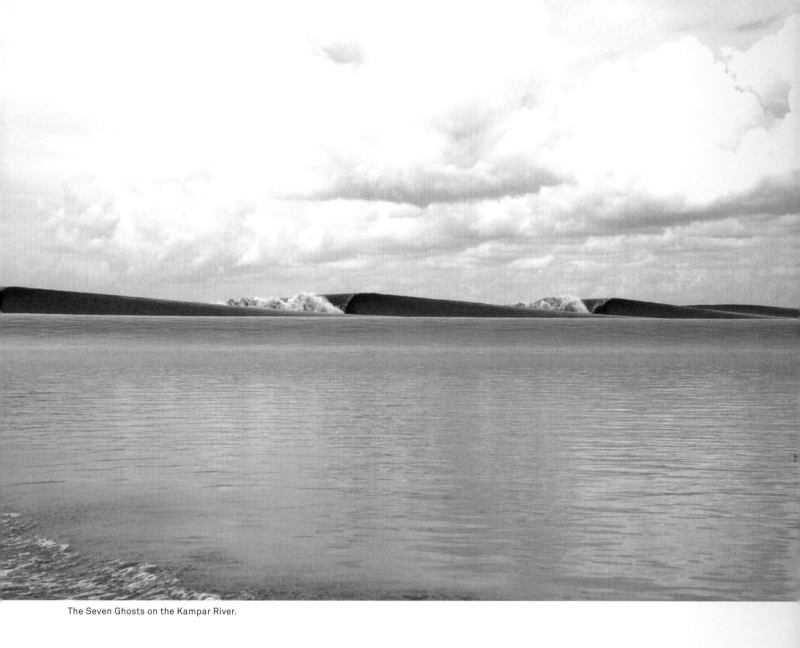

The Seven Ghosts on the Kampar River.

"Some snakes actually grow longer
than crocs – but they don't bite as hard."

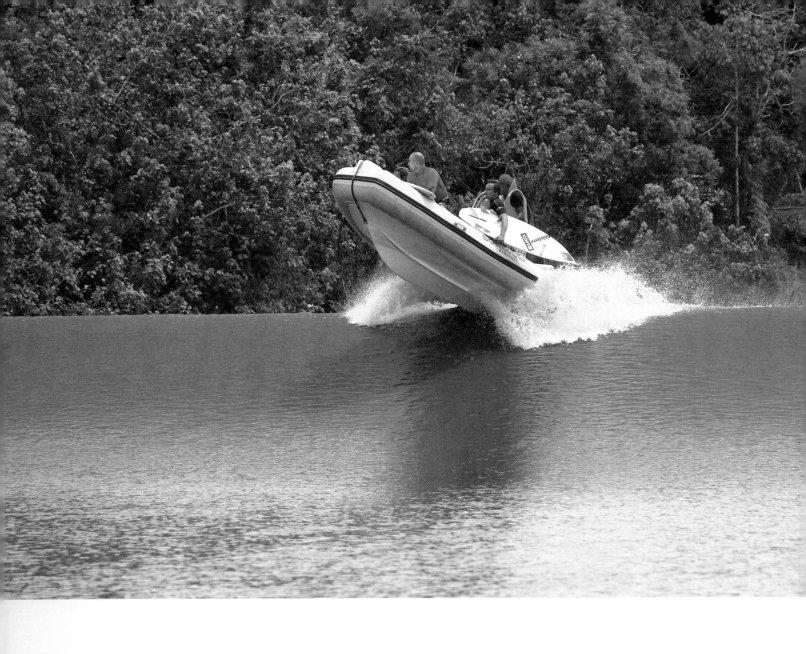

Bore riding: a true team sport.

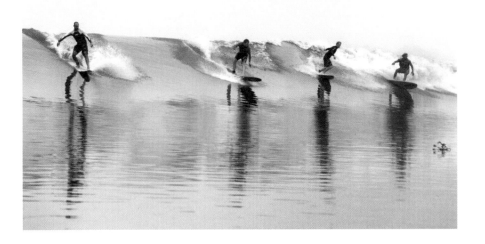

Styling a Sustainable Fin

Luise Grossmann designs sustainable surfboards using recycled plastic from Balinese beaches

— Environmental awareness comes easily when you spend your days steeped in the elements. For some time now, surfers have been seeking out ways to acknowledge the sport's dependency on nature – and the ways in which they can work to protect it. This is what Luise Grossmann, director of ecoFin and FiveOceans, set out to do. EcoFin has seen Luise and her co-founder, Felix Wunner, create the first sustainable surfboard fin made from recycled plastic scooped up on the beaches of Bali.

Luise explains that by incorporating sustainability into a surfboard, ecoFin products speak for themselves. "When exposed to the products, the consumer is automatically exposed to the issue of ocean pollution and is encouraged to change his or her own behavior," she says. Being immersed in nature herself was where Luise began to concern herself with the preservation of it, and she still thinks surfing can be used to understand our environment. "Part of surfing is riding a wave. Riding a wave means to understand, read and feel the wave. This implies respect for it. Or, stated differently, if you don't have respect – well, you will definitely suffer."

EcoFin is trying to be a part of the solution to a problem that Luise has witnessed worsen after 10 years on the ocean. Living in La Réunion, she sees how overfishing, pollution and climate change can "bring those oceans to their knees." As surfers continue to depend on the health of the ocean and the earth's weather patterns, Luise is hard at work, trying to preserve the experience for future generations in search of the perfect wave. ●

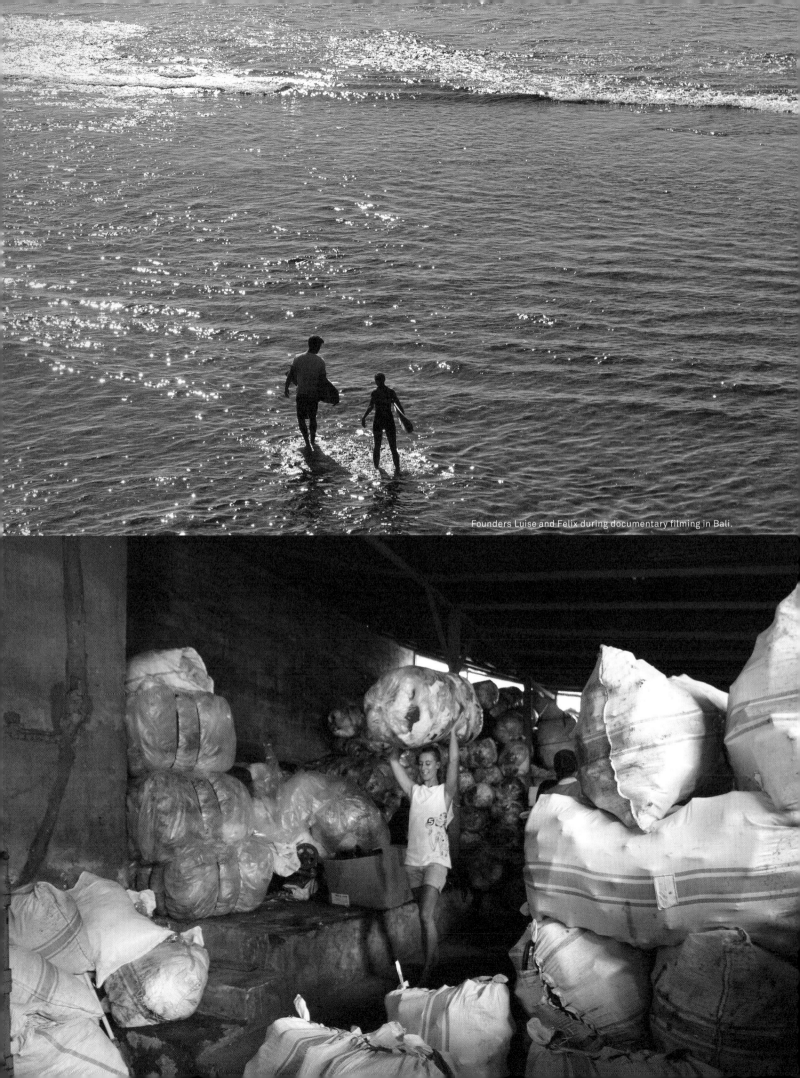

Founders Luise and Felix during documentary filming in Bali.

Behind the scenes with ecoFin's recycling partner.

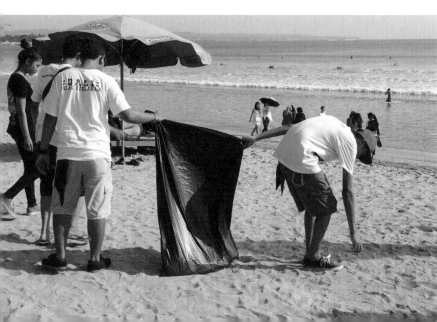

A collaborative beach clean-up in full force.

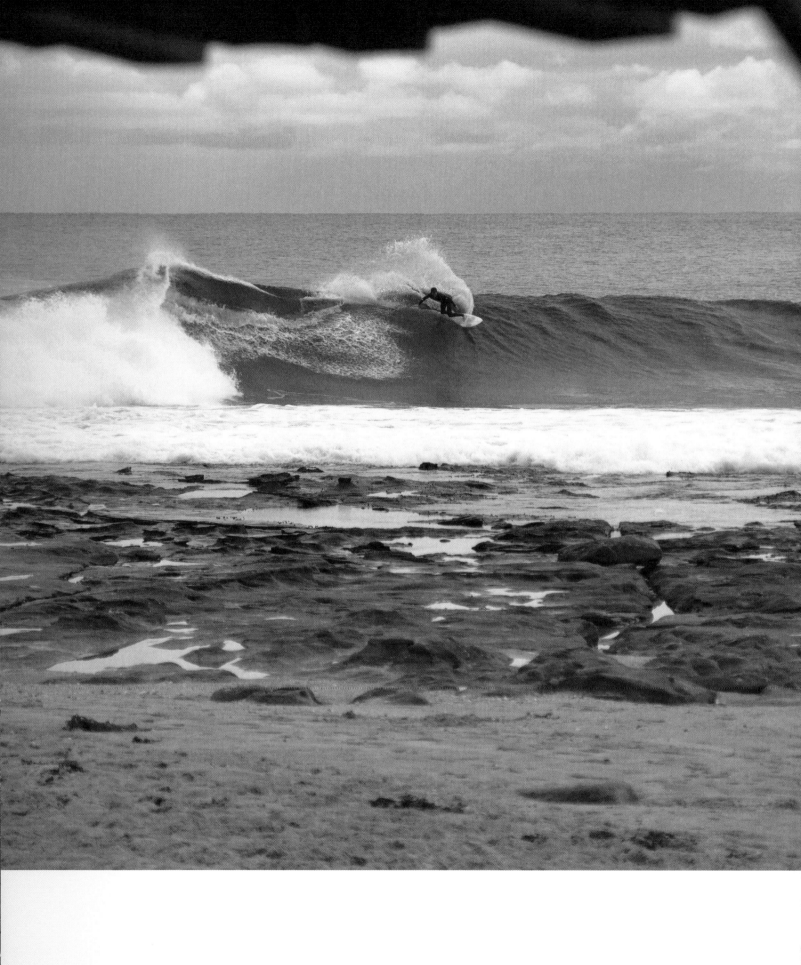

Surfing the City

Unlikely surf spot The Eisbach turns Munich into a river surfer's mecca

— A few meters of moderate incline, two ramps made of wood, some rocks and two riverbanks to stand and wait on – this is the setup of the famous Eisbach river wave. Water flowing over wave-shaped rocks tweaked with two wooden ramps built and installed by local surfers; a wave deemed stationary, and easily mistaken as an inexhaustible machine to practice tricks on. However, the Eisbach break is anything but a consistent apparatus and defies the notion of "artificial" waves found in surfing simulation environments. Its production of waves is seminatural and mostly a result of an engineering error occurring further up the river.

Right in the middle of Munich, the Eisbach has elevated the city to Mecca-status for river surfers who have been flocking here since the 70s. Wetsuit-clad devotees wait for their turn on the banks, usually joined by an audience curious about the unlikely surf spot and the world-class athletes who tame its waves. Different to ocean waves, Eisbach's swells are comparably dynamic yet contained in a much smaller area, an enticing and adrenaline-pumping attribute in itself.

Even though this surf break is paradoxically located in an urban setting, the surfers still recognize its connection to surrounding nature and the waves' origins. "For most of the surfing world, the intensity of swells building out in the ocean defines the quality of surf hitting the shores. For us in Munich, it is about the mountains, the amount of water they collect and how much of it is channeled through Munich," says Quirin Rohleder, one of the river's surfing veterans. ●

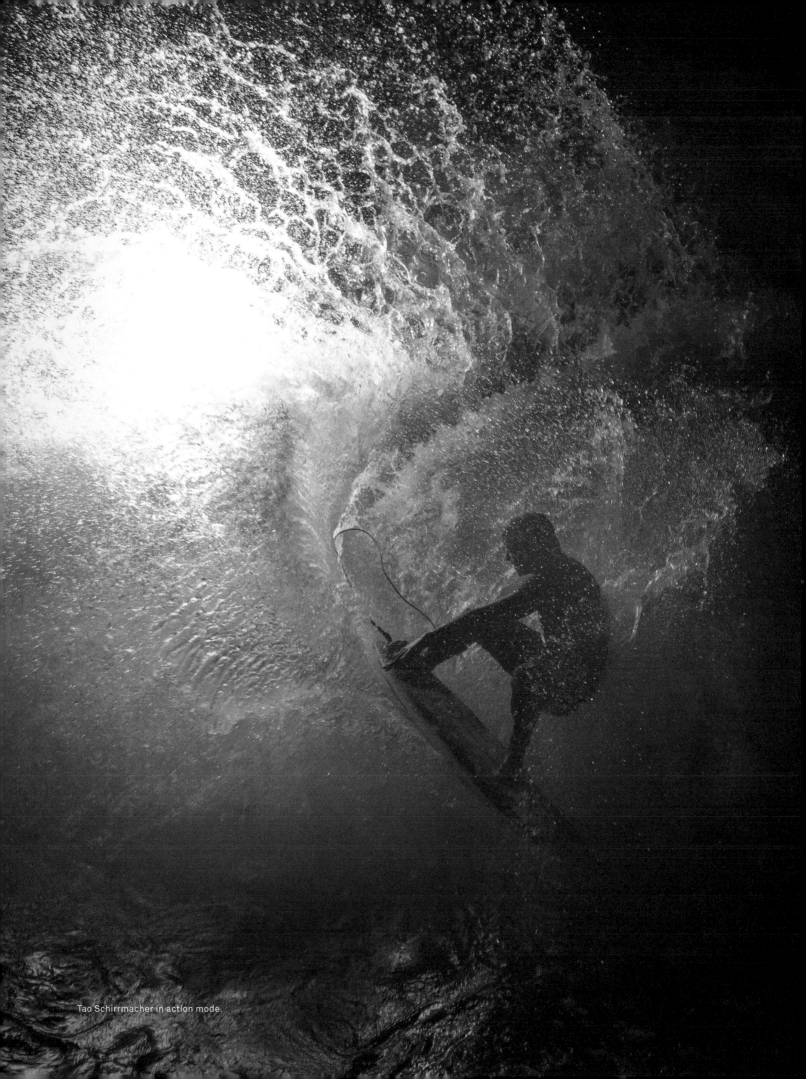

Tao Schirrmacher in action mode.

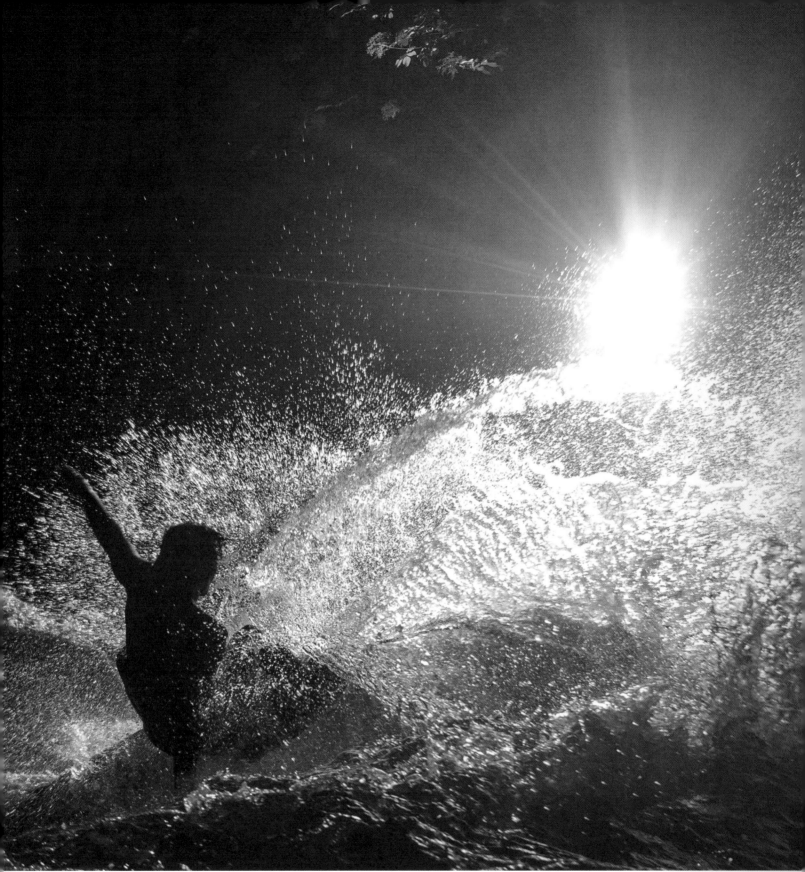

Tao in the spray.

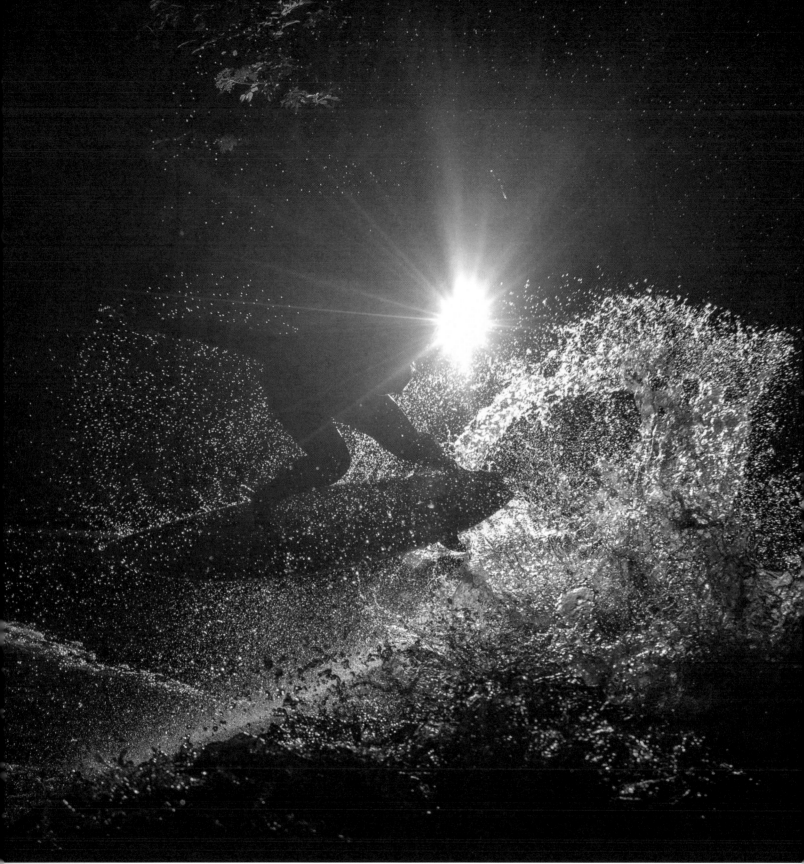

Air time by Quirin Rohleder, a famous veteran of the Eisbach wave.

Thinking Beyond

A groundbreaking documentary explores West Africa's lesser known surfing locations

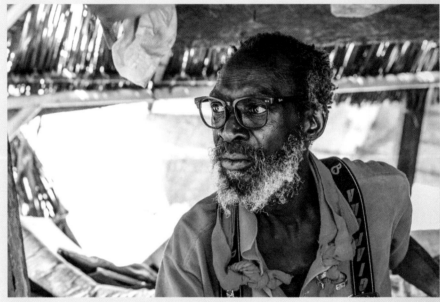

A Dakar man, who, the film crew learned, lives in a makeshift home constructed of materials washed ashore at the beach.

— "Africa, despite its size, still remains a mystery to many. It seems that a faint barrier prevents us from establishing a close connection with this giant continent and its abundance of cultures. It feels like as if it lies in the past, not in the present," writes Mario Hainzl, the director of *Beyond*, a film exploring West Africa's lesser-known surfing locations. The documentary chronicles a three-month-long journey through Morocco, Mauritania, Senegal and Gambia, celebrating unadulterated regions that few have experienced. With surfing as its protagonist, the film weaves a beautiful path, unraveling Africa's arena of empty swells and magical wave spots while introducing viewers to a range of cultures and unparalleled landscapes. Mario, who made his directorial debut with the award-winning film *The Old, the Young & the Sea*, believes lineups are getting more and more crowded simply because the majority of surfers haven't really dared to travel beyond well-known destinations. Watching *Beyond* does what few surf films have accomplished in the past: The evocative storytelling awakens a strong desire for adventure and a sense of wanderlust, whether you're a surfer or not. ●

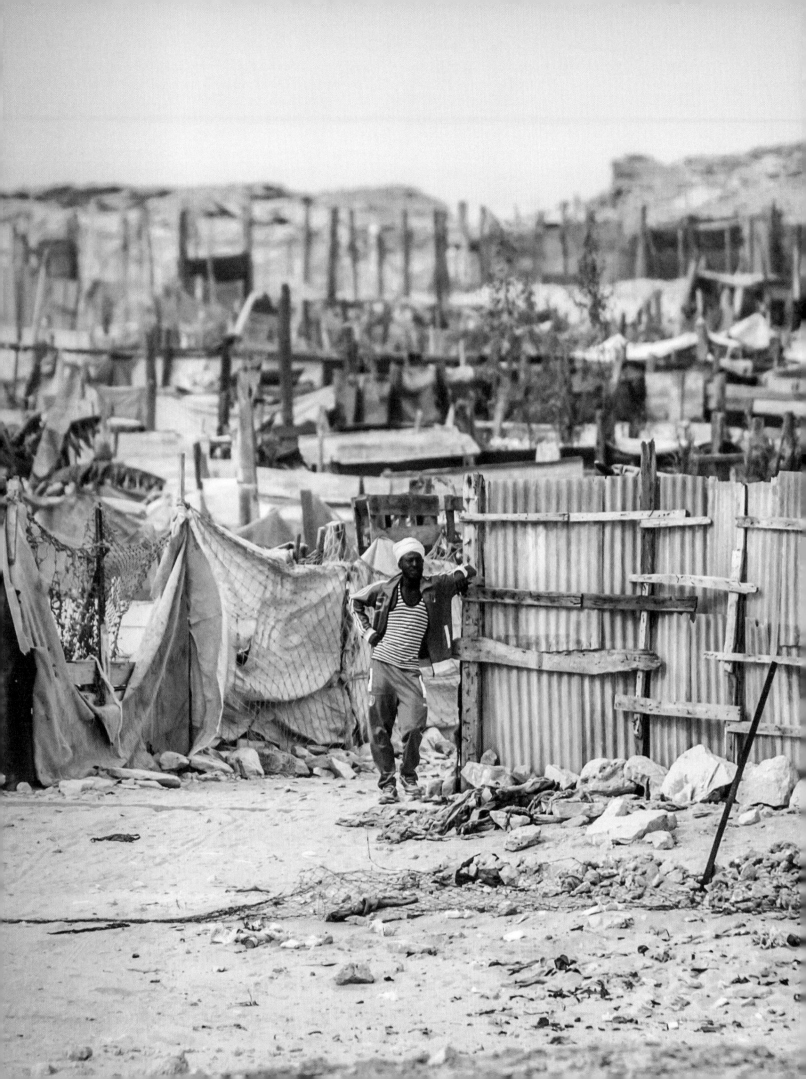

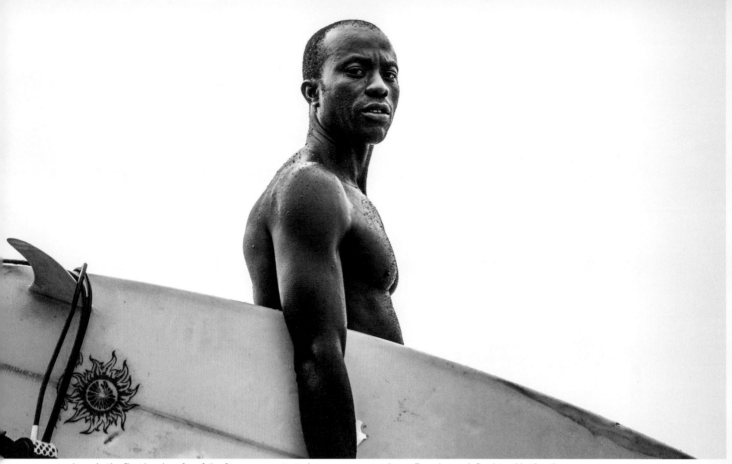

Joseph, the first local surfer of the Casamance, started some years ago when a French man left a board in the sleepy town. Now, some years later, Joseph has started a surf school and dreams of making a living on surfing alone.

Cherif, currently considered the most talented surfer in Senegal.

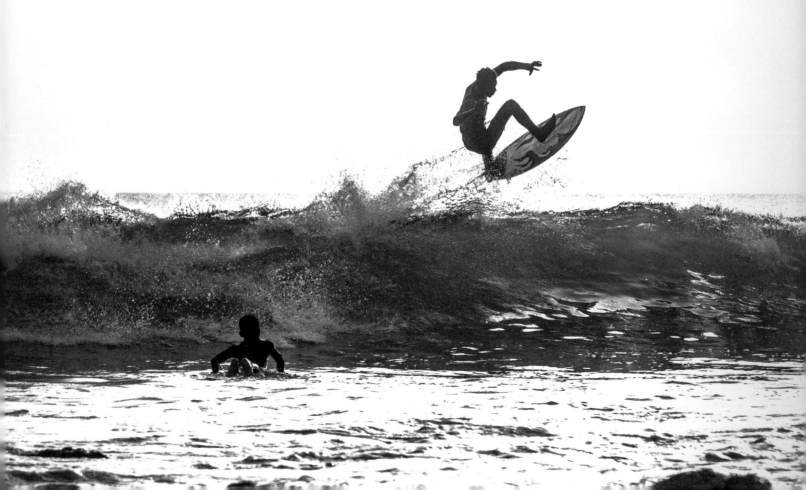

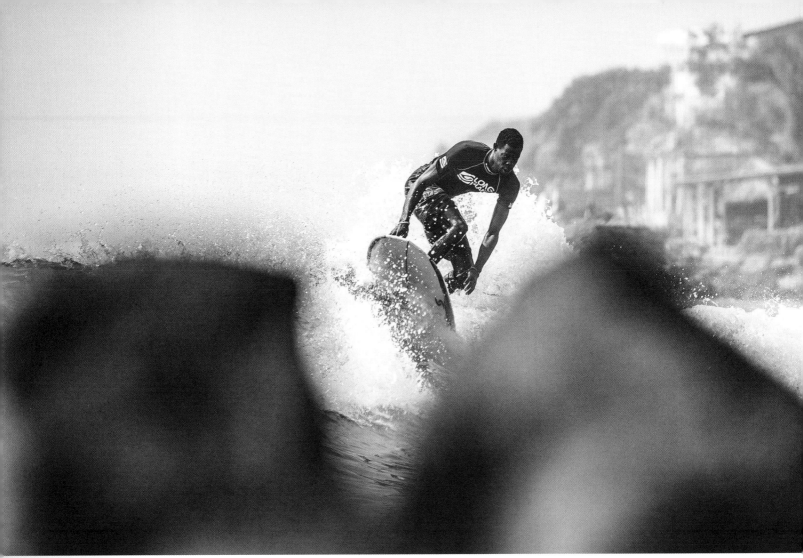

Dakkar Local Kouka shreding.

Children test camera gear. "Every place we stopped, we potentially also left a seed," says Mario. "Who knows, maybe one will become a photographer tomorrow."

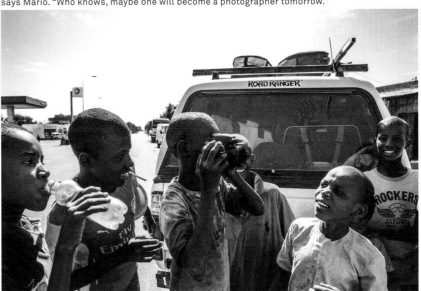

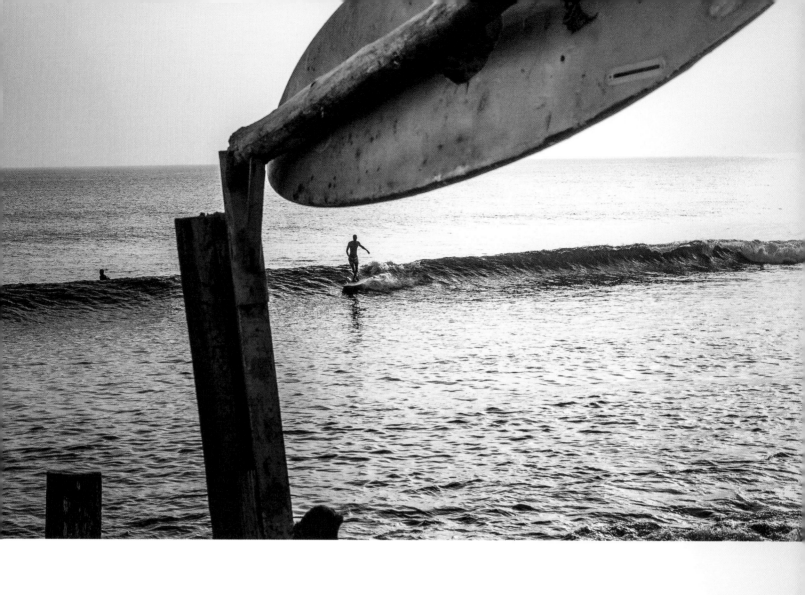

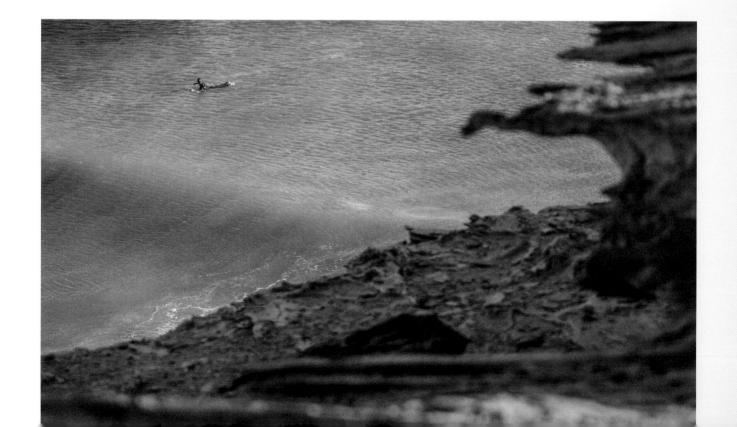

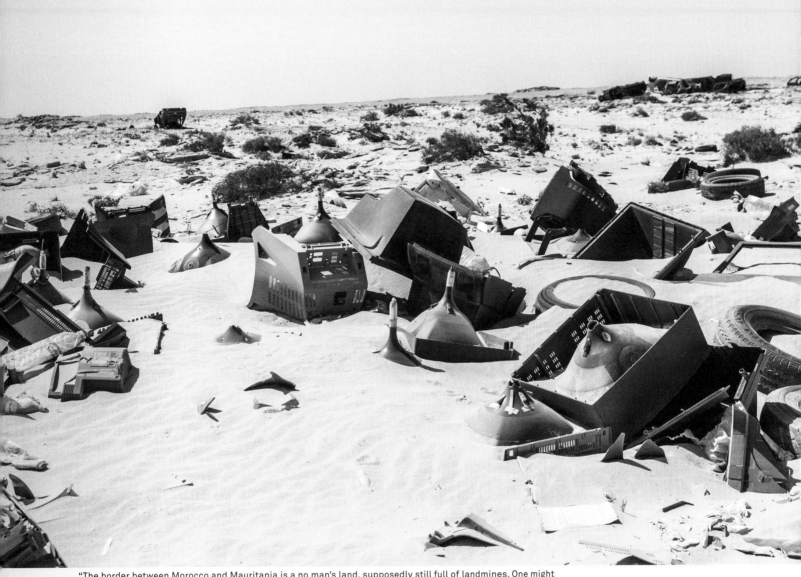

"The border between Morocco and Mauritania is a no man's land, supposedly still full of landmines. One might wonder if there aren't easier places to get rid of the old TV sets—or what other story these broken objects may tell."

Bridging Sport, Art and the Street

Christian Hundertmark may be at the helm of a world-renowned design studio, but his long-standing love of sport endures

Walking back to the "line up" queue at the Eisbach wave.

— With a background in surfing, BMX riding and street art, Munich-based Christian Hundertmark – who opened his multidisciplinary design studio, C100, in 2003 – has proven himself to be something of a creative powerhouse. Since its launch, his company has counted Oakley, Forum & Rome Snowboards and Prada among its diverse clientele, applying "inventive and precise visual solutions" to a wide assortment of artistic endeavors.

Among its most talked-about projects is the internationally acclaimed book series *The Art of Re-bellion*, which shed light on the world of street art – a subject to which Christian, whose own graffiti work debuted in 1989, was able to bring an insider's perspective. More recently, his firm was responsible for the creative direction and chief editorial vision behind *A Bigger Park*, a magazine focused on the intersectionality of surfing, skating, snowboarding, BMX and the arts. The project was nominated for the German Design Award 2016.

Although his achievements in design may take center stage these days, fans who follow Christian on social media know that his athletic passions endure. On his Instagram, there's a photo of the designer pre-tending to surf a painted concrete "barrel" in the streets of Vienna. Another of a cherry red surfboard leaning against a wall in his C100 office – and yet another propped in what appears to be a metro station, ready to brave a rigid night surf at the Eisbach wave. Then, there's his daughter Maya proudly navigating a sea of dirt hills, alongside a pint-sized bicycle. And, tellingly, a wet-suit with the caption "Lunchbreak surf session," a shot that proves that nothing – not the demands of a hectic work schedule, or the December cold – and keep him still for long. ●

A recent work features blue and turquoise tones inspired by a passion for the sea.

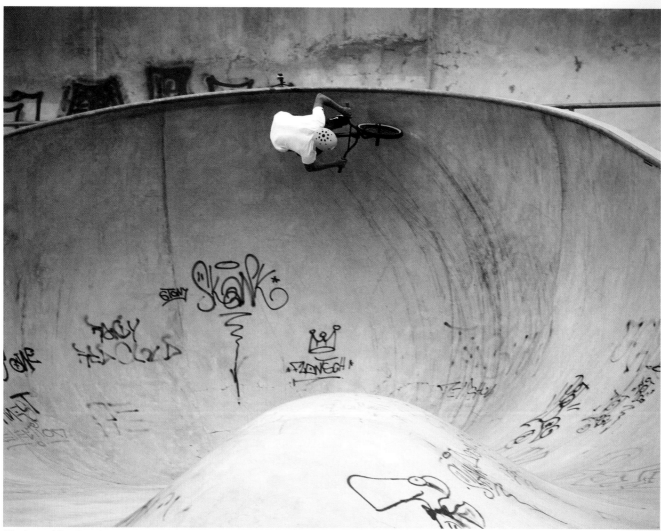

"I've been riding BMX for over 30 years, but have enjoyed it the most since I started riding pools,"
Christian says. "The feeling of doing big carves at full speed gives you a similar feeling to riding a wave."

On the Eisbach river wave.

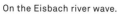

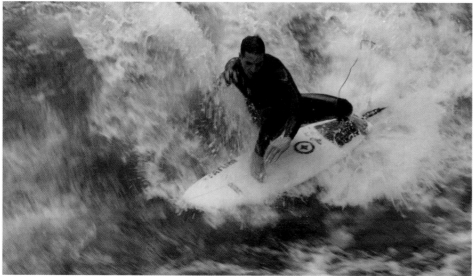

As the collective "Layer Cake" Christian also paints together with his "Graffiti buddy" Patrick Hartl, who is one of the Calligraffiti ambassadors. In their paintings they turn one of the most important rules in Graffiti of not going-over some one else's work upside down.

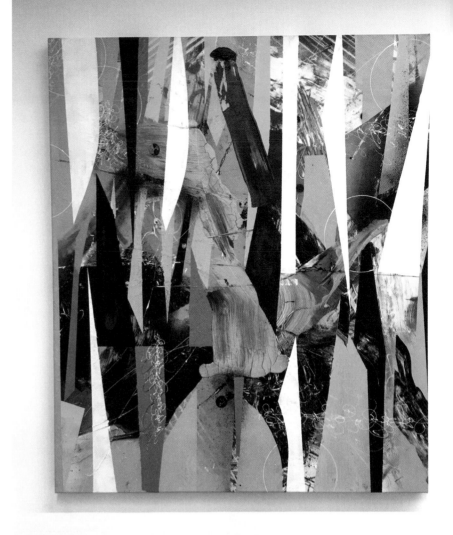

His custom painted Mighty Otter surfboard.

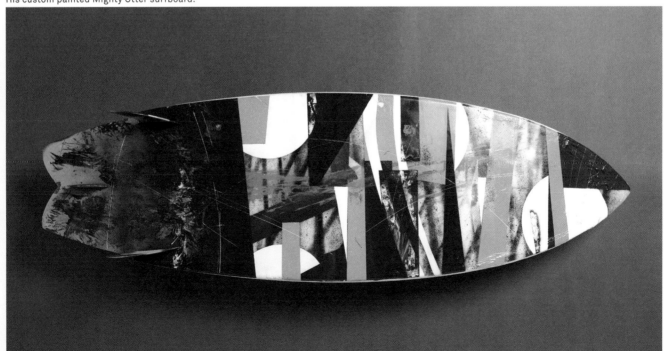

Creating a New Reality

A Slovenian photographer documents the sublime relationship between surfer and the sea

— Coming from Slovenia, an almost landlocked European country with only 45 kilometers of coastline along the Adriatic Sea, surfing seemed a strange hobby for Primoz Zorko to have taken up. While he idolized the sport from an early age, Primoz never imagined that pursuing it could ever be an option for him.

It was only when he was in his first year of university that he got onto a surfboard, having met someone during a snowboarding competition in one of Slovenia's first snowparks. They were promoting a summer school in France, and as the seasons warmed up, Primoz found himself in País Vasco, finally experiencing the sport he had always dreamed of. Recalling that first experience, he says, "To me, it was like a dream, something so special it almost can't be real."

Documenting his surf experiences has become a big part of Primoz's enjoyment of the sport. And though he's begun a career in graphic design, Primoz is slowly building up his photography portfolio in order to make a transition to professional photographer.

Primoz avoids the common trope into which surf photographers sometimes fall – that by photographing nature, they are somehow documenting reality. Instead, he enjoys interpreting the scene in front of his lens: "I like to create my own reality through my photos," he says.

The constructed reality that Primoz develops in his photography stands in stark contrast to his experience on the surfboard, saying, "I don't think you can get much closer to the brutal power and greatness of ocean as you can in surfing." Primoz is attracted to the pure connection that surfing permits participants to have with nature, but he interprets that reality in his own way, through the photographs he takes. ●

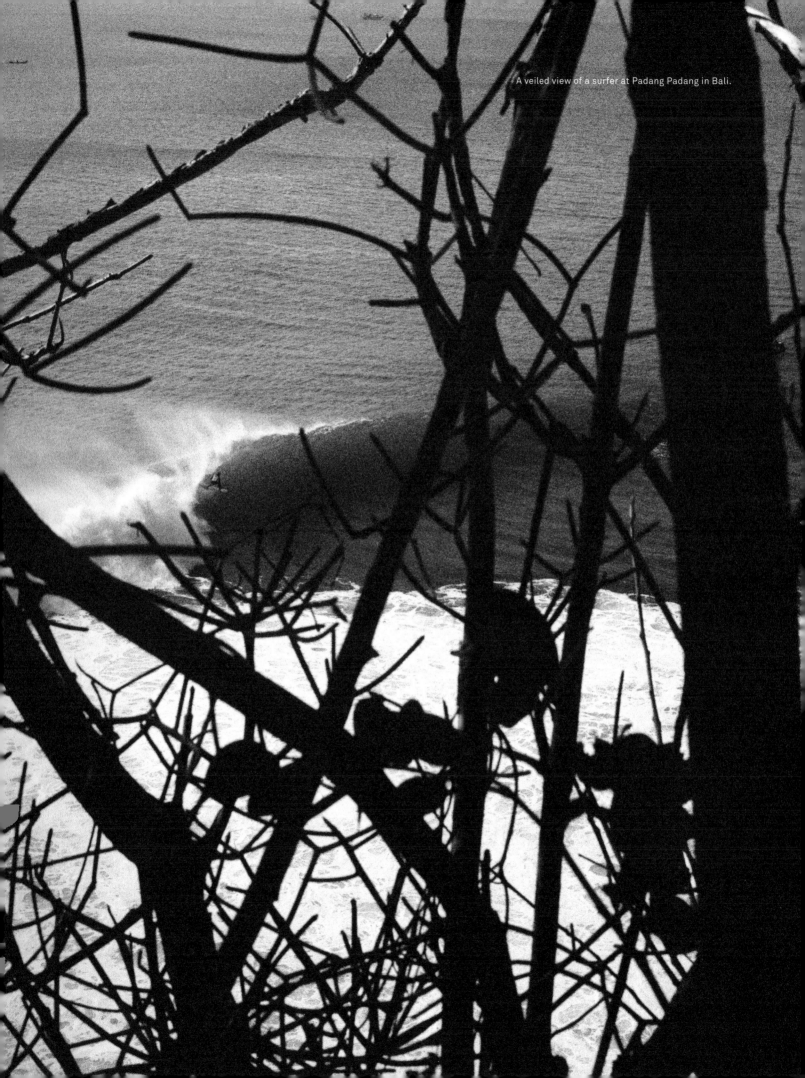

A veiled view of a surfer at Padang Padang in Bali.

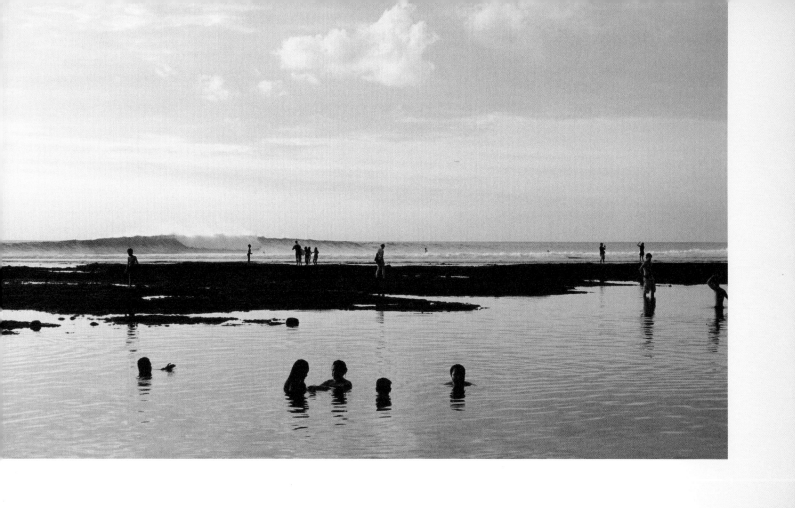

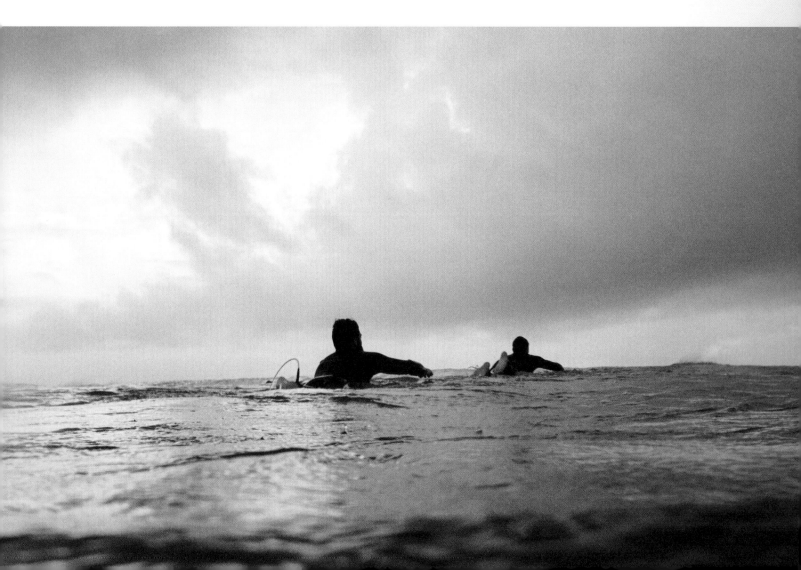

A deserted board on the east coast of Barbados.

"Maybe not as planned," Primoz says of a flying local at one of the sharp reefs of Bukit Peninsula.

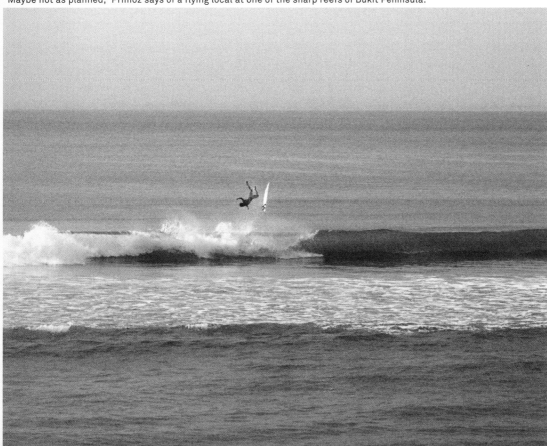

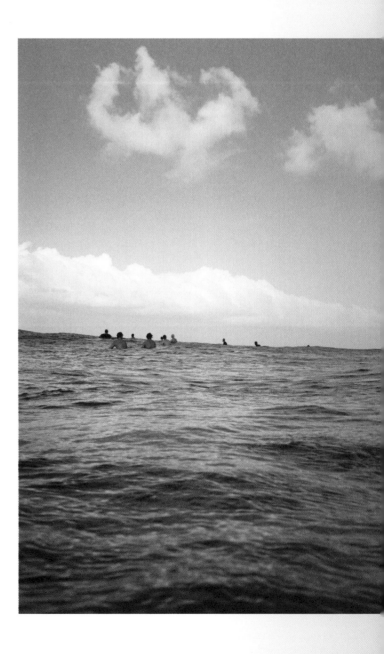

Sculpting from Scraps

Based in Santo Isidoro, Portugal, Skeleton Sea aims to transform trash into beach-friendly works of art

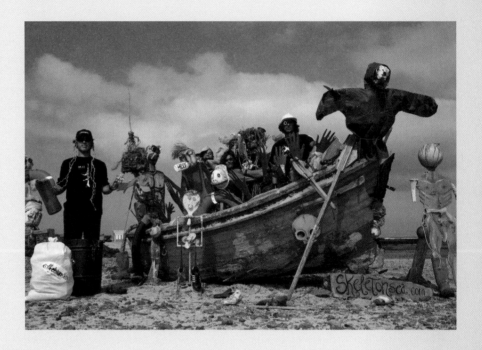

—— While on a surf trip on Portugal's remote Azores Island in 2005, João Parrinha and Xandi Kreuzeder were expecting to find pristine beaches and swells – but what they found instead was something absolutely shocking. Hiking to a secret surf spot on the island, the pair found a colorful, six-meter border between the water and the shore, made entirely of plastic trash. "This contrast was weird, and we realized how immense the plastic and marine pollution already is," says Xandi. They returned from the trip with the inspiration to create a new project, Skeleton Sea.

Already a sculptor for some years, Xandi began to create sculptures using debris that washes up on sea shores. Skeleton Sea has produced pieces using plastic trash, driftwood, cans of tuna, washed up iron and more. "Every sculpture has an individual message to raise awareness for ocean pollution, marine disasters and overfishing to extinction. The inspiration comes from the pieces we find during the beach clean ups."

The works are striking, transforming trash into works of art that have a direct, positive impact on the beaches they collect materials from. The pair are now based in Santo Isidoro, Portugal where they continue to surf and sculpt, hoping to clean up the ocean one piece of art at a time. ●

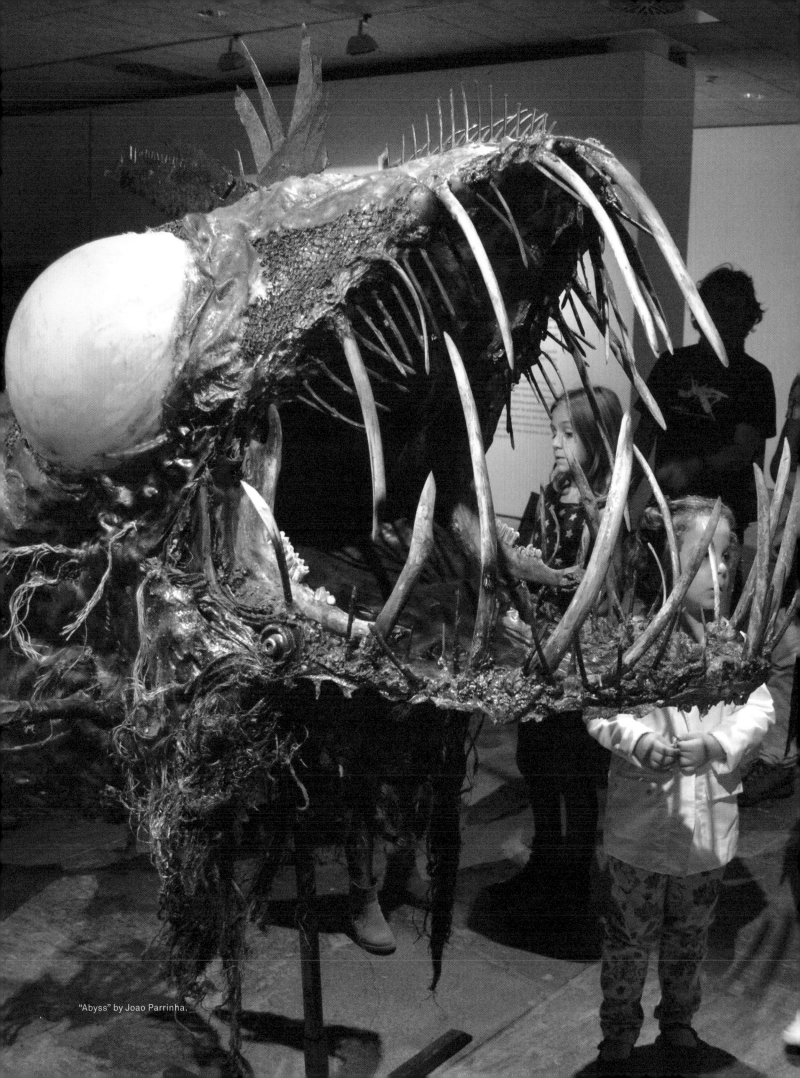

"Abyss" by Joao Parrinha.



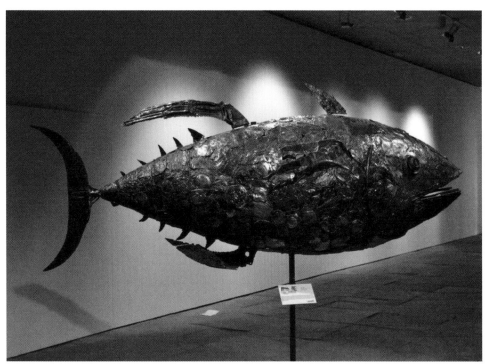

"Last Tuna" by Xandi Kreuzeder and João Parrinha.

"Miss Flip Flop" by Xandi Kreuzeder and Luis de Dios.

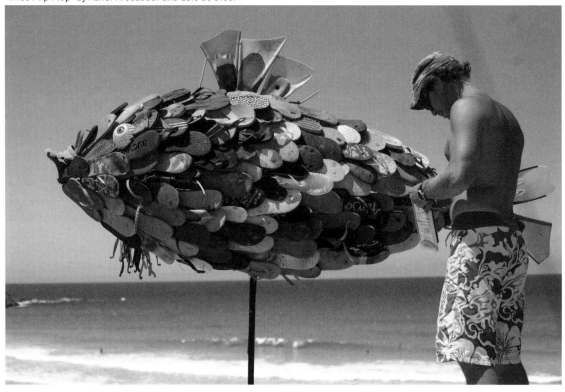

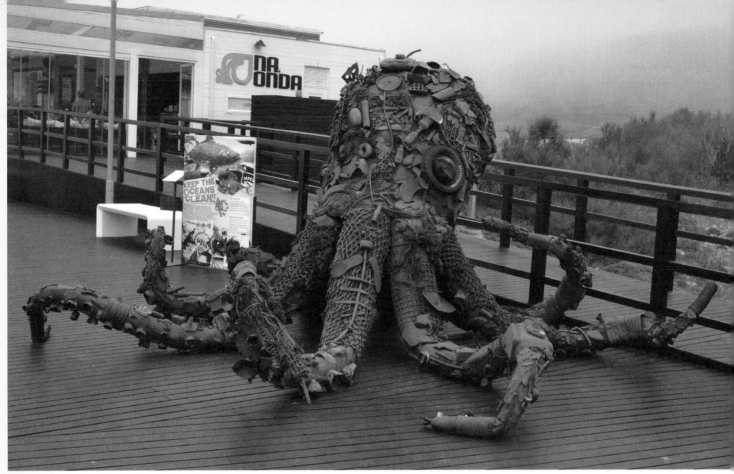

"Polvo Azul" by Xandi Kreuzeder and Joao Parrinha.

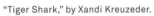

"Tiger Shark," by Xandi Kreuzeder.

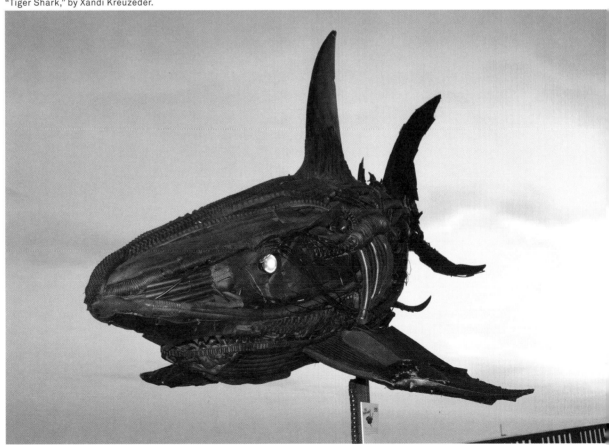

Building a Brotherly Bond

Two Argentinean brothers travel 30,000 kilometers along the American Pacific Coastline; the documentary *Gauchos del Mar* tells their story

—— There are many ways to bond with a sibling, but none quite as creative, productive and extended as the trip which took Argentinian brothers Julian and Joaquin Azulay along the American Pacific Coastline, to film, explore and – of course – surf through their experiences.

Nicknaming themselves "Gauchos del Mar," the Azulay brothers embarked on an epic journey that allowed them to create in an environment that promoted simplicity and non-consumerism. Julian and Joaquin were attracted to the surf towns and local spots that they encountered on their odyssey through 13 countries – not just for the waves they offered, but also for the simple culture of minimal needs. "People share everything they have without waiting for anything to come back... People outside the cities live very happily with their needs and not with the wishes that consumerism puts in their minds," they explain.

As the brothers bonded on their 30,000 kilometer journey, their story caught the interest of journalists and the general public. They recorded their trip in the documentary *Gauchos del Mar*, showing the audience the continent, its culture and, also, the connection they built with each other and with the people they met while on the road. ●

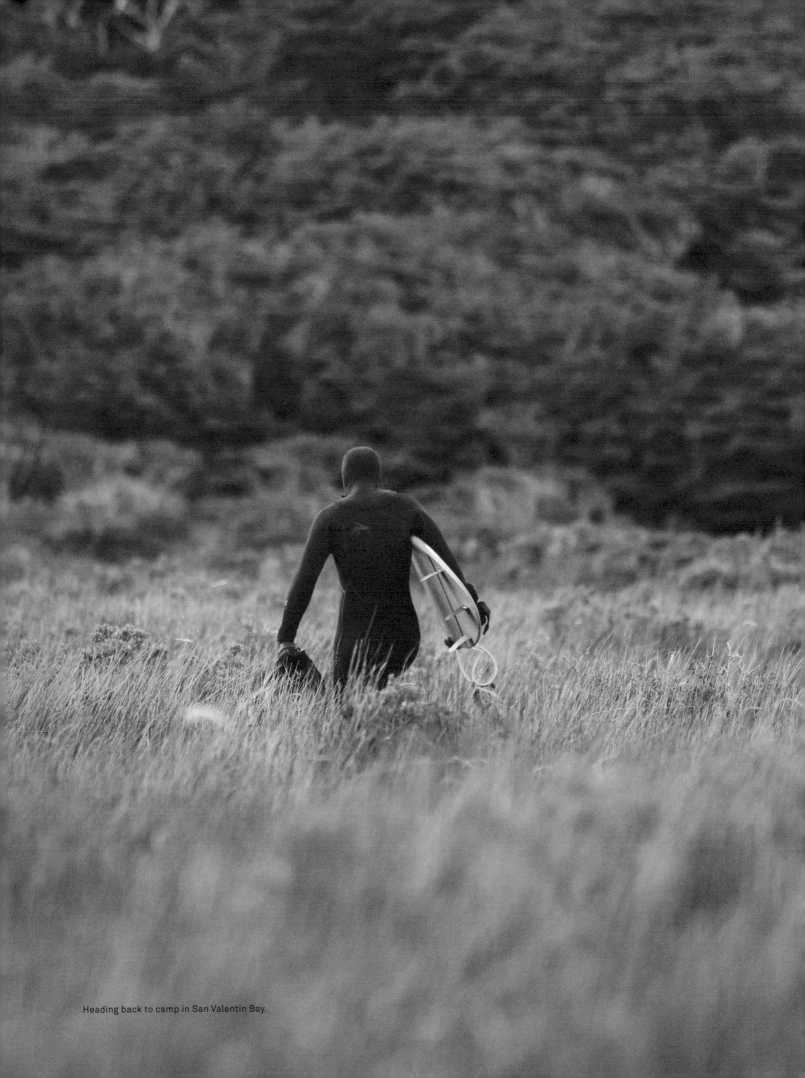

Heading back to camp in San Valentin Bay.

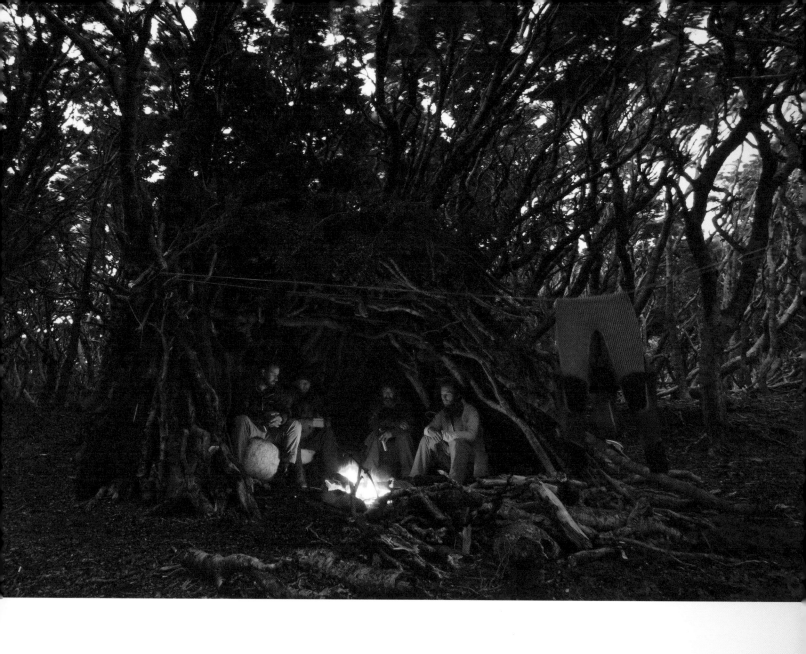

Setting up camp in the desert of Peru.

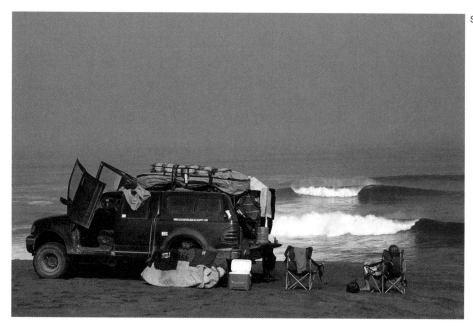

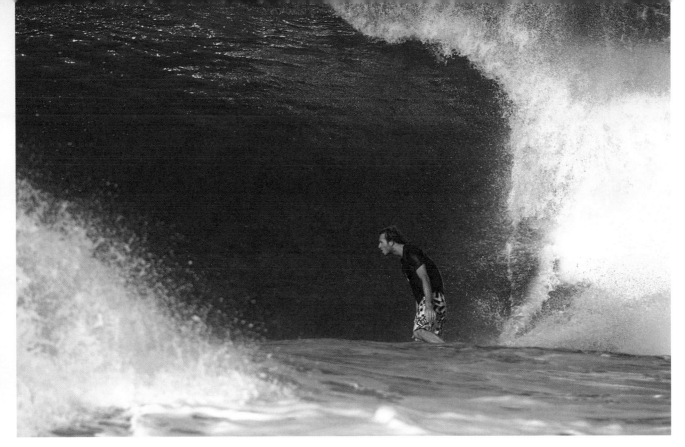

Joaquin standing tall on a wave in Mexico.

"This might have been one of the heaviest walks of the expedition in Peninsula Mitre," the brothers say of a trek that included snowfall, rain, hail, and wind. "But before entering the forest to set up our camping, nature gave us this beautiful present."

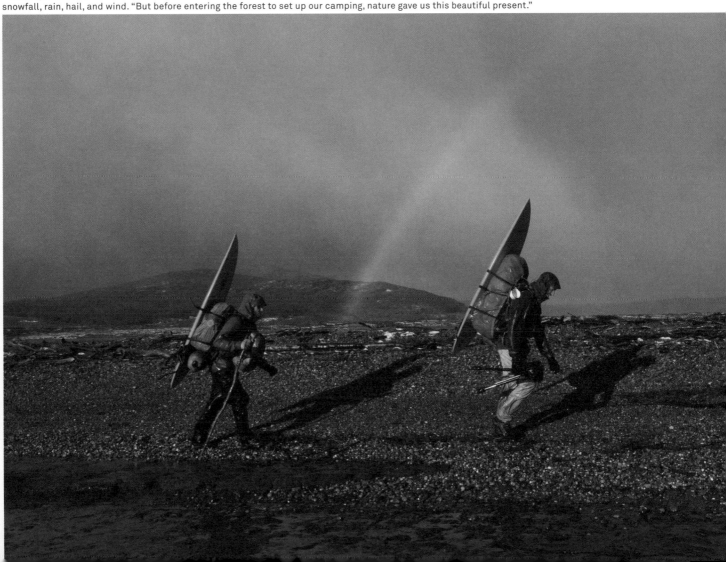

Putting Sun Safety First

Surfer-turned-surgeon Tim Peltz devises a revolutionarysunscreen formulated to stand up to both sun and surf

Tim models classic Byron Bay attire.

—— Surgeon by trade, surfer by passion and the founder of Swox, a surf-proof sunscreen brand, Tim Peltz is a veritable surf Renaissance man. Raised in waveless South Germany, Tim grew up windsurfing, but his curiosity for traditional surf eventually got the best of him. As teenagers, armed with Styrofoam boards pinched from construction sites, Tim and his buddies were among the first to surf the waves of the Eisbach in Munich, where he got his first taste of sail-less surf. On the weekends he'd borrow his mother's car and drive down to Varazze, Italy to catch swells, sleeping on the beach and braving ice cold rain and snow. Soon, his dedication paid off. He qualified for the German surf team, competed in competitions around the world and lived every surfer's dream.

But, Tim set the surf dream aside to finish school, where he studied medicine and went on to become a surgeon, working 70 hours a week or more, and surfing the cold German waves whenever he had the chance. Though the work was rewarding, a tiny voice called him toward warmer weather and the waves. Soon enough, he found himself on a plane to Australia with a job waiting for him and a bright future ahead.

Now thoroughly embedded in the Sydney surf scene, he's created a nice lifestyle for himself that combines a passion for surfing with his background in medicine. His company, Swox – which stands for Sun/Water/OXyge – creates waterproof sunscreen specially formulated to protect the skin – perfect for surfers. For Tim, Swox is more than a business. As a surgeon who has operated on surfers with skin cancer, he knows better than anyone the importance of sun protection. In and out of the water, Tim's mission is all about keeping the sportand those who share his love of it – healthy. ●

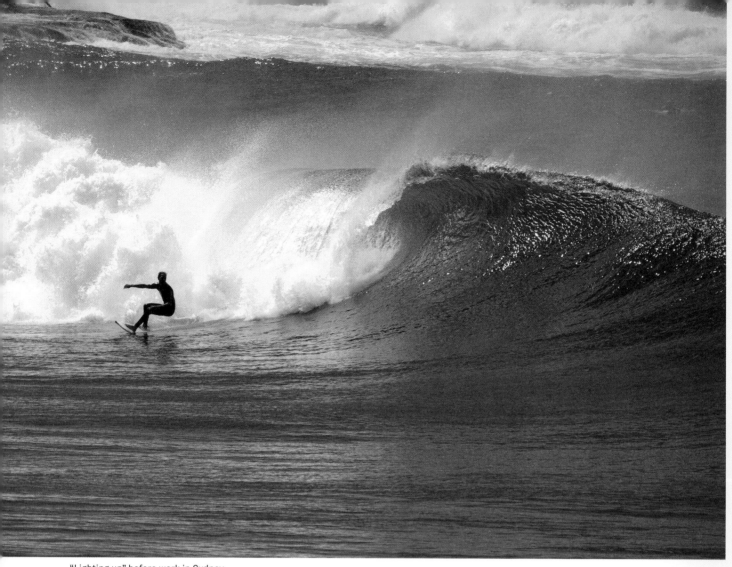

"Lighting up" before work in Sydney.

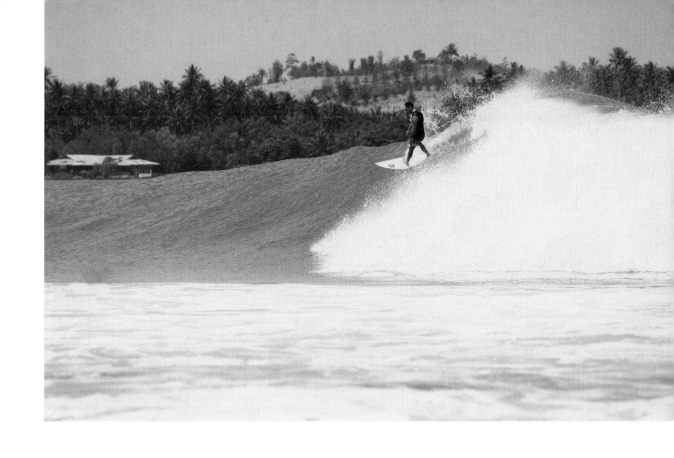

The surgeon enjoying what he calls "Nias perfection."

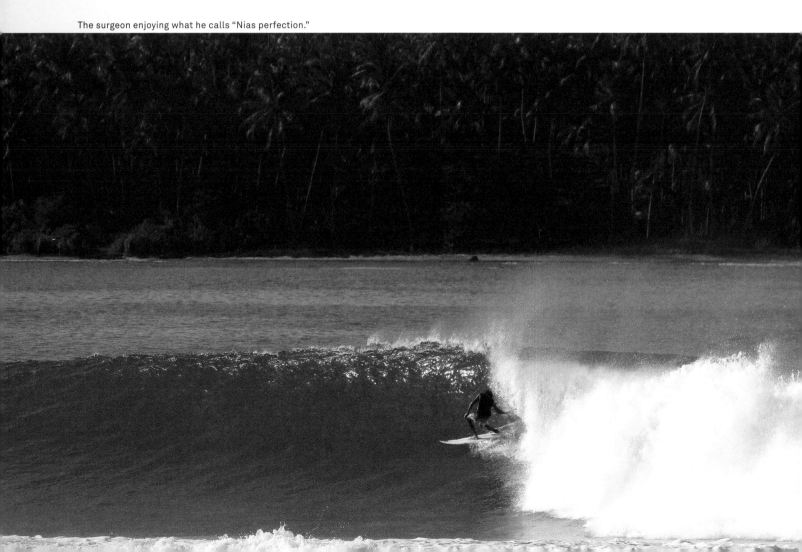

Getting it Bright

Graffiti artist Craig Costello brings bold hits of color to his surroundings – and to the world of surf

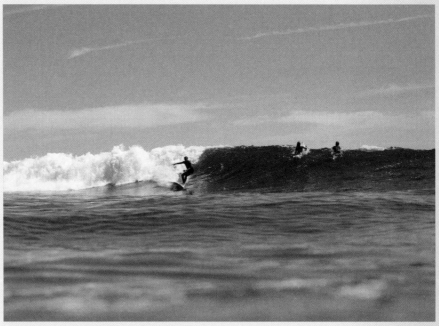

Riding waves "somewhere in the Atlantic."

—— Graffiti artist Craig Costello – the founder of Krink, a graffiti tools supplier that first hit the streets in 1999 —— grew up as a punk in Queens, New York, surrounded by all the concrete tropes that an urban environment has to offer. For this reason, when Craig finally set out on a surfboard, it was a very new adventure.

Skating from an early age has helped Craig see urban landscapes in a different way. New York, for him, is there for exploration, for interpretation. Just as a surfer looks out at the sea and witnesses hundreds of different experiences, this artist and skateboarder looks at the architecture and infrastructure of a city and sees a landscape of moves to be attempted and surfaces to be painted.

Because Craig wants his work to be for the public, he allows us to be witnesses to his creativity. The democratic ideals behind street art have persuaded him to branch out,

into surf style and skating products. "Public art exists in the everyday lives of all people. It's an important experience for all; whether it's seen as good or bad by the viewer, the exposure is what's important." But as large companies recognize the appeal of surf and skate subcultures, Craig notes the value of a continued DIY aesthetic within the communities, which eschews big business.

Krink is known for its unique style, which splashes color onto everyday objects, thus reinventing them. The Krink surfboard is no exception. For Craig, these products are tools for experimentation. Whether spray cans, ink pens or surfboards, he wants those who use his products to explore the opportunities that they can bring. Calling on people to embrace surfing's DIY style, Krink refuse to give you the complete experience, but, rather, they offer you the tools to do the job. ●

Musée Des Abattoirs. Rose Béton Festival. Toulouse, France. June 2016.

"Untitled" at Palais de Tokyo.

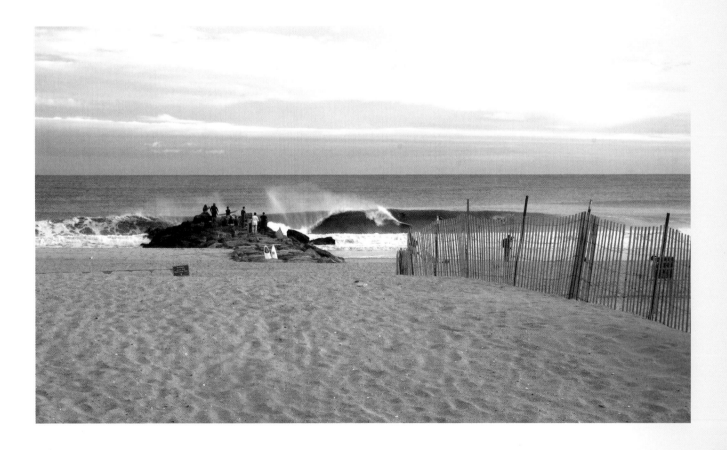

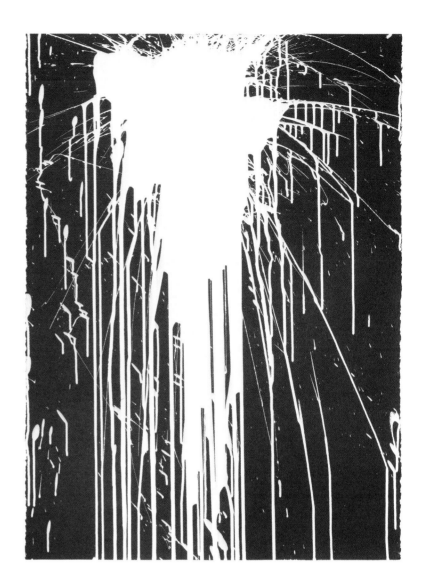

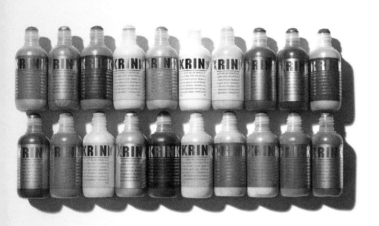

Krink K-60 Squeezable Permanent Paint Markers.

Untitled 2013, 11' x 24' x 6", acrylic on plasterboard and wood.

Building on Experience

San Diego's Tony Alva crafts sustainable surfboards, drawing on four decades of experience in the water

— After 40 years surfing and skating along the Californian coastline, original Z-Boy Tony Alva set up Alva Surfcraft, a line of hybrid surfboards. Born in 1957 in Santa Monica, Tony's exposure to surfing and skating lifestyles began when both were tied resolutely to subcultures on the outer perimeters of society. As he cultivated his passions for the sports, he also developed alongside them, witnessing their steady transitions to the mainstream.

Tony's famous background as a Z-Boy has always linked his passion for skating with his coastal environment. As teenagers in 70s California, the boys would often find abandoned swimming pools in which to skate, embracing their beach town surroundings both on the surf and on wheels. As Tony opened up Alva Surfcraft in San Diego, it quickly became clear that he would be committing his time and energy to a sustainable product that would require meticulous care from inception to final production. After over four decades riding boards, he began crafting them with the patience and experience that only time can bring.

Tony refuses to depart entirely from the sport that brought him recognition and a world of opportunities. He set up sister company Alva Skates, and has used his skating expertise in crafting the design of his surfboards. Hailing as much from the skate park as they do from the beach, the boards are an indelible symbol of Tony's background, expertise and enduring energy. ●

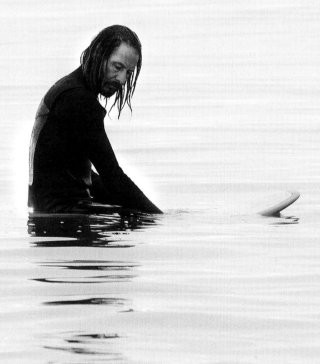

The original Z-Boy reflects between sets, somewhere deep in Mexico.

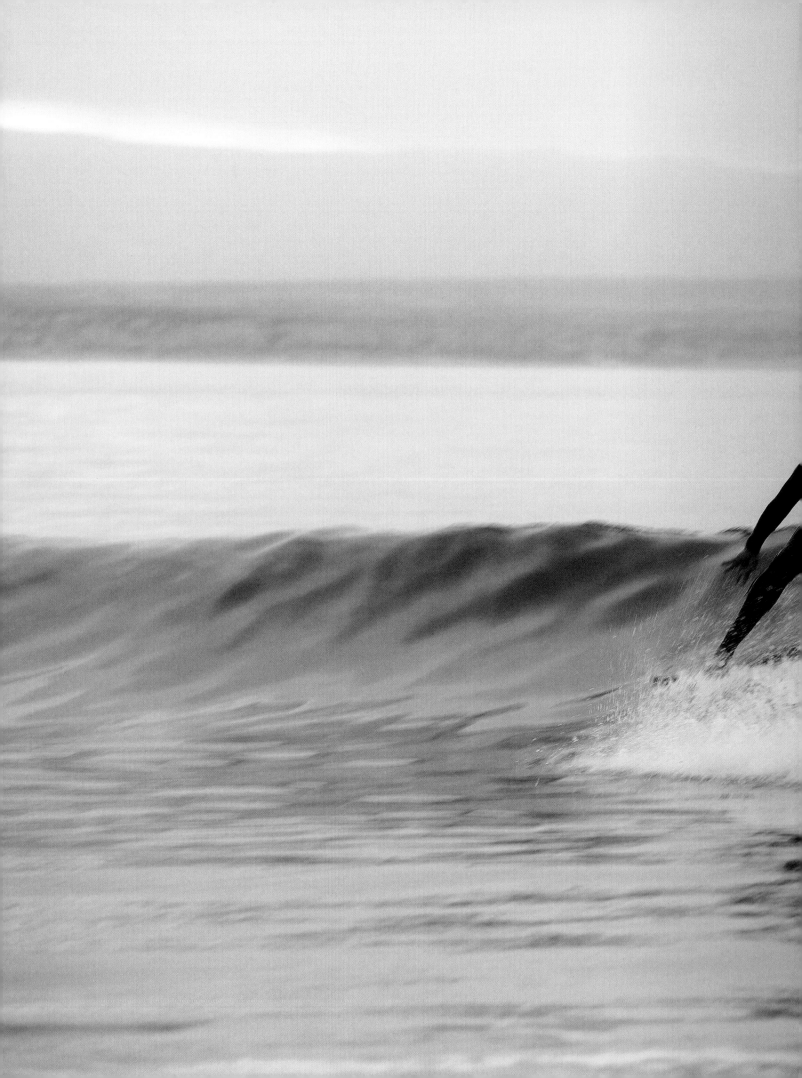

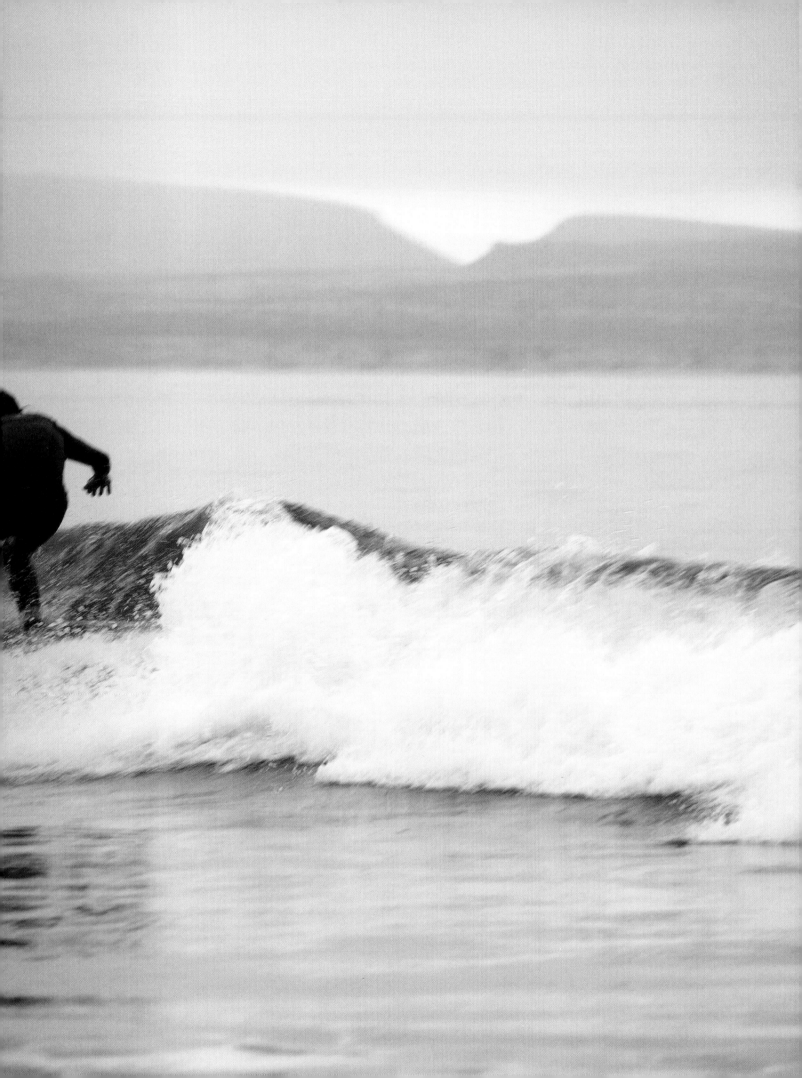

Bringing Wood to Water

Master carpenter Mirko Sebastian Stränger builds handsome, one-of-a-kind boards from certified wood

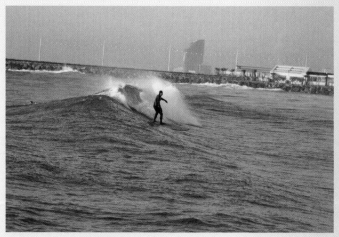

Surfing Marbella Beach in Barcelona.

— Mirko Sebastian Stränger, founder of the Barcelona-based surfboard line Proyecto Sandez, has been making one-of-a-kind wooden boards by hand for ten years. "As a passionate surfing cabinet-maker," he writes on his website, "building a wooden surfboard one day has been the logical progression." Surfing on a board made from cedar, balsa or Paulownia, he says, is a unique experience, one that differs greatly from foam. But the visual appeal of wood – not to mention its unmatchable durability – makes his work a failsafe investment.

Each of Mirko's creations is completed in a tidy workshop in the city's Poblenou neighborhood. For those hoping for a custom design, the master carpenter will add special colors, wooden inlays or burntin designs, finishing the boards in matte epoxy resin. He's honest about the strenuous work that goes into each piece, recording entries to his blog about the complexities of the craft. (In one, he calls glassed-on fins a "pain in the ass," then atones, praising their classic beauty.)

But for an artist nurturing a personal passion for surf, the added effort is worth it. As he reveals in a short film by Marc Castellet, "everysurfer has to build their own surfboard one day – and with the Spanish word for nonsense, sandez, as his chosen designation, Mirko has managed to combine enthusiasm and ingenuity to create a wholly original form of functional art. A board made in his shop may be heavier than one built using foam, but any memory of its weight is sure to be abandoned the moment it hits the water. It's the pitch perfect accompaniment to the fundamental joy of the sport. You surf, Mirko says in the film, "and you forget about any problem for that moment." ●

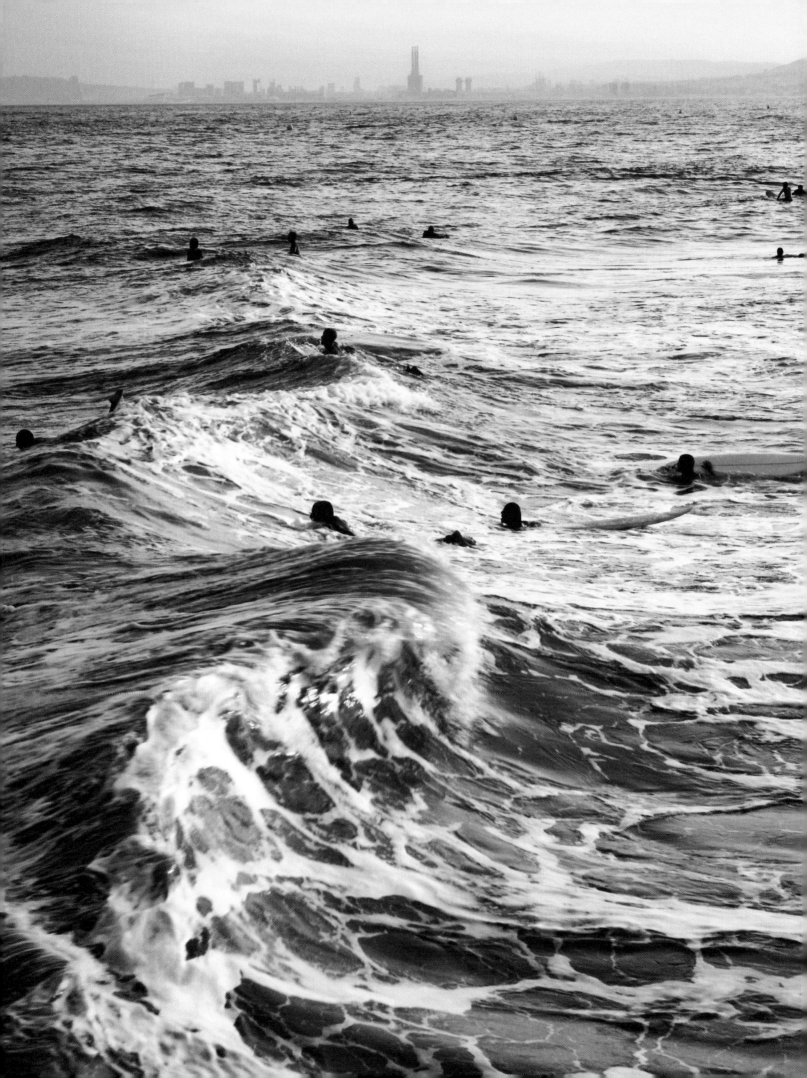

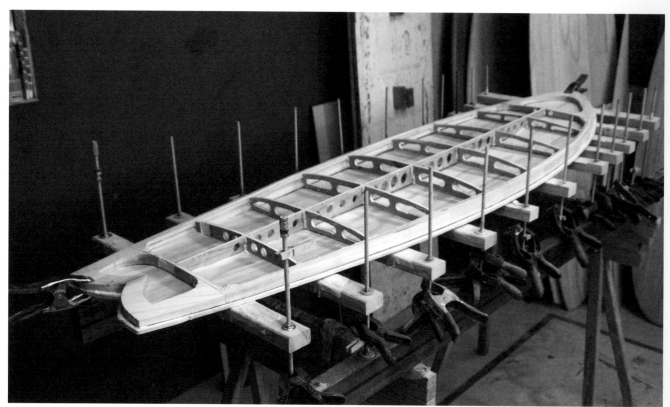

A board in progress at Mirko's workshop in the Poblenou.

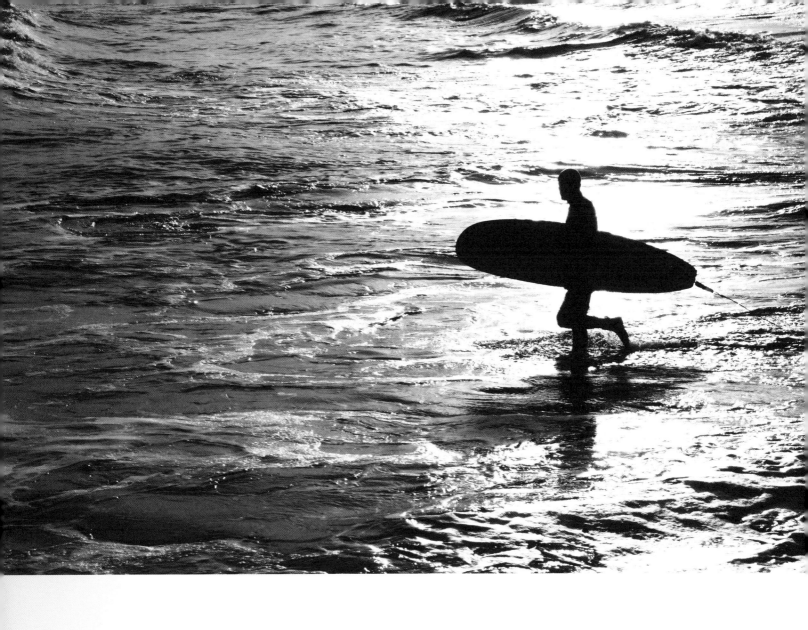

Stunning details on a plywood twin fin.

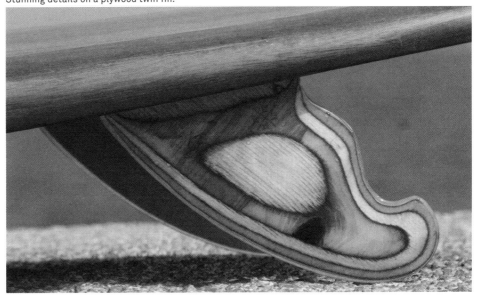

Becoming a World Citizen

French artist SupaKitch applies lessons learned through surfing to his multifaceted work

The artist's "morning commute."

— Like many children of a big city, French artist SupaKitch tried skateboarding before venturing on to a surfboard. It was only when he spent summer holidays at his aunt's house on the coast that the teenager fell in love with the ocean. But once on the water, he was hooked. "I was living [a five-hour drive] from Biarritz at this time and I remember the day I was having my drivers' license [exam]. My car was already packed, ready to take the road to the ocean. I got my license, got in my car and drove all the way to Biarritz."

The travel that surfing demands offers the first point in SupaKitch's artistic inspiration. Identifying himself as a "world citizen", he travels as one-half of the artist pair Metroplastique. Their work can be seen in many places, whether in the form of murals, illustration on surfboards or tattoos – Metroplastique make their mark as they move. "What I also love is coming back to a place I've

discovered and going back to all the places I've been to. It makes me feel that I live there. I don't feel like a tourist anymore, but more like a world citizen. Today, I feel like I have so many homes on Earth and it's a very inspiring feeling."

As he travels to surf, SupaKitch reflects on the lessons taught by surfing that find their way into his art. He explains, "Surfing taught me to stay calm in every situation, and that the key of happiness is balance. I was an angry man with a lot of energy. I still have that energy, but now it's canalized."

This newfound calmness is especially obvious in his tattoos. SupaKitch believes that the tattoo is analogous to the fast-paced, disposable world of the 21st century: "Nowadays, people live in a world where everything is digital and won't last more than 24 hours," he says. "Someone who wants a tattoo is forced to think and engage himself." ●

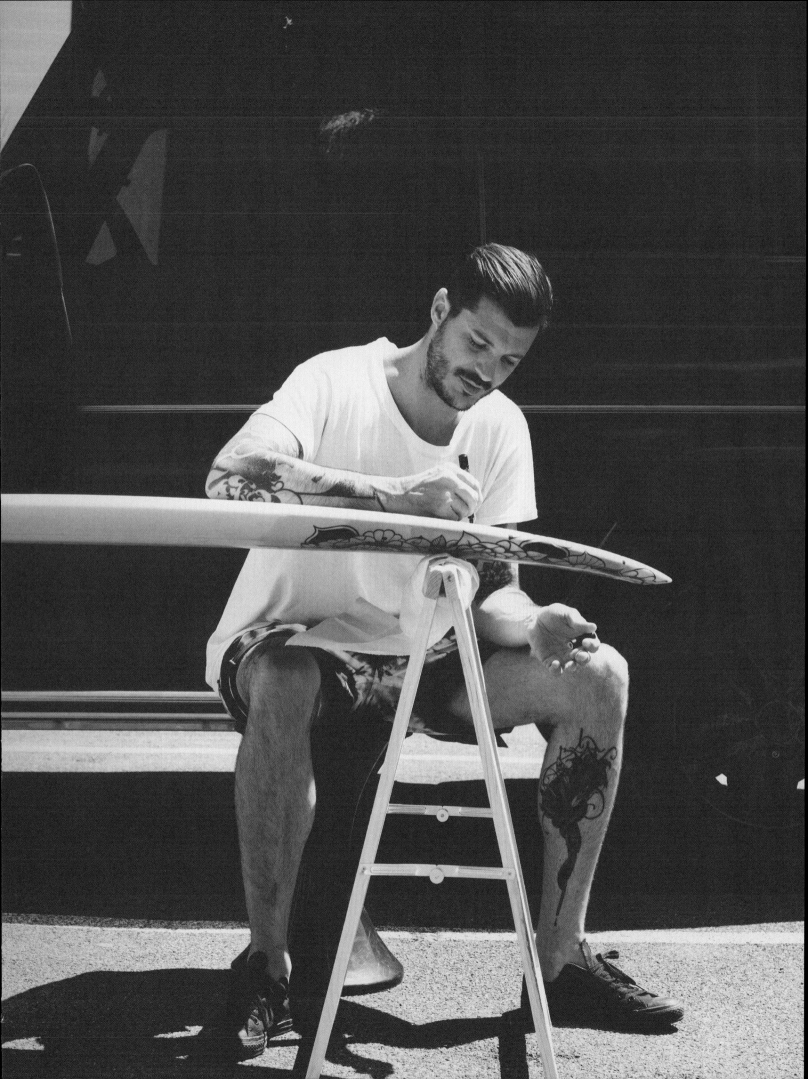

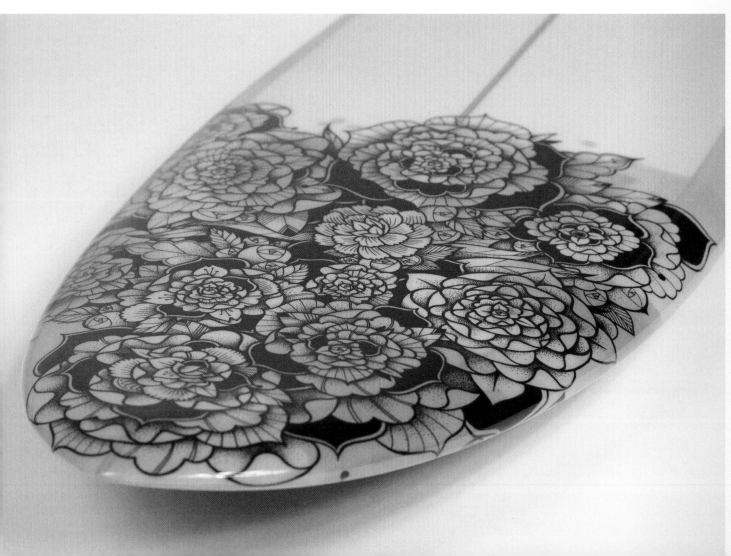

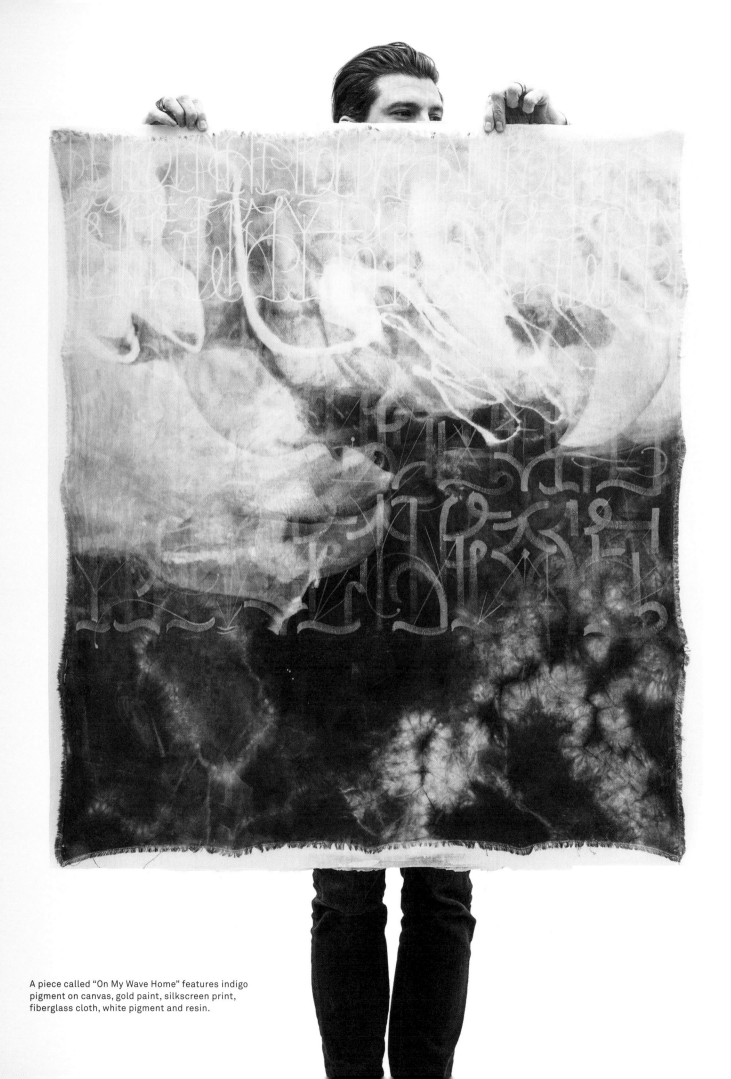

A piece called "On My Wave Home" features indigo
pigment on canvas, gold paint, silkscreen print,
fiberglass cloth, white pigment and resin.

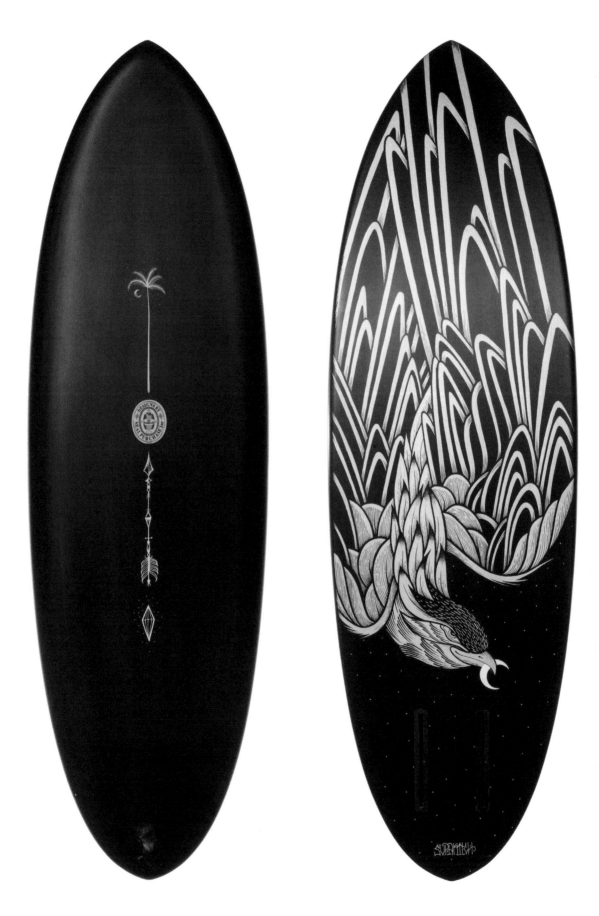

A black-and-gold beauty shaped by Neal Purchase and glassed by UWL Workshop.

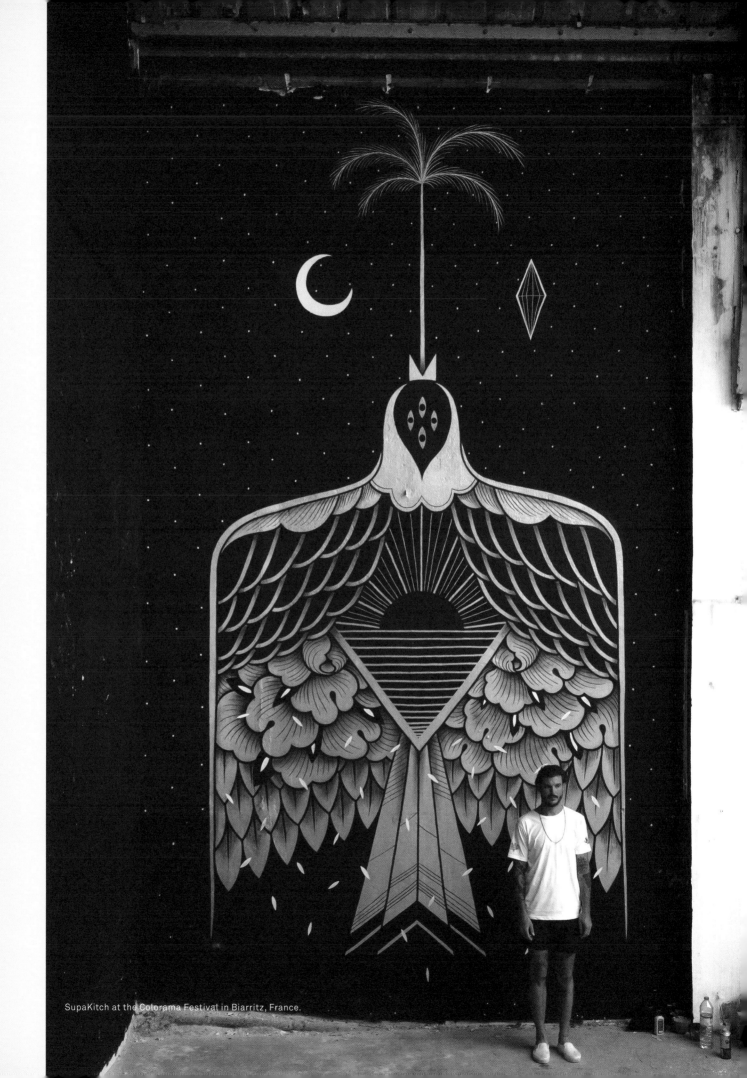

SupaKitch at the Colorama Festival in Biarritz, France.

Exploring *The Oh Sea*

Newport Beach's Jack Belli uses photography and film to offer a raw glimpse into the world of surf

—— Jack Belli grew up in Newport Beach, California, where surfing culture has some significant landmarks. The Wedge's waves that crash against the city's shoreline have attracted surfers far and wide to this particular part of Orange County. Growing up surrounded by this heritage has meant that Jack has been a passionate surfer from an early age.

Jack received his first surfboard as a Christmas present before even becoming a teenager. And as he began to take up his second passion, photography, it became clear that the two pursuits went hand in hand: The waves that Jack grew up around were a natural source of photographic inspiration.

As photography gradually moved him into the world of fashion, this exposure gave his work a very raw aesthetic. The subjects of Jack's images appear extremely present in their surroundings; the environments in which they are shot are as important as the subjects themselves.

With *The Oh Sea* project, Jack has managed to capture the enjoyment others feel for surfing and relay it to his viewers. He films friends, fellow surfers, and they offer snapshots of their experience at sea. Just like his professional photography, Jack's video projects offer the viewer a raw, natural glimpse that comes, in part, from the influence of surf on each frame. ●

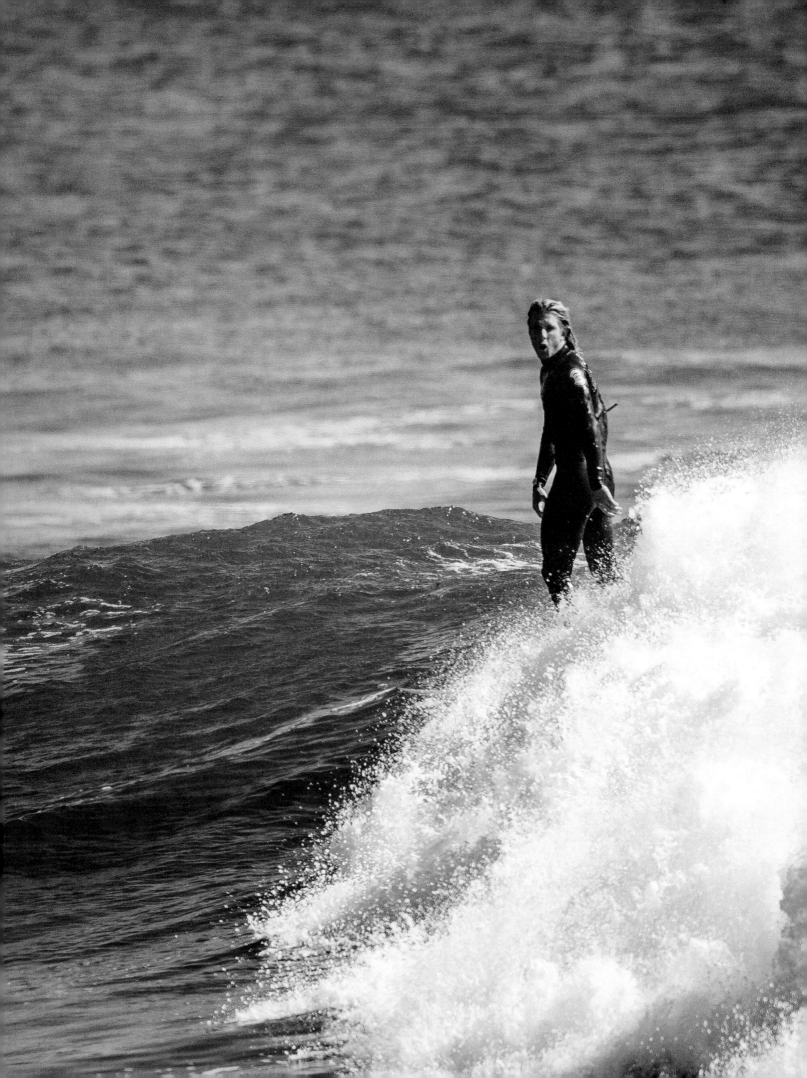

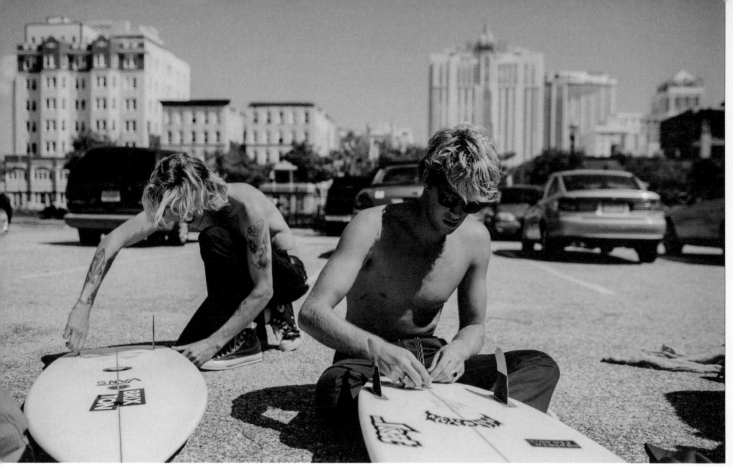

Gearing up to get down.

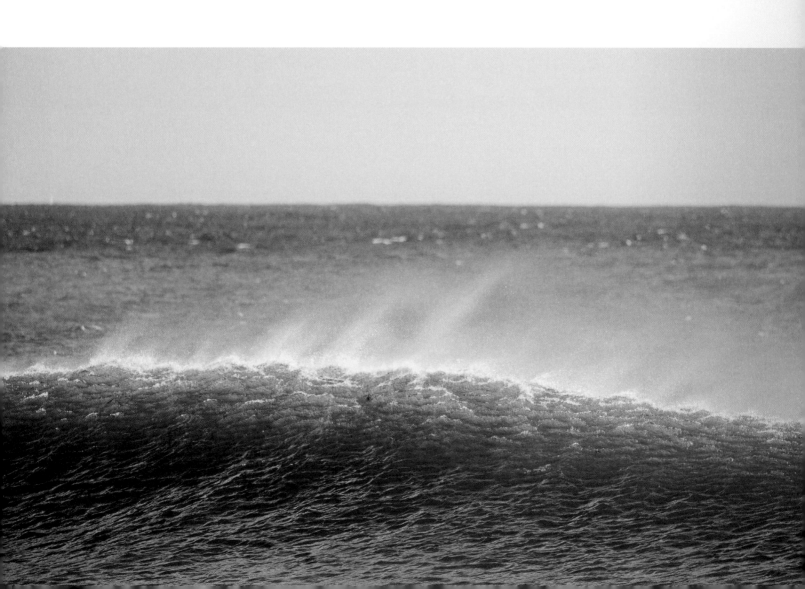

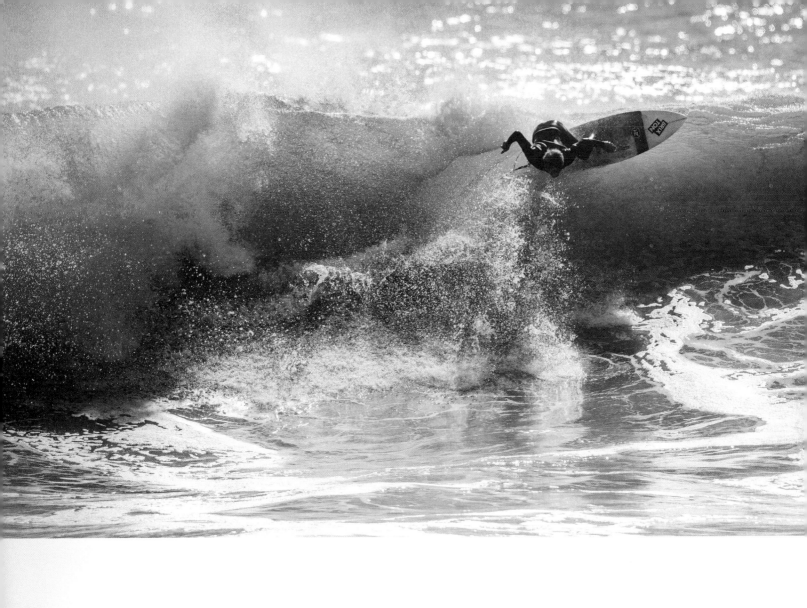

A local surfer with his self-shaped Bonzer.

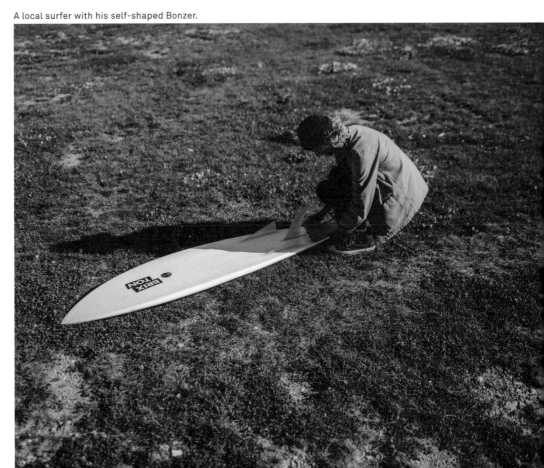

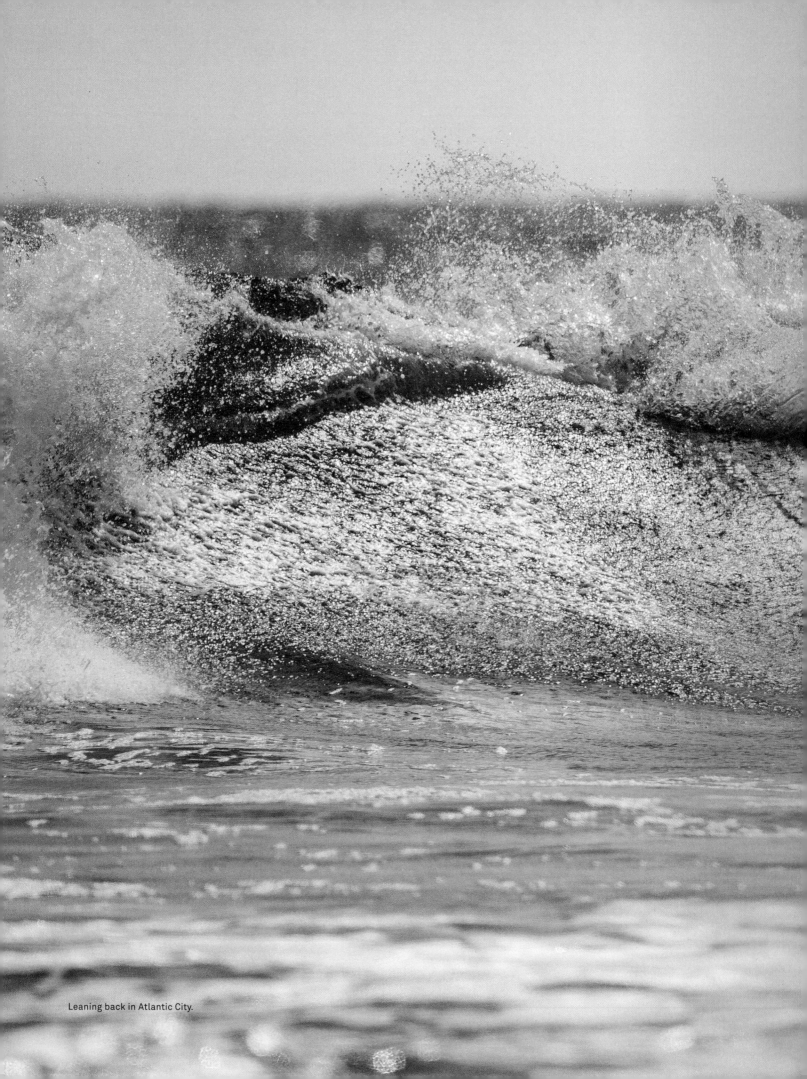

Leaning back in Atlantic City.

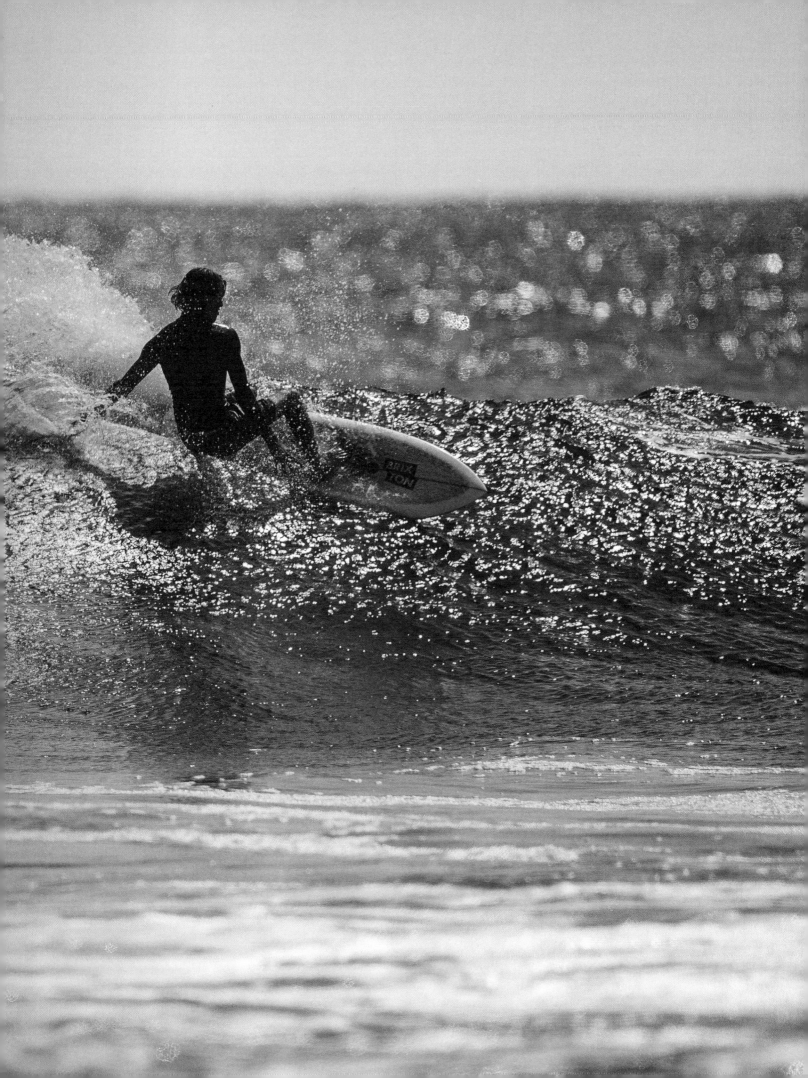

Redefining the Journey

The team at Folch Studio become travel story trailblazers with an innovative publication about 'regular people doing exceptional trips'

— Years ago, Albert Folch devoted himself to the study of geology and later, to photography, too. But it's graphic design – and a proclivity for thoughtful storytelling – that currently occupy his focus. His Barcelona-based multidisciplinary firm, Folch, counts betevé, Puig, Inditex, Mahou and Mango among its international clients; the studio is also home to two in-house editorial publications that have garnered worldwide praise: *Odiseo*, dedicated to erotica, and *Eldorado*, to travel. The latter came to be as a result of a surf trip to Morocco. "Started almost by chance," the team write on its website, "*Eldorado* is now the most ambitious project by Folch."

The project, which its founders – Albert, Rafa Martinez and Guille Cascante – refer to as a "transmedia editorial environment," aims to tell extraordinary stories of everyday people traveling the world. Though Albert is an avid surfer, the platform is designed to highlight all manner of adventure using multiple forms of media, including text, video, sound and photography. With *Eldorado*, readers can experience the Mediterranean, the Galapagos, the Arctic and beyond, all without leaving the comfort of home (of course, the Moroccan expedition that started it all is documented on the site, too).

Albert, who learned to surf only seven years ago, has since grown to love the sport for its therapeutic effects; appropriately, *Eldorado* caters to those with an urge to dig deep, to dive in to experiences head first, to discover nature – and themselves. Visitors are greeted with a compelling nod to this concept: "There are no uncharted places in the world anymore: this is why Eldorado is not the destination, but the journey." ●

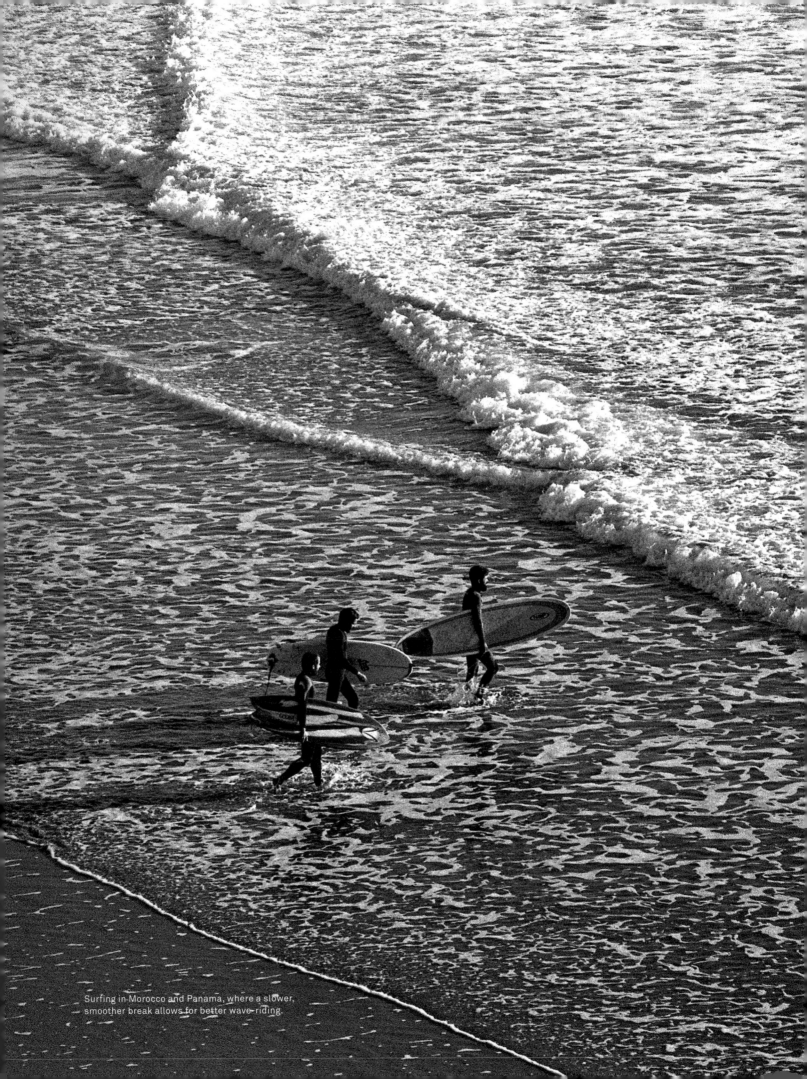

Surfing in Morocco and Panama, where a slower, smoother break allows for better wave-riding.

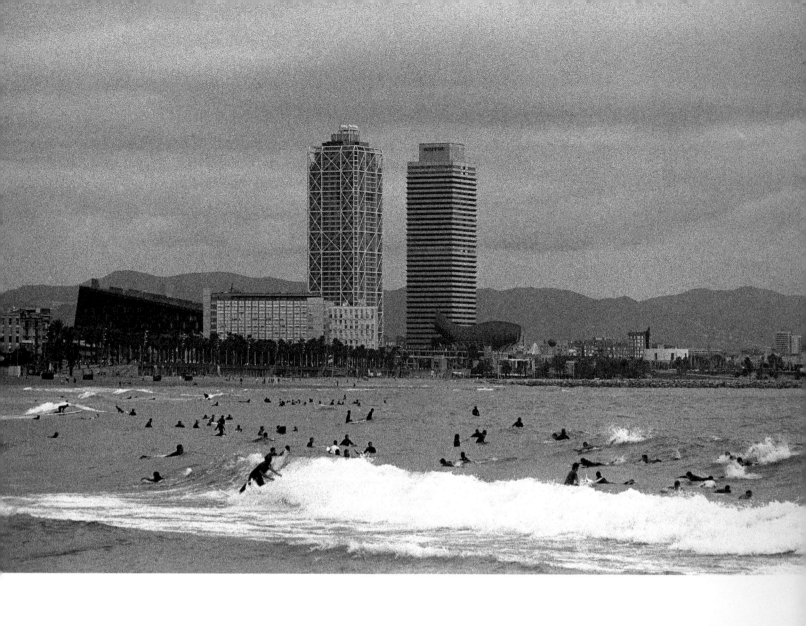

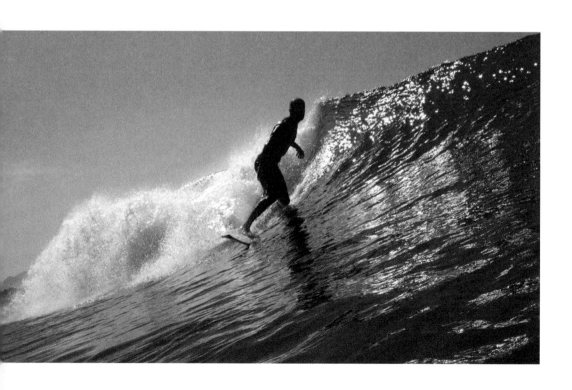

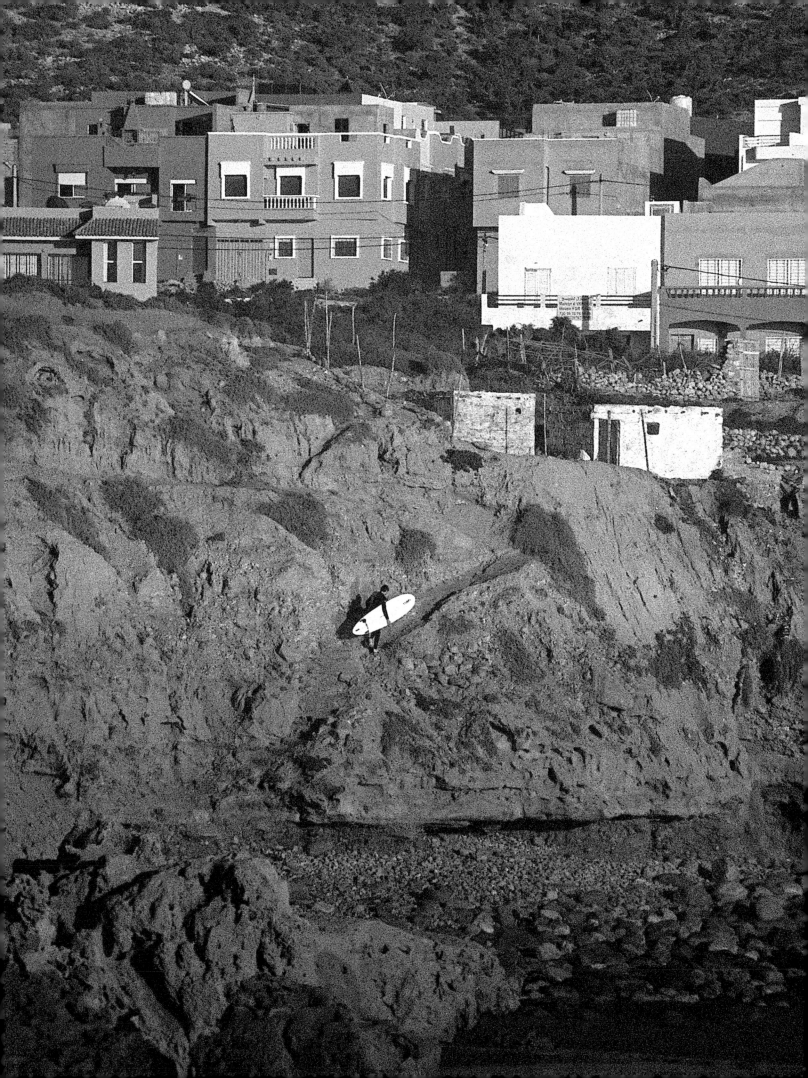

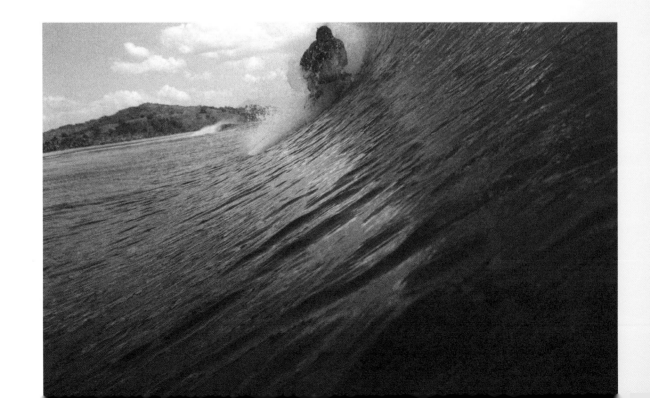

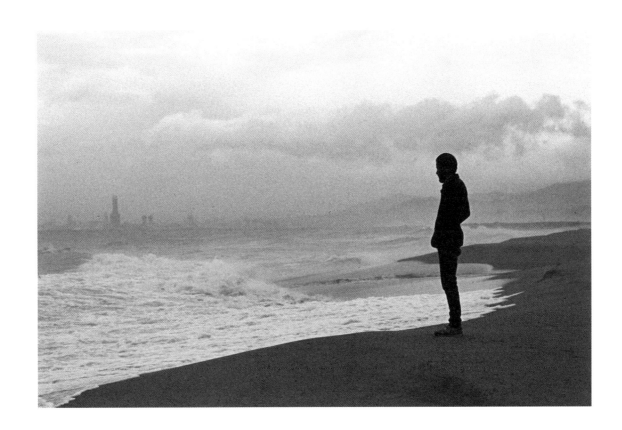

Designing Durability

Thom Hill creates pieces designed to be passed down through generations

—— It's rare that a store would discourage consumerism, but when Thom Hill opened Iron and Resin, he set out to make products that would last – that would allow their customers to spend years surfing on the same boards clad in high-quality, long-lasting gear. As Thom explains, this desire for durability is something that has come with age. "As I've gotten older, I've realized how little we actually need to make us happy," he says. So instead of fast fashion, Thom set out creating pieces that could be passed down for generations. "Everything I personally own, I want to be able to pass on to my kids one day and have it mean something to them, because that item meant something to me."

Although the products that can be found at Iron and Resin have hallmarks of fashionable and "in season," they harken back to something simpler. Thom thinks that the current appeal of the outdoors –

and the lifestyle of a modern explorer – is just the natural response people take as our societies urbanize. "The more boxed-in we feel in large cities, the more we want to get out and experience the opposite of that." For Thom, that outdoor experience can be found anywhere from dirt roads, to mountains, to – of course – the ocean.

Despite being a lifelong surfer, Thom isn't someone with a single passion. This is apparent in the products he creates for Iron and Resin. The store marries a passion for surfing with motorcycling, skating and, more generally, the outdoors. More important than the specific activities that take people into the wilderness, Thom wants his products to be a means for those experiences – whether in urban jungles, woodland or on the waves.

●

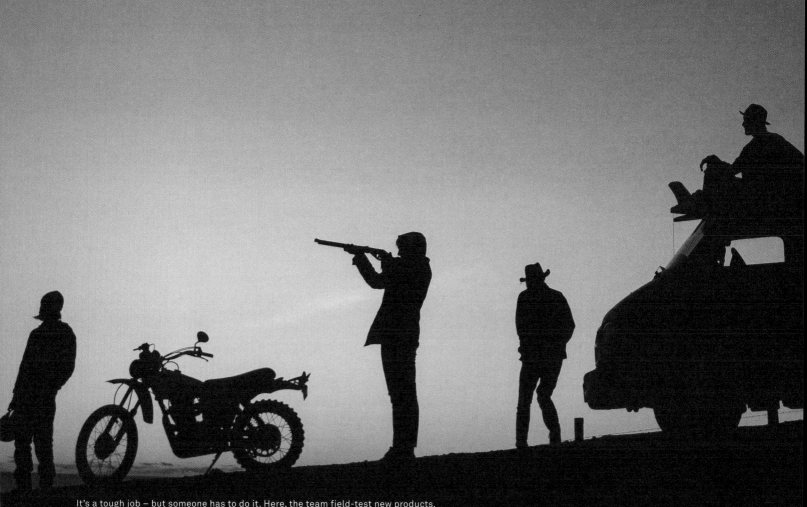

It's a tough job – but someone has to do it. Here, the team field-test new products.

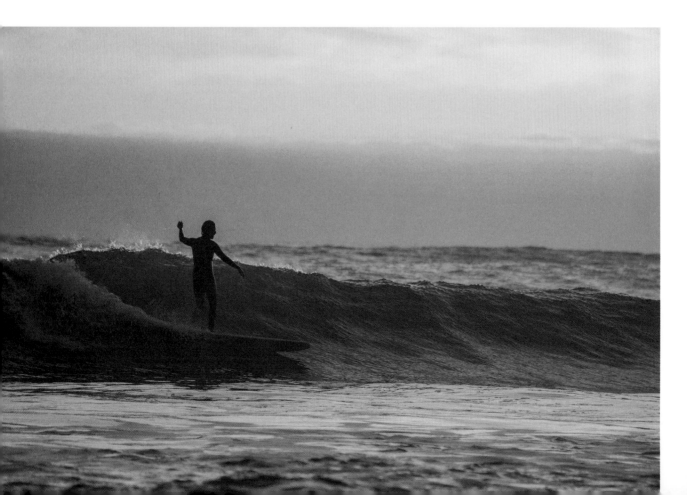

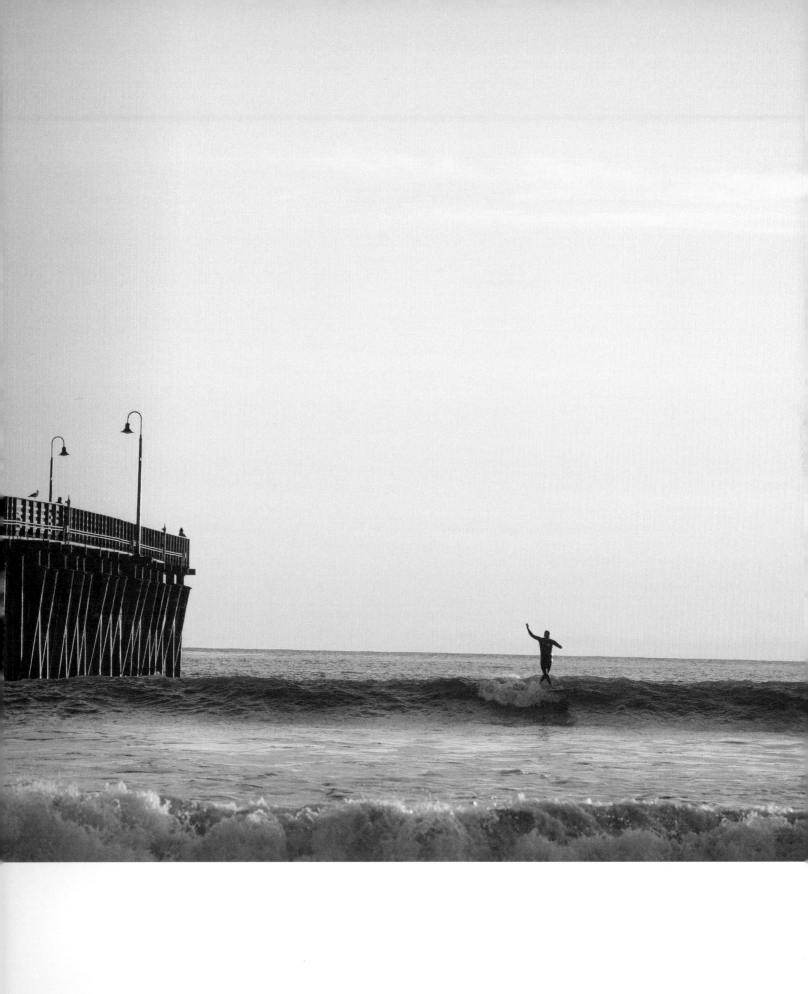

Setting Out Solo

Surfer Kepa Acero seeks out the world's best waves solo, sharing
his adventures along the way with thousands of eager followers

— If ever there were a surfer who embodied the true spirit of adventure, it would be Kepa Acero. Originally from the Basque Country – and the younger brother of professional surfer Eneko Acero – Kepa has become known worldwide not only for his skills on the board but for his solo globetrotting missions to the world's best and most far-flung destinations. His travels began after achieving a measure of success in the world of high-profile surfing – but at the time, it was the experience of traveling to visit a lover that inspired him to rethink his path. He packed his bags in 2010 and left home.

Since then, Kepa has lived as a nomad, traveling from Angola to Antarctica, Peru to Patagonia, India to Indonesia – and that's just scratching the surface. What's more, he's done it all alone, posting clips of his journey on Youtube, where each video invariably receives tens of thousands of views. And though he admits that prolonged solitude presents the occasional challenge, he remains unquestioning about its merits. The rewards of his travels, he says, extend far beyond the satisfaction of catching the perfect wave. As he told *Surfer* in 2015, "Every solo trip for me reflects what life is: we come here alone, experience the world, meet people, love these people, but then we must leave alone again."

By all appearances, Kepa's adventures will continue as long as he is able to remain on his feet. Even near-fatal injury can't keep him down: In January 2017, he suffered a hard fall at the Mundaka sandbar, breaking his neck and back but miraculously escaping paralysis. Days later, updates on his progress were posted to his Instagram; in nearly all of them, Kepa, seemingly unfaltering, was beaming. ●

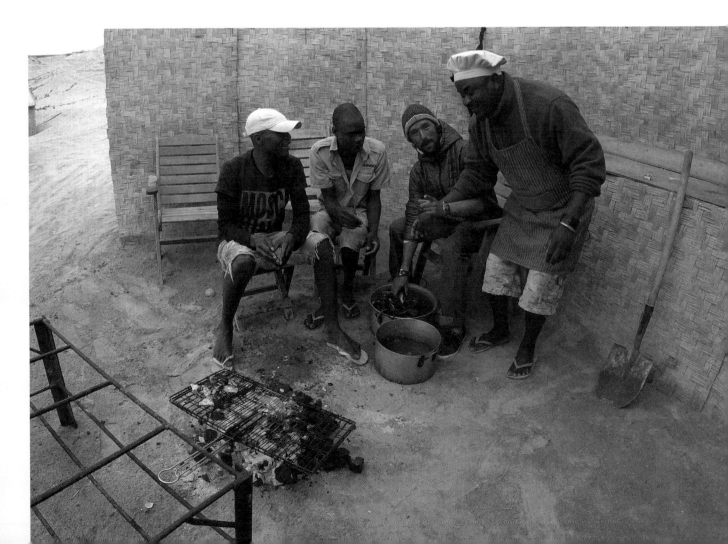

Guiding Globetrotters

Antony "Yep" Colas has traveled 50 countries, chasing surf and reporting back to readers

Tidal bros Fabrice and Antony, sharing a pocket-size take-off zone at Libourne.

— Thrill seekers and intrepid adventurers can easily be drawn into surfing culture, but few have explored the depth and breadth of the waves that the world's oceans have to offer more than French-born surfer Antony Colas. Author of the *Stormrider* surfing guides, Antony has spent the last 30 years traveling – to around 50 countries on more than 200 trips – to capture surf and share it with his readers.

In 1988, at the age of 20, Antony went to Bali with a friend to surf, and a few years later he traveled to Latin America, where he lived on a budget of five dollars a day. Chasing waves around the globe was a way for Antony to travel and, in the process, find the money, time and courage to keep his passion going.

For someone who has spent over half his life seeking out surf around the world, Antony now reflects on how his obsession came about. It offers a unique sense of accomplishment, he points out: "Contrary to most sports, you're only facing the ocean and yourself." Trying to define the experience that he has returned to time and time again over three decades on the waves, Antony says, "The ecstatic feeling of perfect waves and the beauty of the ocean became a strong incentive to do it again and again."

"Someone said surfing is the most elegant way to ruin your life," Antony recalls jokingly, before conceding that there's some truth to the claim. "It is, in a way, when you consider how much time you need to spend in the water to catch the good waves and ride them properly," he says – words spoken, humbly, like a true expert. ●

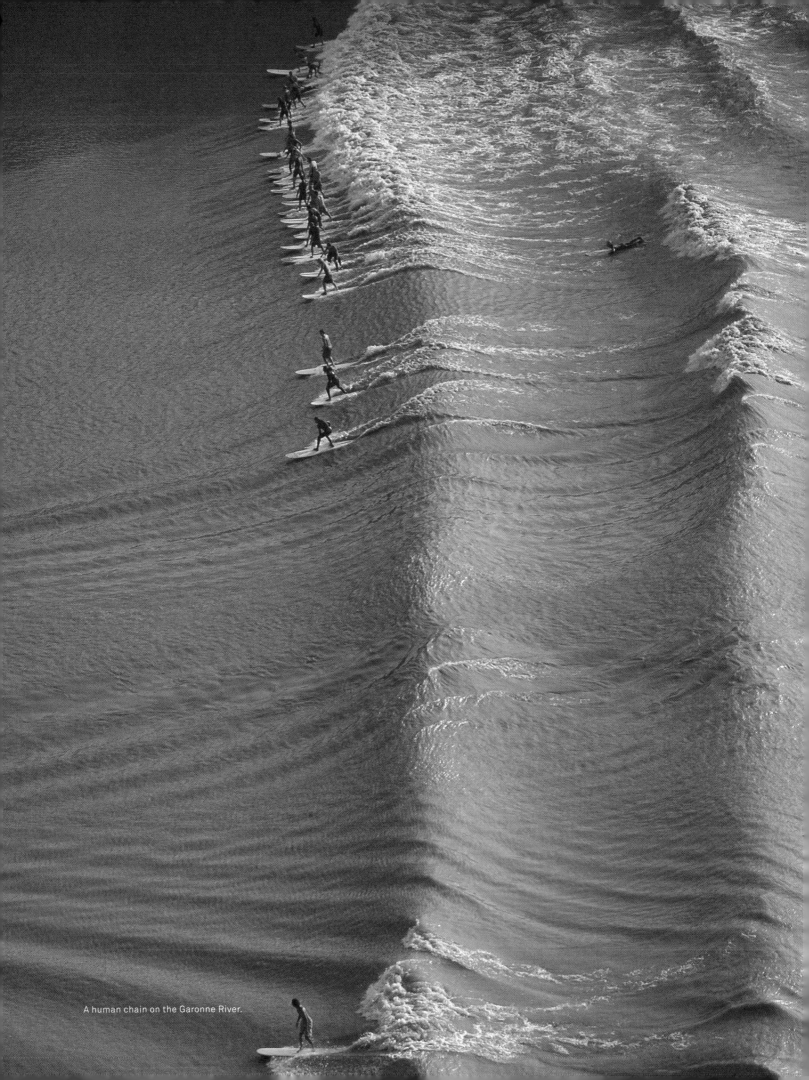

A human chain on the Garonne River.

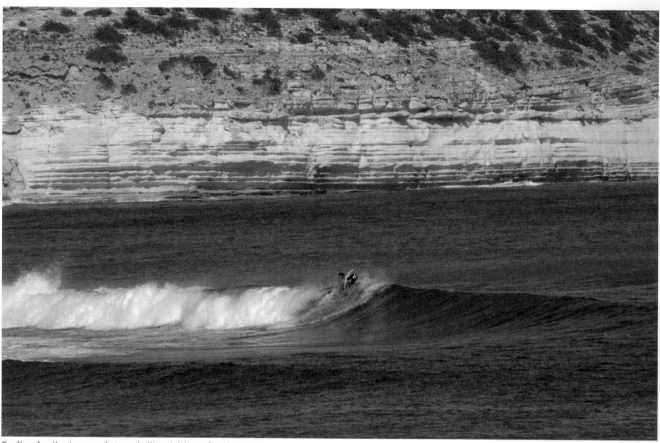

Surfing Apollonia, says Antony, is like visiting a Greek museum.

Waves abound on the Algerian coastline.

French expat Cédric Flahaut enjoys Chenoua beach near Algiers.

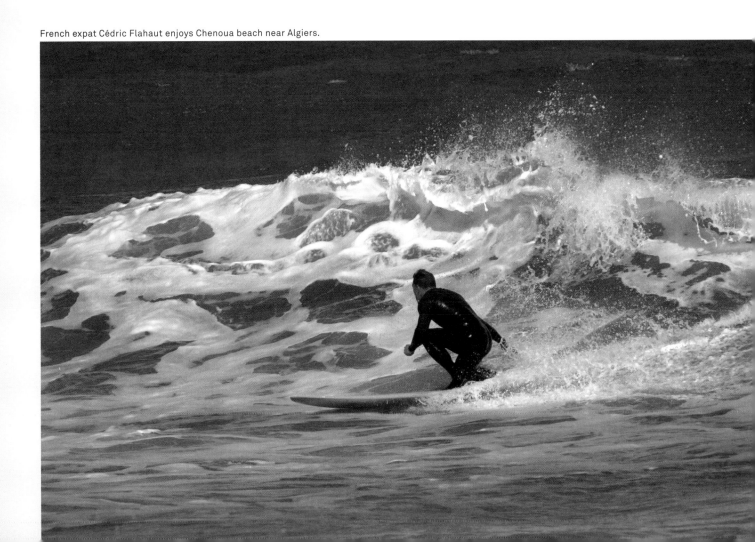

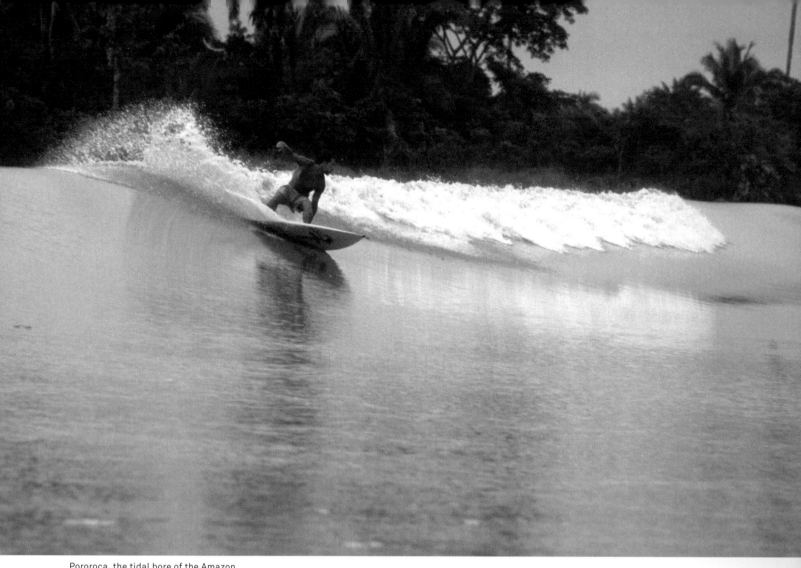

Pororoca, the tidal bore of the Amazon.

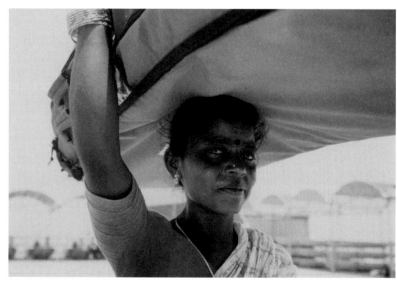

Though Indian surfing is still in its infancy, the Indian coastline offers plenty of opportunities for great surf.

239

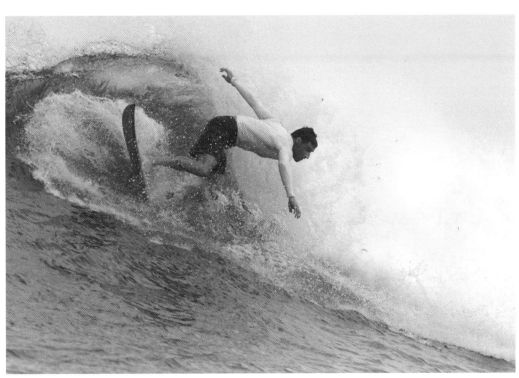

Antony Colas riding Yinyang in the Maldives.

The Qiantang River in China produces the biggest tidal bore in the world.

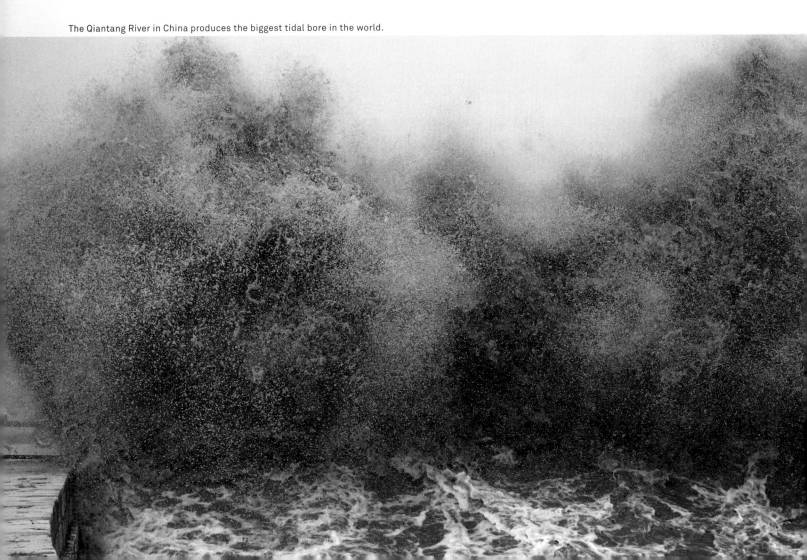

Surfing Off the Beaten Track

A filmmaker provides a look into the lives of northeast England surfers, who hit the waves despite the region's uncongenial conditions

—— The cliché "it's grim up north" must have been coined by someone who was taken in by the windswept, wave-battered coasts of northeast England. It's a harsh landscape that gives way to intimidating icy black waters – an extremely inhospitable environment, to say the least, in which to step out on a surfboard. Nevertheless, there are hardy surfing communities in and around Northumberland, a fact that caught the attention of filmmaker Simon Reichel, who set out to interview northern surfers and to explore the unique appeal of surfing off the beaten track.

The short documentary *Through Clouds and Water* engages with the economies and social structures with which these surfers grapple on a daily basis – and for which the sport can offer a much-needed release. The setting also offered Simon a new perspective to play with; he sees quality in its removal from typical surfing environments. "We wanted to portray this experience far away from the merchandising and lifestyle of beachside hotspots like Newquay – take away all the commodification and comfort and strip it down to its bare essential pursuit."

Using derelict steel mills and barren industrial landscapes to shoot a surf film allowed Simon to say more about the sport. Eerie, despondent surroundings are overlaid with the voices of Geordie surfers as they show viewers their passion – both for their hometowns and for the waves that hit the northern shoreline. ●

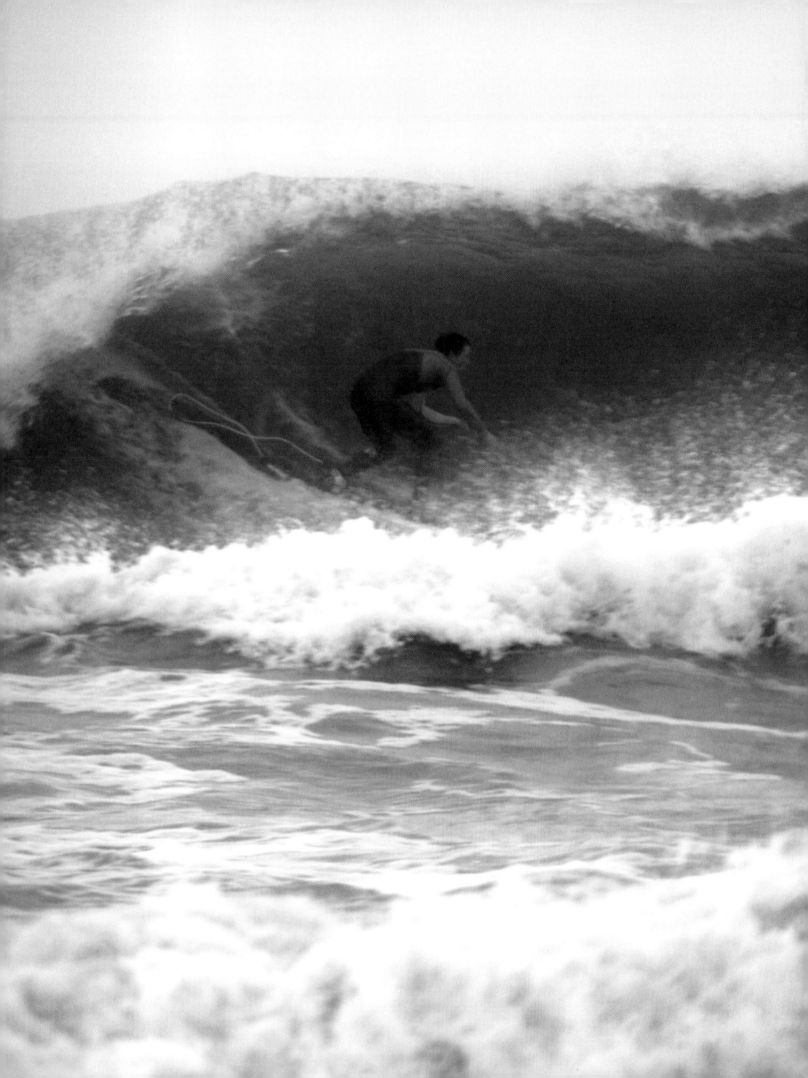

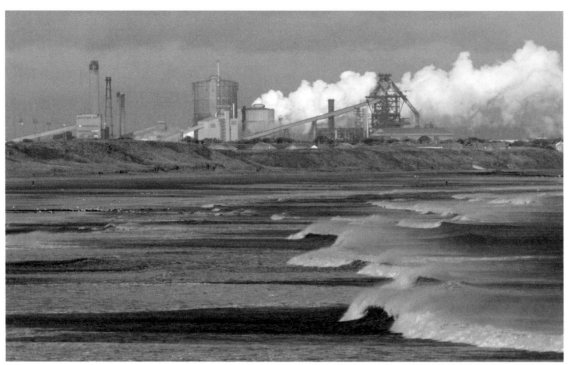

Surf spot The Gare draws adventure seekers undeterred by its rocks and pollution. "You can look back across at the factories," says one, "and it's the most uninviting place to surf ever."

Encouraging an Alternative

A surf and skate brand makes a mission of protecting the environment and educating others

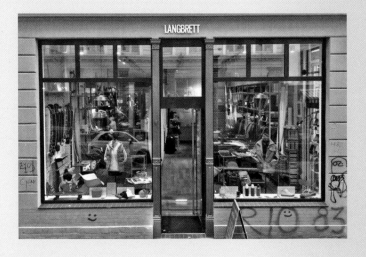

— While waiting for the first winter swells on the northwest coast of France, a small group of friends traded ideas over wine and a shared passion for the sport. Tired of the faceless products, senseless consumerism and lack of ethics within the mainstream surf industry, they decided to take matters into their own hands and form Langbrett, a surf and skate brand devoted to creating sustainable and durable products without complying with obsolete marketing rules. The team's main objective is to protect the environment and the people crafting and using their products. They're especially passionate about recycling and upcycling, which they promote not just through their selection of materials, but also by offering repair and reuse workshops to educate consumers. Much like other small businesses and impressive ventures in the world of outdoor activities, Langbrett's numerous projects and initiatives strive to contribute toward a more sustainable line of production, as well as the cultivation of a well-informed customer base.

The team started off by making everything on their own in Berlin and, since the city only offers urban waves and curves, they decided to handcraft longboards using wood from fallen trees in the forest of Saxon-Erzgebrige. Soon after, Langbrett managed to attract like-minded people who wanted to be a part of what the group was trying to achieve. Seeking to inspire, influence the status quo in retail and offer an alternative to mass production is what keeps their motivational engines running, in the hopes that others will follow their lead. The romantic – but not unrealistic – idea is to influence large-scale companies to use their insights and knowledge on materials and eco-conscious innovations (one such creation: a pair of vegan shoes whose soles are made from discarded coffee grounds). Langbrett has recently established a non-profit called Stop! Micro Waste and developed Guppy Friend, a special bag that prevents microfiber from entering our rivers and oceans. ●

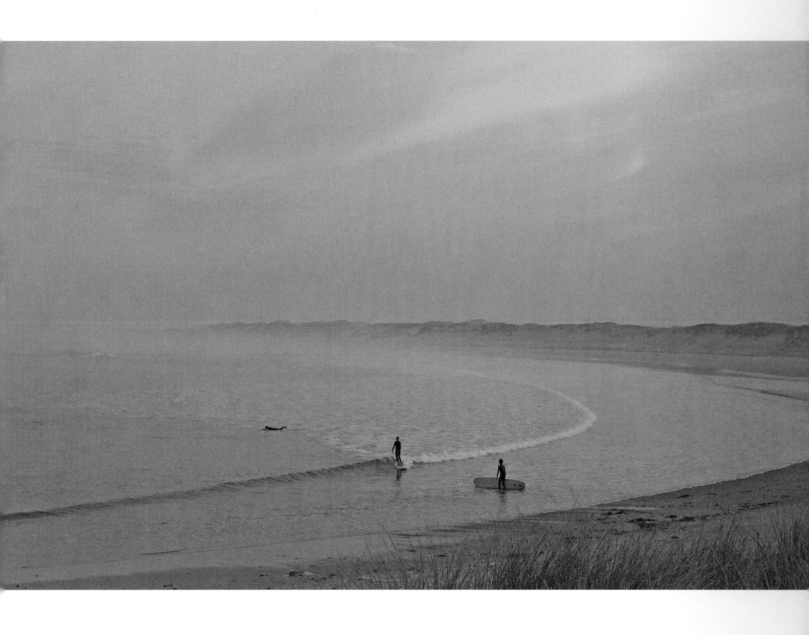

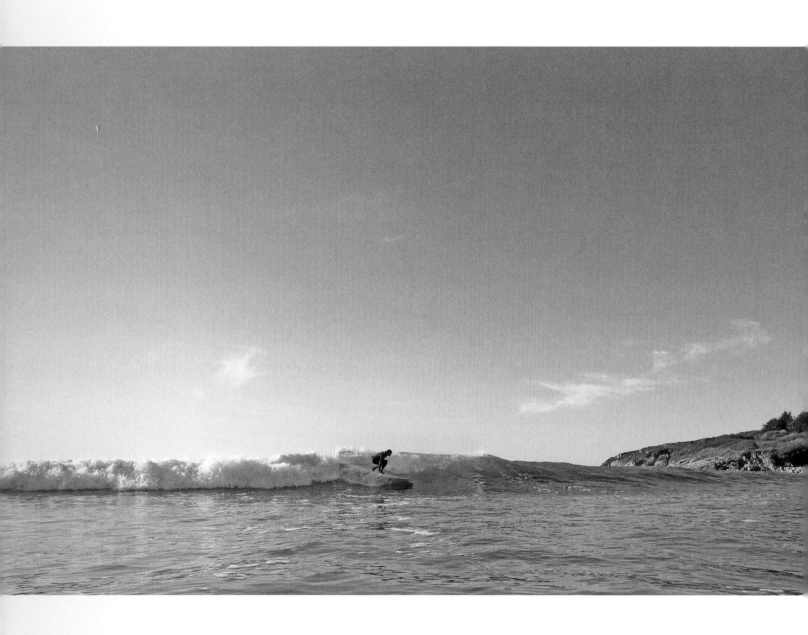

Telling Surf's Most Unique Stories

A pair of publications tell stories inspired by the diverse, multifaceted and continuously evolving landscape of surf

—— Beyond photogenic barrels, salty locks and postcard-perfect landscapes, a crop of niche publications approaches surfing in an eclectic way, focusing on the rich fabric of its culture, its stories and the all-encompassing experience that extends further than the shoreline.

One such magazine is Paris-based *Acid*, which portrays surfing in a broad context and explores its relation to art, science, philosophy and poetry. According to Olivier Talbot, one of its two founders, this publishing project seeks to be both intellectually and visually stimulating by viewing surfing merely as a gateway to a diverse range of topics.

Moving in a similar editorial direction, the biannual publication *Wax* shares the stories of New York City surfers who work within various creative fields. What lies at the core of this magazine is the need to celebrate the urban surf community – those who live and work in large cities and have

somehow figured out how to incorporate their love of surfing into their daily lives. On and off the breaks, *Wax* delves into New York's surfing history and the creatives faithfully engaging in the sport against all odds.

Created out of love of boardsport culture, art and design, Munich-based *A Bigger Park* believes in featuring a lifestyle that worships differences. Rooted in Munich's river-surf community, the minds behind this publication are interested in individuals who have embraced a more adventurous way of life, whether that's through their artistic work, dedication to extreme sports or a combination of the two. The team's drive comes from being ever-curious about the world: "We all live in a bigger park which we are cultivating as a community of designers, surfers, artists...citizens and outlaws, mountain people praising the sea and old spirits young at heart." ●

A BIGGER PARK

12 € — #1 Summer 2015 — abiggerpark.com

SUMMER 2014
IMMEDIACY

W
A
5
X

Acid

Saturdays
Magazine

Issue #003
Winter 2014
$25 US

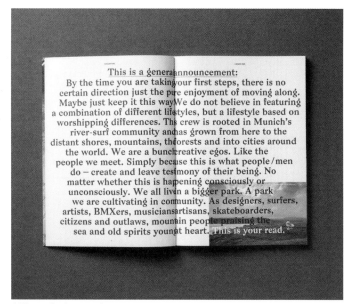

A Bigger Park magazine

WAX magazine

A Bigger Park magazine

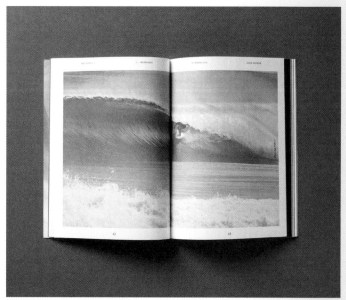

WAX magazine

A Bigger Park magazine

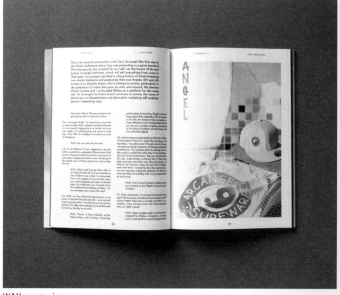

WAX magazine

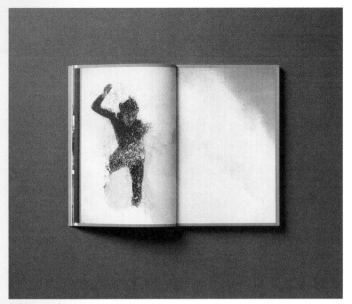

Acid magazine

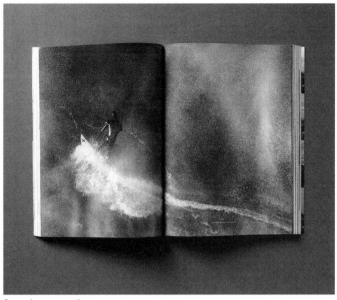

Saturdays magazine

Acid magazine

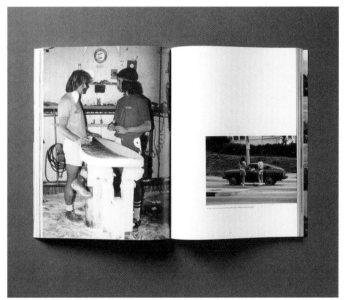

Saturdays magazine

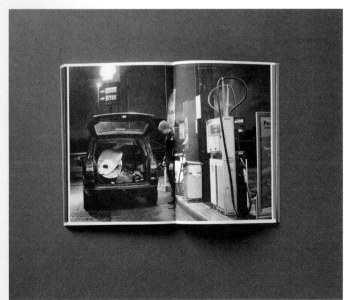

Acid magazine

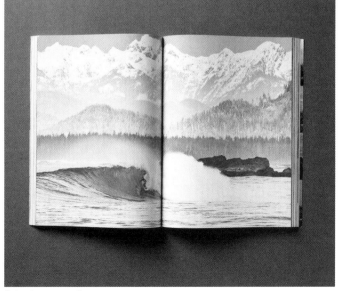

Saturdays magazine

Index

Firmamento
Barcelona, Spain
www.firmamento.com
INSTAGRAM: @firmamentosurf
PHOTOS: Anne Roig
www.anneroig.com
TEXT: Kevin Chow
PAGES: 68-71

Albert Folch/ Eldorado
Barcelona, Spain
www.folchstudio.com
INSTAGRAM: @folchstudio
PHOTOS: Dizy Diaz
www.dizydiaz.com
TEXT: Shoko Wanger
PAGES: 218-223

Frankenhein Surfboards
Ventura (CA), USA
www.frankenhein.com
INSTAGRAM: @frankenhein
PHOTOS: Rishi Linley
www.rishilinley.com
INSTAGRAM: @rishilinley
TEXT: Effie Efthymiadi
PAGES: 26-29

**Gauchos del Mar/
Joaquin & Julian Azulay**
Buenos Aires, Argentina
www.gauchosdelmar.com
INSTAGRAM: @gauchosdelmar
PHOTOS: Joaquin Azulay (p.187, 188)
Justin Smith (p.189 top)
Sergio Anselmino (p.189 bottom)
TEXT: Aggi Cantrill
PAGES: 186-189

The Handsome Collective
Byron Bay, NSW, Australia
www.thehandsomecollective.com
INSTAGRAM: @thehandsome-
collective
PHOTOS: Chris Grant/ JettyGirl Surf
Magazine
www.jettygirl.com
INSTAGRAM: @chrisgrantphoto
SURFER: Sormarie Nieves
TEXT: Kevin Chow
PAGES: 80-85

Christian Hundertmark/ C100
Munich, Germany
www.c100studio.com
INSTAGRAM: @c100studio
@c100art.com
PHOTOS: Christian Hundertmark
TEXT: Shoko Wanger
PAGES: 172-175

Iron & Resin
California, USA
www.ironandresin.com
INSTAGRAM: @ironandresin
PHOTOS: Dylan Gordon
TEXT: Aggi Cantrill
PAGES: 224-229

Andrew Kidman
Australia
www.andrewkidman.com
INSTAGRAM: @andrewkidman
ARTWORKS: Andrew Kidman
Litmus, Derek Hynd (p.49)
Garth Dickenson (p.50-51)
TEXT: Effie Efthymiadi
PAGES: 46-49

Klitmøller Collective
Klitmøller, Denmark
www.klitmollercollective.dk
INSTAGRAM: @klitmoller_colletive
PHOTOS: Peter Alsted
www.peteralsted.dk
TEXT: Effie Efthymiadi
PAGES: 76-79

KRINK/ Craig Costello
New York (NY), USA
www.shop.krink.com
INSTAGRAM: @krinknyc
PHOTOS: KRINK (p.194 top-197)
Henry Leutwyler (p.194 bottom)
TEXT: Aggi Cantrill
PAGES: 194-197

Langbrett
Berlin, Germany
www.langbrett.com
INSTAGRAM: @langbrett
PHOTOS: Langbrett
(p.244, 247 top)
Emi Koch (p.247 bottom)
TEXT: Effie Efthymiadi
PAGES: 244-247

Elijah Mack
LOCATION: Portland (OR), USA
INSTAGRAM: @elijahmackcutwell
PHOTOS: Courtesy of Elijah Mack
(p.132), Jordan Junck Photography
(p. 133), Benjamin Brayfield
(p. 134 top & bottom, 135)
TEXT: Kevin Chow
PAGES: 132-135

**The Magic Quiver/
Mario Wehle**
Ericeira, Lisboa, Portugal
www.magicquiver.com
INSTAGRAM: @magicquiver
PHOTOS: Yuki Yajima (p.144)
Mario Wehle (p.145, 146 top, 147 top
left & right, 148 top)
Francisco Henrique Melim
(p.146 bottom, 147 bottom)
Jesper Molin (p. 148 bottom)
Christoph Haiderer (p.149 top)
Filipe Neto (p.149 bottom)
TEXT: Effie Efthymiadi
PAGES: 144-149

Mambo
Los Angeles (CA), USA
www.mambo.vu
INSTAGRAM: @instamambo
PHOTOS: Pat Nolan (p.128)
Mambo (p.129, 130, 131 bottom)
Nicole Pham (p.131 top)
TEXT: Kevin Chow
PAGES: 128-131

Index

Index

Imprint

Editor-in-Chief
Effie Efthymiadi

Editor
Christian Hundertmark
Quirin Rohleder

Preface
Aggi Cantrill

Texts
Aggi Cantrill
Kevin Chow
Effie Efthymiadi
Shoko Wanger

Art Direction & Design
C100 Studio
www.c100studio.com

Tyefaces
Akkurat Bold
Akkurat Regular
GT Sectra Book / Italic

Cover Design
C100 Studio
www.c100studio.com

**Front & Back Cover
Photography**
Primoz Zorko (Front)
www.primozzorko.com
Nathan Oldfield (Back)
www.nathanoldfield.com

Proofreader
Shoko Wanger
www.shoandtellblog.com

Printer
Livonia Print
www.livoniaprint.lv

Publisher
Galindo Publishing, Berlin
www.galindo-publishing.com
ISBN 978-3-9817710-0-8

ISBN 978-3-9817710-0-8
Printed in Latvia

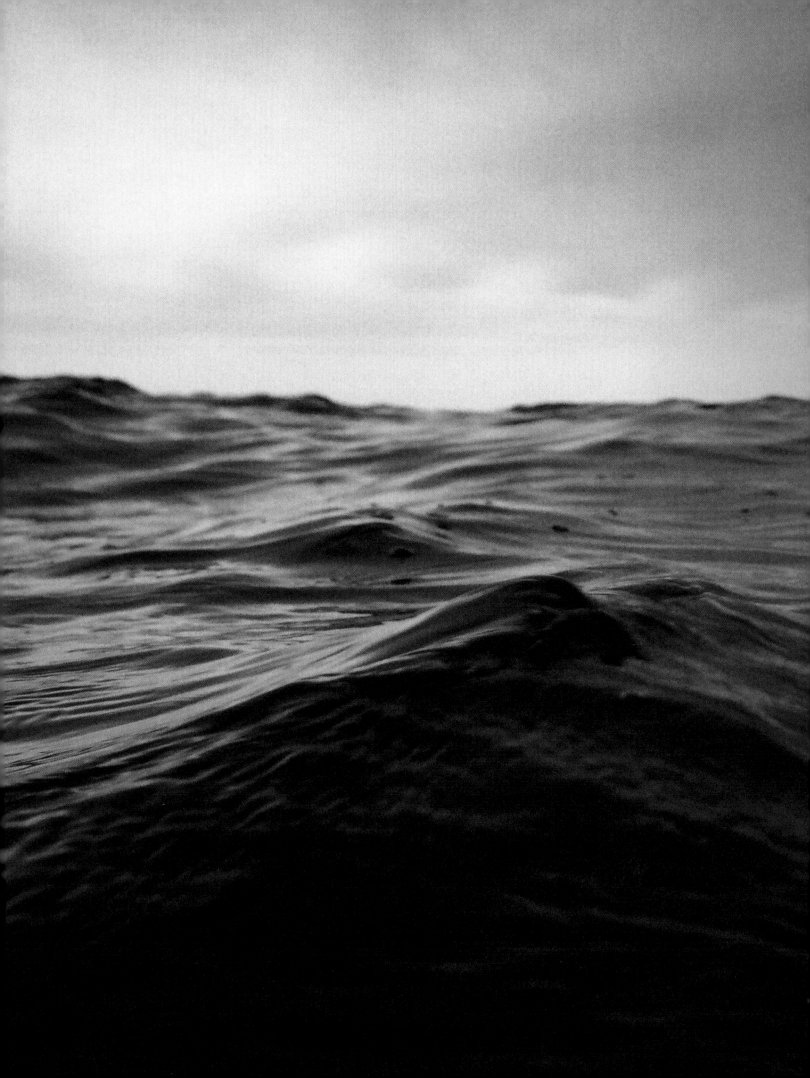

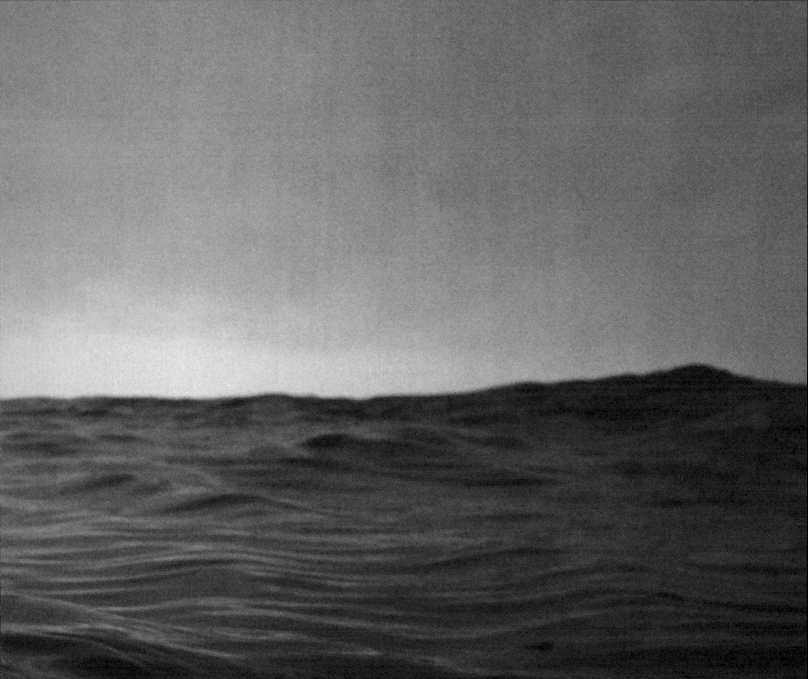